THE LITERATURE OF PHOTOGRAPHY

THE LITERATURE OF PHOTOGRAPHY

Advisory Editors:

PETER C. BUNNELL
PRINCETON UNIVERSITY

ROBERT A. SOBIESZEK
INTERNATIONAL MUSEUM OF PHOTOGRAPHY
AT GEORGE EASTMAN HOUSE

SUN ARTISTS

EDITED BY

W. ARTHUR BOORD.

ARNO PRESS

A NEW YORK TIMES COMPANY

NEW YORK ★ 1973

Reprint Edition 1973 by Arno Press Inc.

Reprinted from a copy in
The Museum of Modern Art Library

The Literature of Photography
ISBN for complete set: 0-405-04889-0
See last pages of this volume for titles.

Manufactured in the United States of America

———◆———

Library of Congress Cataloging in Publication Data

Boord, Arthur.
 Sun artists.

 (The Literature of photography)
 Originally published in 1891.
 1. Photographers, British. 2. Photography,
Artistic. I. Title. II. Series.
TR139.B6 1973 770'.92'2 72-9184
ISBN 0-405-04895-5

SUN ARTISTS.

SUN ARTISTS

(ORIGINAL SERIES).

EDITED BY

W. ARTHUR BOORD.

KEGAN PAUL, TRENCH, TRÜBNER AND CO., Ltd.

PATERNOSTER HOUSE, CHARING CROSS ROAD, LONDON.

MDCCCXCI.

LIST OF ORIGINAL ASSOCIATES OF "SUN ARTISTS."

W. Arthur Boord, *Hon. Editor.*

J. France Collins.

Alfred R. Deane, *Hon. Secretary.*

Herbert J. Gifford.

J. Stanfield Grimshaw, *Hon. Treasurer.*

J. Mason Harrison.

Herbert L. Noel-Cox.

INTRODUCTION.

AS with a play, so with a book, the prologue is at most tolerated, not encouraged; it is, nevertheless, necessary for the promoters of this serial to say that which would fall with but indifferent grace from other lips.

In producing " Sun Artists " it is their endeavour to emphasize the artistic claims of Photography by reproducing the best work of the best photographers in the best possible manner. The efforts which have already been made in the same direction have almost invariably had a basis personal to the artist reproduced, deriving undoubtedly therefrom their chief merit. The present attempt, however, has as its foundation a body of amateurs, resolved to show a catholic appreciation of good work and— while themselves corporately unassociated with any particular phase of photographic endeavour—to give the widest field wherein the individuality of each artist may assert itself. The whole series, it is hoped will form a true, because comprehensive, representation of modern artistic photography. In this sense the promoters confidently believe that " Sun Artists " dis-covers virgin soil.

The plates in the first number have been executed by the Typo-graphic Etching Company, to whom great credit is due for the delicacy and perfection of their reproduction. All hand-work upon them has been scrupulously avoided. Typographic excellence has been obtained by placing the letterpress in the care of the Chiswick Press, the type being from punches cut by Caslon in 1720, and the paper being Van Gelder's hand made. The cover is from an original design by Mr. Laurence Housman. The artist speaks for himself, while the descriptive text is by a well-known amateur, whose large experience of his subject entitles his

words to complete respect. The plates both individually and collectively are copyright.

This first number will be succeeded by others, uniform in appearance, at quarterly intervals. The promoters are unwilling by any words of theirs at this early period of their existence to curtail in any degree their liberty of action, believing that such a course would be prejudicial to the best interests of the scheme. For this reason they will not offer a detailed forecast of future issues. As has been already said every effort will be made to eventually include all that is most excellent in photography, and in carrying out this endeavour it may happen that names previously known to but a few will come into deserved prominence. To effect these purposes the promoters may ultimately be compelled to modify that which has been appropriately termed the " one man " character of each issue, but this departure lies in the far future, and will not be made without most careful consideration, nor at the sacrifice of the individualization attained by the present method.

The day is dawning when Nature as rendered by photography will occupy a much larger share in the esteem of cultured men, when Truth as Truth will also be conceded its claim to Beauty. The ripeness of Time may not as yet have come; should such prove the case, " Sun Artists " will help to prepare the way. In however small a degree, it is at once the ambition and the pride of the promoters of this serial to be associated with a movement which strives to gain for Photography a recognition until now denied her.

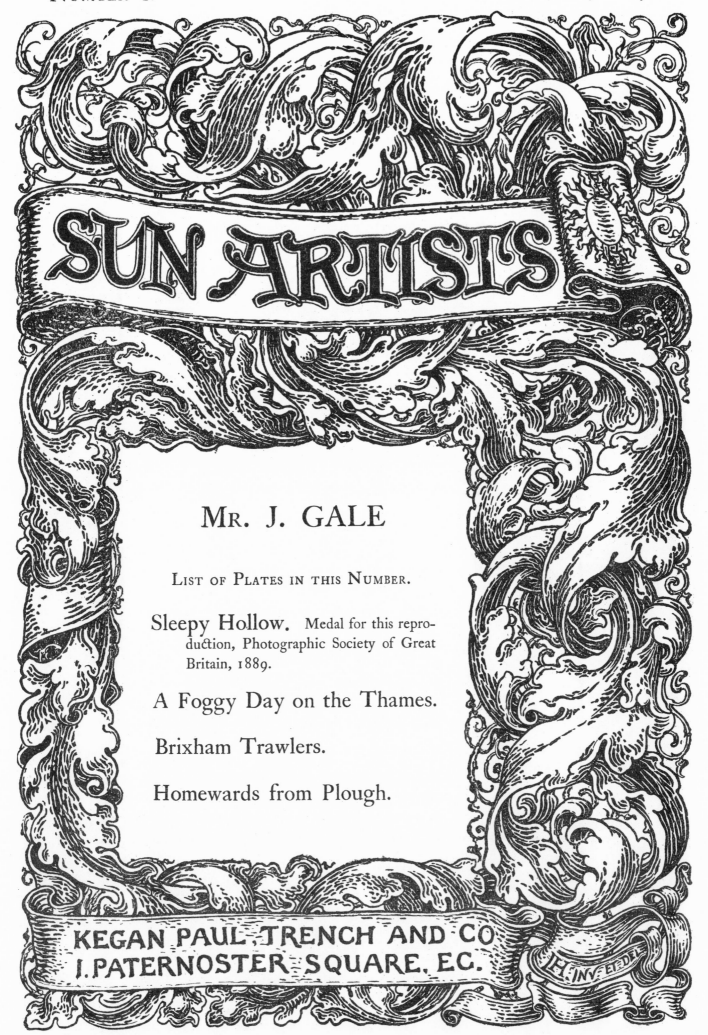

SUN ARTISTS

Mr. J. GALE

LIST OF PLATES IN THIS NUMBER.

KEGAN PAUL, TRENCH AND CO
I. PATERNOSTER SQUARE, EC.

NEW YORK: THE SCOVILL AND ADAMS COMPANY, 423, BROOME STREET.

SUN ARTISTS.

The second number will be published in
JANUARY, 1890, and will contain four Photo-
gravures from pictures by

MR. H. P. ROBINSON,

with descriptive letterpress. A limited number
of signed, unlettered proof copies will be issued.

All communications relative to this serial should be addressed
to the Hon. Sec.,

MR. ARTHUR BOORD,

Care of MESSRS. KEGAN PAUL, TRENCH & CO.,

1, PATERNOSTER SQUARE,

LONDON, E.C.

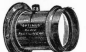

Applications for space in these wrappers should be accompanied by a draft of the proposed advertisement. Under no circumstance whatever will announcements be accepted for insertion in the matter pages.

MR. J. GALE.

ALMOST every one interested in photographic pictures is familiar with the character and quality of the work done by Mr. Gale; comparatively few can have any knowledge of the long period of practice, the care and patience in manipulations, the persistent endeavour and sound judgment which have combined and co-operated in the production of that work. It is somewhat the fashion amongst those having only a superficial acquaintance with the working of photography, to speak of it as though it were entirely mechanical and incapable of any variation in its rendering of natural scenes. Mr. Gale's work may fairly be taken as an illustration of the argument in reply to this opinion, that in photographic productions, as in some other arts which, at first sight, seem to be more distinctly handicrafts, the character and individuality of the photographer are clearly exhibited. There would be little difficulty in any exhibition in putting the finger at once upon pictures produced by Mr. Gale. They are marked by a delicacy of detail, precision in line composition, careful exclusion of anything awkward and inharmonious, a happy introduction of figures, and success in the combination of clouds with landscapes from different negatives. His photographs are almost all of the class known as "landscape with figures," and, from his earliest practice, he seems to have devoted himself in his photographic recreation to rendering country scenes in which the life of the place played an important part. In a letter recently published, he writes, referring to early gelatine dry plate days: "Figure photography afield was a gradual process, and with the comparatively few fellow-workers then, there was but little emulation in this direction. For years, however, before this, simple landscape without figures had but little attraction for me."

Mr. Gale's special delight, as he has himself said, has been in the rustic and the rural. His work has much of its motive and origin in his keen, never-satisfied love of the country. Country customs and manners have been matters of close and constant observation with him in his occasional summer flights to some peaceful village or hospitable farm. The birds and brooks have always sung him special songs; the former being often favoured with attentions through a field glass for the better watching of their movements and habits, and the latter a never-ending source of interest and delight with fish and weed, movement, music, and mystery. And then the sheep and cattle. It is interesting to notice how observation and knowledge teach tact in dealings with the flock and the herd. Which of us would be diverted from a serious intent to picture sheep by a friendly desire to amuse the woolly ones by bowling a hat (his own) in such a manner as to bring around it the whole company of silly curious things, staring at the shapely felt with wonder and amaze? And in how different a style does the photographer, skilled in

the ways of animals, approach a herd, compared with the man of city instincts, who takes up his stand with camera and tripod, as if seizing a position in face of an enemy, with possibly some slight misgivings about " horns."

Mr. Gale, starting with country associations, has kept the country about him in the town. Of Surrey he has trod every lane; in many a Berkshire cottage of wattle and dab and thatch he is known and welcome. The Sussex Downs, where he takes up summer quarters are, in his own fanciful expression, " his back garden." Here he knows every combe in the hills; and many a shepherd's home contains on the walls interesting photographic studies, in which the proud possessor figures as a part.

How important to a photographer tact and judgment are in dealing with the various contingencies which arise in the study of figure in landscape work, every man with experience will know. Some meet the circumstances with a cheery " known-you-all-my-life " advance, and this is all well if there is no tinge of condescension in the introduction; others of an older school naturally drop into a more courtly demeanour, having flavour of bygone days in their approaches and dealings with models, or the " landed proprietors " with whom the prosecution of their hobby brings them into contact. Mr. Gale is the type of this latter class and very rarely has had to put up with a rebuff.

To go back to the time when Mr. Gale commenced photography will carry us to the year 1859, when wet collodion reigned supreme. As is usually the case the contagion was caught from a friend, and the work was taken up as a congenial hobby. Mr. Gale brought to the practice of photography some training as a draughtsman, that necessary for the professional occupation to which his life has been chiefly devoted—architecture. To a friend he writes : " As a student in architecture I had filled many books with sketches " and drawings of buildings of past ages; the delineation of ancient towers and spires (at a " period before the wholesale restoration of church architecture) had been the joy of my " holidays; but, in an evil moment, the thought possessed me that much might be done, " much labour saved, by applying the limited acquaintance I had with photography to the " representation of my favourite subjects; and many future holidays saw me in full swing " with a 10 in. × 8 in. Ottewill camera and paraphernalia steeple-chasing over a large " extent of country." Further, associations, by reason of family ties and sympathies, with painters and other artists have helped to keep alive and develop his interest in picture making. It must not, however, be supposed that he has given the undivided attention and absorbing study to photography that are essential to be applied to any art, whether painting, etching, or engraving, if all its possibilities to the worker are to be explored. His photography has been merely a relief from other occupations; to quote again from the " Camera Club Journal," " the intermittent pursuit of a hobby by a man much " occupied in sterner duties." Such time, alone, in country holidays and relaxation hours, has been given to the practice as could be spared from professional duties, and from the onerous tasks which fall upon a volunteer officer. It is as a holiday pastime and amateur pursuit that Mr. Gale has worked photography, and he has continued to be the type of the most rigid amateur. Frequently, however, and with unusually kind readiness, he has given way to a request to lend his negatives for reproduction, and it is to be hoped that he, and other photographers whose work may be worthy of being put before the public, will see fit to proceed further and publish careful selections, in processes of such quality as

to bring credit to the art. In the earlier days of wet plate shortcomings and difficulties, physical and chemical, a very prominent question would appear to have been whether the results repaid the exertions. Many a disused wet plate camera, laid away in the lumber room, testified to the want of sufficient energy and enthusiasm of those, at one time or another, devotees of the silver bath. But Mr. Gale stuck to his tent and wheelbarrow, and can now, with some contempt for modern luxurious photography, look back to the time when the process took so much, but gave so little. He was one of the last to abandon the wet for the gelatine dry plate, but one of the first to explore and prove the fuller capabilities and flexibilities of the new process in landscape work. It required years to acquaint the fraternity with the actual possibilities of the new power, and even to-day there is much to be learnt of the proper application to art purposes of the superior qualities given by " dry " over " wet."

The present day photographer can probably have no idea of the difficulties, often with a comic side to them, which beset the early worker both in laboratory and in field. Some experiences when actually photographing in rural villages, before cameras became part of the rustic's education, are sufficiently amusing to be narrated. Mr. Gale himself has quite a fund of adventure to draw upon, and we are able to give the following in his own words :—

Little Wesleyans.—A drive of some miles had brought me on one occasion to a certain village, and the camera was duly planted in the centre of the village for a view of the church.

A happy lot of children watched the operation, and the nicest and most suitable were selected to form a group in the foreground of the picture.

It was soon known throughout the village that there was " someone drawrin the church," and numerous were the visitors. Among the most interested was, of course, the parson, who arrived on the scene as I was finishing and examining the negative, and whose eagerness to see what I had been doing I indulged.

He looked at the negative and its pretty group with great admiration, which to my astonishment suddenly faded from his face as he exclaimed, " Oh! you have spoiled your picture, you have spoiled your picture, they are all nasty little Wesleyans."

This was amusing ignorance in a quarter where it was not to be expected. For the consternation narrated in the next story there was more excuse :—

Burying the Baby.—A good many years ago I drove with a friend, well known in the locality, to a village in Buckinghamshire, the same where the inhabitants run down to a pond at the bottom of the village to ascertain if it is raining.

I wanted to photograph the church, so stopping at the gate of the churchyard, I proceeded to open out a 10 in. × 8 in. Ottewill camera with long focus landscape lens, and, covering it with a large square of the orthodox black velvet, I slowly carried it on my shoulder to the other side of the churhyard and planted it in position for a view of the church. As I went I had noticed three children watching my movements at a respectful distance, and having put the camera in position I returned in the hope of getting them to sit in my picture, but to my astonishment they were gone. So I went on without them ;

the plate was inserted, the velvet carefully folded back and the lens cap taken off, and we sat down to time the exposure and await the result.

Suddenly our quiet chat was broken in upon by three men rushing up in hot haste—the clerk, the sexton, and the gravedigger. A look of blank amazement spread over the face of each one of them when they recognized my friend.

While two of them remained to interrogate us as to the nature of the dreadful work we were engaged upon, the third went to make examination of my camera; he lifted the velvet, and his suspicions being apparently confirmed, he proceeded to look into the lens to see what he could find; being none the wiser, however, and having succeeded in nothing but spoiling my picture, he returned to his comrades and they then explained to us that they had hurried up there in consequence of three children running down to the village to report that " there were two gentlemen in the churchyard *burying a baby*."

Early photographic adventures had a way of happening in churchyards. Another experience enjoyed and narrated by Mr. Gale, he entitles:—

The Ghost.—Ghosts are frequently associated with churchyards; so was mine. They are usually white; the colour of mine you will learn as you read.

Long before the recent revival of the memory of John Bunyan, I was getting together some photographs of places associated with him, and at that time was working the slow tannin process. In order to change the plates, I used a black bag shaped like a balloon into which I put my head and arms, and then fastened the bottom round my waist with an elastic belt; it was provided with armholes and had a round piece of yellow cloth for a window. I used to take my box of 10 in. × 8 in. plates in with me and the one carrier, and so could change them on my lap easily enough.

One day I was comfortably seated changing plates with my back to the wall of Elstow churchyard, and was conscious, from the subdued voices of numerous youngsters, that I was an object of interest to a group of juvenile spectators.

It happened that I had omitted to bring in with me some requisite (a dusting brush or something of that kind), but knowing exactly where I had placed it I thought I could put my hand on it without emerging from my chrysalis covering; so, rising from my seat and passing my hands through the armholes, I groped about with outstretched hands in search of the missing article.

As I moved the excitement outside increased; first a scream, then a yell, then a general rush in the direction of the village.

When I quitted my changing bag a few minutes later, not a trace of my group of spectators was left, which was disappointing, as I had meant to induce one or two of them to sit in my picture for the requisite five or ten minutes.

However, I proceeded with the work of photographing the church, and presently observed my young friends peeping cautiously over the wall, accompanied by a number of grown up people all furnished with sticks and staves. After a hurried glance among the tombstones from behind the wall, the grown up party entered the churchyard.

With wild looks and gestures they gazed at me and my camera, and then continued their search for something of which I was ignorant.

Being evidently unsuccessful they returned to me and asked me if I had seen

anything; I replied that I could not say that I had not, but what sort of thing? Confusion seemed to possess them: at length one of the party, blushing crimson, asked me in a hesitating manner if I had seen anything like—like a ghost? The children had run down to the village, he said, and frantically declared they had seen a ghost with one eye—with one large yellow eye.

I would fain have kept a grave face and have carried them on, but was seized with an uncontrollable fit of laughter. When I recovered I explained that I was the ghost, a solid flesh and blood one, however, and presented my arm that they might judge for themselves. But they were difficult to convince, and it was not till I took them to my changing bag and, having attired myself in it, moved about with the appropriate gestures, that they were satisfied that there was not lurking about among the tombstones a black ghost with a large yellow eye.

Probably the earliest misapprehension of the camera as an infernal machine is reported in the following narrative of Mr. Gale's :—

A Scare.—I once paid a visit to a certain island off the west coast of Scotland, and the first morning after my arrival I was out betimes. In the course of wandering up a retired glen I came upon a charming waterfall, and forthwith setting up my 10 in. × 8 in. camera for a view of it, started the exposure of a slow tannin plate. It was now breakfast time, and the exposure would last well on towards dinner, so back to my quarters I must go. I had noticed, however, that the inhabitants of a cottage close by the point of view, but behind it, were watching my movements with much interest, so I called in and asked if they would see that the camera was not disturbed in my absence. As it is not always easy to get a direct answer from a Scotch peasant, I took their consent for granted and hied me back to breakfast a mile or two away.

As I went, I mused on the anxious and, as it seemed to me, frightened look of the people at my making this simple request.

After an interval of an hour or so I returned and found the camera just as I had left it; but wishing to be satisfied that nobody had touched it I went to the cottage again. Very tardily, in answer to my knocking, the door of the cottage was opened by a woman, whose terrified looks were only exceeded by those of a man behind her, and of several others behind him.

On intimating my supposition that nobody had disturbed my camera, the woman responded, "Inteed, sir, no whateffer! we tared na' gang out to look." The man choking with consternation and still half-hiding behind the woman, implored me to tell him what the machine outside was.

On my telling him it was a camera and perfectly harmless, he affected to be intimately acquainted with such things, and to regard them with great unconcern, and he even expressed a determination to go and look at the thing for himself; but from this valiant resolve he was turned by the entreaties of the women. He was so desperate, however, as to accompany me, though it must be confessed that he was inclined to regard me (as formerly he had his wife) as a very good shield; and from his earnest inquiries as to the nature of the projectiles and explosives used in the machine, it was evident that his bold demeanour was but the cloak to a most penetrating terror.

In quite recent years Mr. Gale has taken new interest in photography. The introduction of new ideas and methods and new claims for the art, amongst other and personal considerations, keep up the desire of an ardent photographer to examine into and try the best that is said and introduced. Mr. Gale prefers to leave to others having a stronger bent in that direction, the useful work of scientific experimenting. The processes themselves have less interest for him as chemistry or optics than as means to an end. He is generally one of the last to give up a process, the peculiarities of which he has mastered (silver paper for instance) for any new recommended method or material. At the same time, as soon as the superiority of any fresh process has been thoroughly established, he has not failed to avail himself of it.

One of the first photographs in which Mr. Gale achieved success after the introduction of gelatine plates was " Brixham Trawlers," a pleasing natural picture in which the subtle beauty of a well-known effect upon the sea is admirably caught, and in which the grouping of the boats gives feeling of distance, and is most effectively characteristic of the subject. It is very noticeable in almost all photographers' attempts at " landscape with figures " that the best are those in which the accessories selected for the interest they add to the scene, are inanimate objects, or at least figures unconscious of the photographer and his intention. Now and again a very natural figure study is seen, as in several of Mr. Gale's photographs, but the human element appears to be very generally too much for the methods of the ordinary photographer.

Another of Mr. Gale's happiest efforts is that entitled " A Foggy Day on the Thames," (a subject secured under the conditions of a heavy snowfall) in which the whole effect is true and striking. " Homewards from Plough," taken in a Berkshire upland country, is a fine bit of tone, and a spirited study. " Sleepy Hollow " is a delicately pretty scene at Crossway's farm, Abinger, an old friend of Mr. Gale's camera, and the picture is already well known and popular amongst photographers.

It is to be hoped that other work by Mr. Gale will soon be reproduced by photo-etching, such as " A Sussex Driftway," " A Berkshire Harvest Field," " Lambs in the Lane," " On the North Downs," " Cornish Fishermen," " Little Chippers," " A Hay Patch," and " The Path to the Hills."

Separate series, such as a set of illustrations of " Country Cottages," or " English Cottage Doorways," " Scenes about the Downs," " Farm Life," could be selected from Mr. Gale's pictures, and these would be appreciatively welcomed by the public, and make for the higher credit of photography. Such credit can only accrue from the production of photographs in photogravure, the medium which renders the work with the finest quality possible to it. Further than this there is another development, the only one at present in view which can raise photography to its highest possible position in art and critical estimation. This is, that artistic photographers, whose work is worthy of production, should study photo-etching and bite their own copper-plates. Thus a new interest and enthusiasm would be acquired in our fascinating art. The importance of this to photography cannot be over-rated. It will be matter for surprise if there be not an early and great movement in this direction.

GEORGE DAVISON.

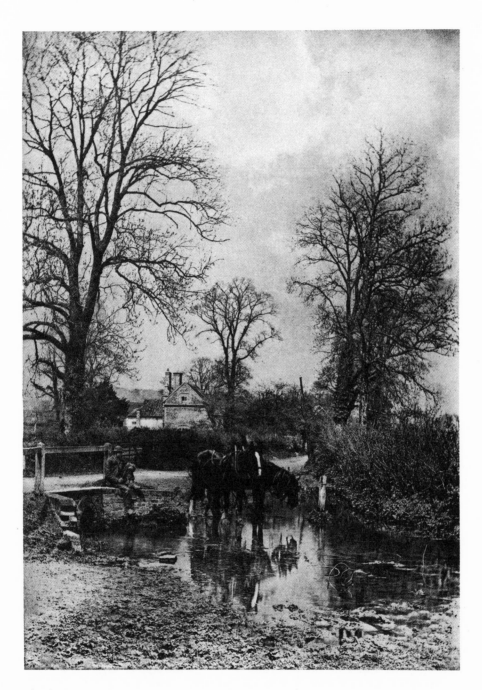

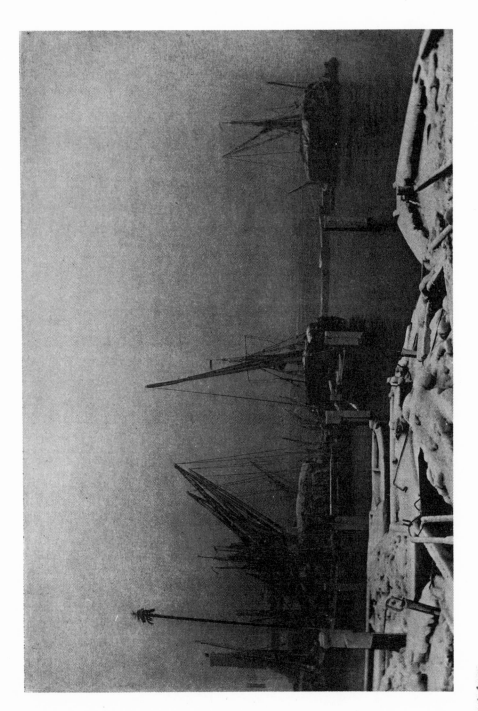

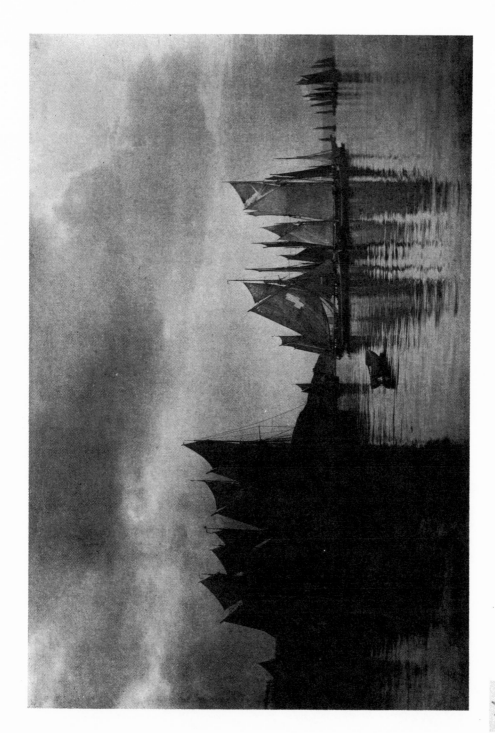

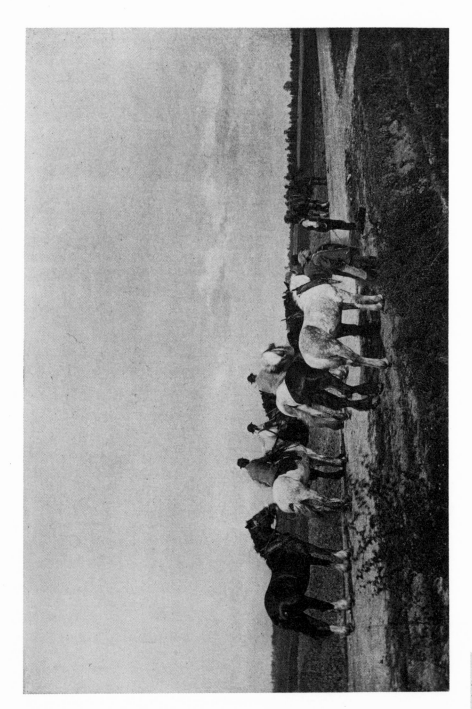

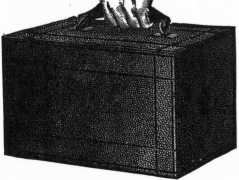

NOTICE.

In answer to inquiries, " Sun Artists " is the only serial entirely devoted to the reproduction of artistic nature pictures in first class photogravure.

In case of any doubt, and to avoid disappointment, intending purchasers should ascertain beforehand whether the publication offered them is issued under the authority of the promoters of this serial.

NUMBER 2.

JANUARY, 1890.

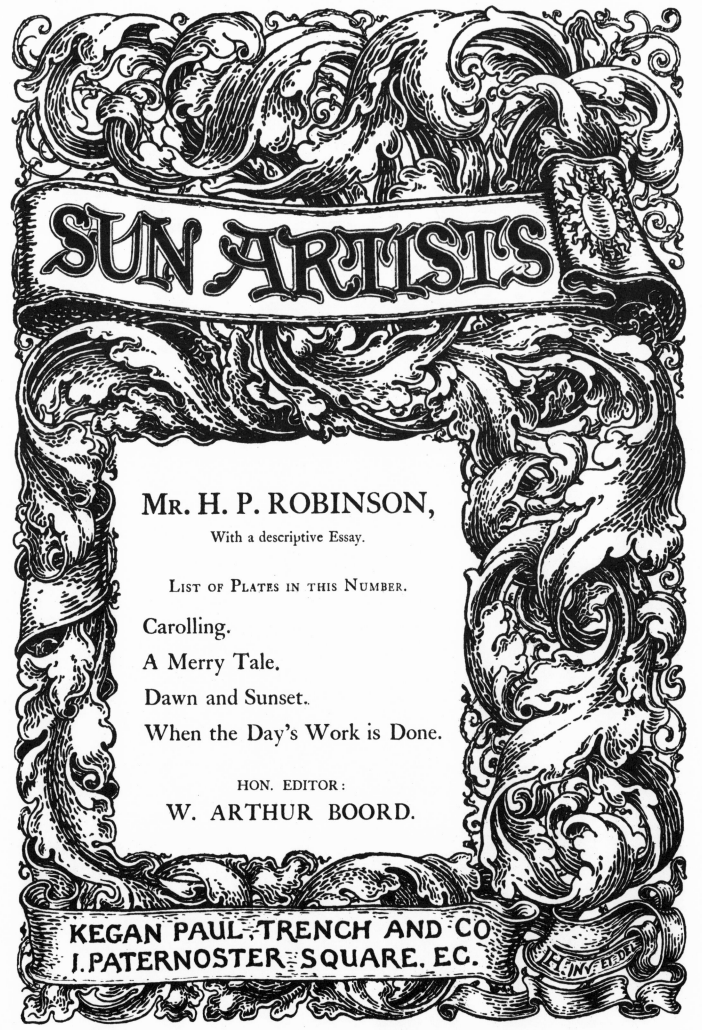

SUN ARTISTS

Mr. H. P. ROBINSON,

With a descriptive Essay.

LIST OF PLATES IN THIS NUMBER.

HON. EDITOR:

W. ARTHUR BOORD.

KEGAN PAUL, TRENCH AND CO
1. PATERNOSTER SQUARE. EC.

NEW YORK: THE SCOVILL AND ADAMS COMPANY, 423, BROOME STREET.

ABRIDGED PROSPECTUS.

OWING to various causes, too numerous to specify, no publication at present exists which adequately represents the actual artistic position of Photography.

Several amateurs have associated themselves for the purpose of placing this phase of Photography forcibly before the public, and by reproducing selected works of the foremost Photographers, in the highest style of art, hope to advance Photography in the estimation of the art-loving public, and to obtain for it the position which it now deserves. With this object in view "SUN ARTISTS" is published.

It is evident that this production marks an epoch in Photographic history, and for this reason—if for no other—it should recommend itself to the notice of every lover of Progress, whether himself a photographer or not.

NOTICES.

No. 1. MR. J. GALE (4 plates) has been reprinted.

LIST OF PLATES IN No. 1.

SLEEPY HOLLOW (Medal for this reproduction Photographic Society of Great Britain, 1889).

A FOGGY DAY ON THE THAMES.

BRIXHAM TRAWLERS.

HOMEWARDS FROM PLOUGH.

No. 3 will be published in April next, and will contain photogravure reproductions of pictures by

MR. J. B. B. WELLINGTON.

A limited number of signed unlettered proof copies will be issued.

Descriptive leaflets can now be obtained of all booksellers throughout the kingdom.

A form of order has, to meet the convenience of our friends, been inserted in this number on the fourth page of the wrapper.

Leading Press opinions appear on the third page of the cover.

All communications relative to this Serial should be addressed to the Hon. Editor,

Care of MESSRS. KEGAN PAUL, TRENCH, TRÜBNER AND CO. (LIMITED),

1, PATERNOSTER SQUARE,

LONDON, E.C.

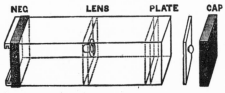
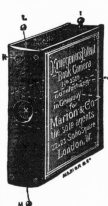

MR. H. P. ROBINSON.

THE Artist to whom we owe the pictures in this issue of " Sun Artists " may well be pointed out as one of the most prominent figures in the history of photography. This history does not at present cover a very long period of years, for photography is but a child; none the less the history of the art as well as of the science of photography has been full of stirring and strange events; and while we wonder at the ease and rapidity with which we can now achieve a graphic and permanent result, we wonder no less at the strides photography has in fifty years made from the Avernus of chemico-mechanical experiment into the Parnassus of fine art. For many years after photography became an accomplished and public fact, its votaries never wandered, nor dreamed of wandering, beyond the field of scientific research, or at the most beyond the production of " likenesses " for money; but the time came when its nobler possibilities were seen, its wider capabilities apprehended, and one pilgrim after another placed his shrine nearer and nearer to the sacred centre of their aspirations. A few words on some of the early phases of photography may not be out of place here, for in viewing any results it is well to consider by what paths and over what obstacles the results have been achieved.

Without entering into the details of the very earliest processes, and dismissing entirely the Daguerrotype process which is practically forgotten now, and was only a " positive " process at the best, we may say that the earliest " negative " processes entailed the use of paper or other " flexible support." Probably Fox Talbot is to be credited with the original idea of negative processes, for before his experiments the images obtained by the first series of manipulations corresponded in light and shade with the lights and shades of nature, and the first image obtained could not be multiplied without an entire repetition of the process for each copy required. But Talbot conceived the idea of making the first image a " negative," *i.e.*, reversed as regards light and shade and as regards right and left, and by making the negative translucent—on paper, for instance—he was enabled to produce by direct and simple processes an unlimited number of " positive prints " from his original negative, which may be called the *matrix* for all the positive prints so obtained. Various imperfections in the paper—or " calotype "—process soon were felt; the grain of the paper was reproduced with blemishing effect upon the positive prints, and a good many years passed before photographers began to wax the negative paper. The waxing of the paper minimized the grain shown in the prints and increased the rapidity of the printing operation, but before waxing was resorted to *glass* had come into use as the " support." Glass was not flexible, it was heavy and brittle, still it had the great advantage of transparency. Glass was suggested by Herschel about 1839, and the following years, up till about 1850, saw various *menstrua* used as " vehicles " for the

sensitive salts essential to the production of an image. Albumen was the "vehicle" chiefly used, but on account of certain properties of albumen the salts carried by it were not brought to any great point of sensitiveness to light action and chemical development. In other words the processes of those days were very "slow." Le Gray's, or Scott Archer's, introduction of collodion as the *menstruum*, or "vehicle," for the sensitive salts, was a complete revolution of photographic science, and the "wet collodion" process on glass, for both positive and negative pictures, was the universally accepted process for many years. And in truth, so great was the *beauty* of the process that we do not wonder that it was accepted with so much satisfaction; had it not been for the *inconveniences* of the process it would have had even a longer reign than it did enjoy. As many of Mr. Robinson's works were produced by this process, it may interest the reader to notice a few of the more conspicuous difficulties and inconveniences entailed by wet collodion.

Most people, even those not practically conversant with photographic *technique*, have some idea of the general steps necessary to the production of a "wet collodion" negative. We are all familiar with the pleasant odour of the volatile solvents of pyroxyline, and we rather enjoy their fragrance in an open apartment. But let the uninitiated one try the effect of ether and alcohol fumes in a little closet, or still better, in a photographic tent on a hot day, and the effect will be more appreciated if the inquirer after truth has himself carried the tent a few miles. Silver nitrate solution in distilled water is a beautiful, limpid, clear liquid, but in combination with the organic matters of skin or garments its effects and appearance are very different. Beautiful and interesting as wet collodion processes are, the drudgery and the dirt inseparable from them must not, and cannot, be overlooked. Yet the enthusiasts of wet collodion days braved anæsthesia, disfigurement, toil, and many evils beside, in pursuit of art, or science, or livelihood.

Henry Peach Robinson was one of the earliest of these devotees, and alas that we should have to say he is now almost the only living link we have with that small circle of men who first made bold to leave the beaten track of material and roam in the fields of sentiment. For those who best know the works of Mr. Robinson in our art are best assured that in every one of the pictures which he has from time to time produced, he has at least endeavoured to do something more than portray facts; he has always displayed intention and left something for imagination—he has, in short, aimed at art.

To most minds the mere biography of a man, however illustrious, is uninteresting, unless the events and conditions of the life have some definite bearing on the man's work and teachings. In the present case, the character and inborn tastes, as well as the outward circumstances of the man, have a most direct and conspicuous bearing on his relations to the photographic world; we therefore do not hesitate to give in a few words an outline of Mr. Robinson's personal history, in order that we may show to what extent by nature and by early training he was qualified to make a mark in photography, and in some measure to account for the mark he certainly has made; but a task even more congenial to us, and as we venture to hope, even more acceptable and useful to our readers, will be to touch upon the cardinal points of his doctrine, and to trace his precepts in his practice as exemplified specially in this number of "Sun Artists." Mr. Robinson was born in 1830, at the pretty little town of Ludlow, in Shropshire. Art seems to have claimed him for her own at a very early period of his life, for he "cannot remember the time when he

was not drawing." He devoted himself warmly to art-study from his youth, and we hear of him etching, and practising sculpture, and having paintings hung at the Royal Academy before he was twenty-one. Moreover, he had a marked taste for botany, natural history, and archæology, and had not neglected his education in literature, for we find him at an early age contributing to the "Illustrated London News" and a journal of archæology. In fact, he was a zealous lover of Nature in her every phase. He who has loved and studied nature may well address himself to woo art.

In 1852 Mr. Robinson's attention was first directed to photography, but what a different photography, as we have shown, from the simple, plain-sailing photography of to-day! Every trouble then had to be overcome by original experiment, almost every material to be made by the experimenter. Soon the late Dr. Diamond crossed Mr. Robinson's life, and from that time the life was devoted solely and without stint to photography. Dr. Diamond was then the head centre of all that was photographic, and his headquarters a rendezvous for many men of art and letters. The picture perhaps that first drew marked attention to the subject of this notice was "Fading Away," exhibited in 1858. The novelty of the "departure" and the aim of the picture were so evident as to draw storms of approbation and of reproach on the artist, some applauding the intention, others raging at the audacity and questioning the propriety of photographing a young girl dying or apparently at death's door. The controversialists adverse to the picture used no measured terms in their condemnation, but kept themselves within the bounds of fair criticism and dignified though severe protest.

From the time when Mr. Robinson produced "Fading Away," the picture alluded to as the cause of so much controversy, it may be said that never a year has passed without the birth of some new child of Mr. Robinson's fancy. Some of Mr. Robinson's early pictures, before he had begun to study "combination-printing," show marked traces of the principles he later carried out more thoroughly. His aptitude for catching and reproducing facial and postural expression in the human subject, is well exemplified in a series of figures entitled "Vanity," "Fear," and "Devotion," produced about the year 1858. After a year or two Mr. Robinson's ambition seems to have led him to more important or at least more difficult compositions, for in 1860 we find a picture comprising ten figures in very various poses, and very variously occupied. This picture bore the title "A Holiday in the Wood," and bears the evidence usual in Mr. Robinson's more ambitious works of careful study, with perhaps a trace of over-design apparent in the arrangement of his several groups. As his experience increased, so Mr. Robinson was enabled more and more to banish from his compositions the traces of formality which marked his earliest works. In this respect we find a decided improvement in "Bringing Home the May," though this picture was printed from nine negatives and contains several figures.

The year 1863 saw the production of a photograph which has often struck us as one of the best Mr. Robinson has ever produced. The title is "Autumn," and as usual with the artist, several negatives were combined in one printing. The intention of representing a fair English landscape and a comely group of English youth is evident, and we have a perfectly simple composition, a perfectly appropriate *entourage*, and an "atmosphere" well suited to the subject. The title is "Autumn," and Autumn is suggested not baldly nor

artificially, yet forcibly by every detail of subject and treatment. Limits of space forbid us to go more fully into the growth of Mr. Robinson's art; he has advanced surely year by year, and when the more rapid and convenient gelatine processes became available, Mr. Robinson felt himself more at liberty than ever to give his best attention to his progress in art. Among the pictures which have chiefly arrested attention, we may mention "Wayside Gossip," a group of girls characteristically engaged; "A Nor'-easter," a sea-piece with figures and very bold and attractive lighting; "He never told his Love," another sympathetic episode of rusticity; the very animated group of girls over the title "A Merry Tale," of which a reproduction is given here. The idea of this last picture originated, as we are told in "Picture-making by Photography," not with a party of peasants in a wood, but with a few young ladies in a drawing-room. The ladies fell unconsciously into certain attitudes, the *tout ensemble* of the lines seized the artist's fancy, and the picture was built up on similar lines, but with the " *venue* " changed to a woody dell.

Mr. Robinson's pictures never fail to find favour with the jurors at photographic exhibitions, and he now stands the most be-medalled photographer in the world. He was not the first to introduce the special line of photography with which his name is now so intimately connected—" Composite " photography,—but he was quick to perceive its possibilities when he saw the efforts in this direction of another worker, the late O. G. Rejlander. Many of Mr. Robinson's most important works, including three of those now placed before the public, were, as we have said, produced not from one single negative, but—strange as it may appear to the half-initiated—from two or more negatives printed on one sheet of paper, the lines of fusion so deftly managed as to puzzle the most experienced photographers. The " knowing ones " have often been completely misled as to the situation of the "joins;" composite printing has repeatedly been discovered where it did not exist in the picture at all, and the lines of demarcation often demonstrated in the wrong places. The most ignorant of photographic *technique* will realize the danger and difficulty of blending into one picture scenes photographed at different times and places, the manipulative skill required being even less than the necessary artistic conception and grasp of the circumstances. Our friend never trusted to luck or chance conditions, for most of his pictures of the combination kind were carefully thought out and indeed sketched before the real photographic work was begun. After spending a good many of the best years of his life as a professional photographer, Mr. Robinson laid aside his active duties in the profession and retired into private life, taking with him for his hobby what he had so successfully cultivated as his business.

Mr. Robinson's tenets on art matters are widely known, for he has been a somewhat prolific writer on photographic art. Many a photographer owes all his art education to Mr. Robinson's writings; and we assert fearlessly that the influence of these writings has been enormous and beneficial; so far as art can be taught, Mr. Robinson has taught us. So far as we know, he first directed public attention to the possibilities as well as to the limitations of photography in the direction of art; we are not aware of any writings that can be placed side by side, in either date or merit, with " Pictorial Effect in Photography," his first and best publication on the subject. In that book, without laying down laws, he pointed out principles on which composition and chiaroscuro elementarily depend;

but his doctrines were never trammels. It will be interesting and, we hope, instructive to many, to endeavour to trace his teaching and his intentions in his works.

The very first criticism we make on his works is that in every case we find an evident *intention*—some story is told, some conception worked out, though the whole of the story or conception is not given, and we are left to imagine some things and to connect others. At the first blush we should expect the *two* women in " Carolling " to be joyous and frivolous, but we find one is not so gay as her companion ; she looks *back* as well as forward, she has doubts as well as hopes, and her comparative gravity enhances the gaiety of the other, and gives intensity and intention to the episode.

Mr. Robinson's *technique*, as we have pointed out, has been by no means simple ; yet as a rule simplicity is one of the charms of his finished works. Photographers conversant with, or at any rate aware of, his methods, are apt to lose much of this charm from their knowledge of the labour and care required to produce one of these pictures; still, as a rule, the *tout ensemble* of the picture is not intricate in detail, nor glaringly artificial in treatment. If Mr. Robinson had not been so candid regarding his methods, we doubt not that he would have found even more numerous admirers of his works. " When the Day's Work is Done " is an example of perfect simplicity of treatment and unity of conception. There are a good many accessories in the way of furniture, garden produce, and the like, in the picture, yet they are not distracting—they are helpful to the composition, even if they are somewhat profuse. There is no secondary episode, but a single and simple scene—an aged couple resting, but not idle.

Since Mr. Robinson himself pointed out that he usually had for his figures models more or less trained to his requirements, we have often had critics pointing out the awkward and artificial appearance of these models. Mr. Robinson's experience of " real " models, such as peasant girls pure and simple, is in accord with our own—that they are usually totally without grace and hopelessly constrained when they are subjected to the scrutiny of a photographic lens. Accordingly, his models were frequently " dressed up " to represent rusticity ; and on one occasion, at least, the travesty was so successful that an officious and irate gamekeeper warned two " models " off the sacred precincts of " real property," not recognizing the daughters of his employer in the country maidens whom he thought he was addressing. So far as we have observed, excepting in some of his very earliest pictures, which are seldom seen nowadays, Mr. Robinson's models never look like dressed-up aristocrats aping the rustic. It cannot fairly be said that there is any lack of the genuine in the figures of " A Merry Tale," yet we are informed the whole picture, so far as the figures are concerned, was a bit of successful masquerade.

The word " Retouching " is now familiar to the public, but it is matter for doubt whether the public is fully aware of its meaning, and of the extent to which retouching is carried in what is known as high-class portraiture. In explanation of this term, it may be said that after the purely photographic work needed to produce a negative is finished, when we have a "negative" image of a face—that is to say, an image wherein the whites of nature are represented by the blacks of the metallic image—much may be done by means of a pencil to alter the form of the negative face-image, and to remove fortuitous and other blemishes from it. Thus, freckles which appear in a negative as pale spots may be darkened, and so prevented from appearing on the positive print,

but much more may be done. Wrinkles may be obliterated, hollow eyes lighted up, sunken cheeks rounded, long mouths shortened, noses straightened, and the whole texture of the human face may be so manipulated on the negative as to produce in the prints images sometimes called "prettier," or more "flattering," or more "just," according as the critic is a friend or rival of the party whose face is depicted. This artifice is very often carried to a most ridiculous and dangerous extent in photography, and the subject is here introduced in order that we may record Mr. Robinson's consistent and strenuous enmity to this most unwholesome and mendacious practice. We are not aware of having ever seen a face "modelled" in this way by Mr. Robinson; and his example of abstinence must have had a salutary effect in deterring many from going to outrageous lengths in this false and inartistic direction. For this reason, if for no other, the world of photography lies under obligation to the subject of this sketch.

Mr. Robinson's supremacy in the art branch of photography has not, in these enterprising days, been left unchallenged, indeed, it were matter for regret had this been the case, for the history of photography is the history of a campaign in which the keen eyes and clear brains of the combatants have but served to make its advancement more sure and more rapid. True to this tradition a school (if we may be excused the word) has lately arisen calling previous methods of artistic treatment in photography in question. Mr. Robinson as the chief exponent of what may be termed the old school, has borne the brunt of this onset, and the battle even now is raging with unabated vigour. There is no doubt that so far the besiegers have made no sensible breach, though this is possibly due in some measure to that feeling of conservatism which is a characteristic of our race. Mr. Robinson's dignified moderation and self-respect in controversy, if nothing else, would tend to retain the allegiance of his disciples. The "naturalistic" party (as the new sect has come to be called) has certainly youth on its side, since its existence dates back but a few years, and, with the impetuosity of youth, its arguments frequently savour rather of invective than logic, in fact, to gain its end, it seems almost indifferent as to the means employed. To impartial spectators—as we desire to be—there frequently appear strange movements in its ranks, so that the leader of one day is discredited on the next. We have also noticed a large contingent of what, for want of a better name, we must describe as camp-followers, people of undecided tendencies, possibly even ignorant of the questions at issue, who swell or diminish the size of the band according to the fortunes of war. It will thus be seen that Mr. Robinson is assailed by a more or less intangible foe, and this impression is strengthened when we examine the tenets of the naturalistic school and compare them with its practice. These tenets have been presented quite recently to the world in the form of a text-book by Dr. Emerson, the present acknowledged leader of this little band of reformers, and we cannot do better in the limited space at our command than quote the following paragraph from " Naturalistic Photography," which we believe broadly sets out the principles of the new photography.

" It will now be understood that a picture should not be quite sharply focussed in
" any part, for then it becomes false ; it should be made just *as sharp as the eye sees it and*
" *no sharper*, for it must be remembered the eye does not see things as sharply as the
" photographic lens, for the eye has the faults due to dispersion, spherical aberration,
" astigmatism, aërial turbidity, blind spot, and beyond twenty feet it does not adjust perfectly

" for the different planes. All these slight imperfections make the eye's vision more
" imperfect than that of the optician's lens even when objects in one plane only are
" sharply focussed, therefore, except in very rare cases, the chief point of interest should
" be slightly, very slightly, out of focus, while all things out of the plane of the principal
" object, it is perfectly obvious from what has been said, should also be slightly out of
" focus, not to the extent of producing *destruction of structure* or fuzziness, but sufficiently
" to keep them back and in place."—P. 119.

There are those, no doubt, who would characterize this faithful translation of the disabilities of the human eyesight into the realm of art rather as a tribute to the scientific spirit of the age than as a real advance upon earlier artistic methods, but the practice of the new school, in the estimation of the majority of those best qualified to judge, differs greatly from its theory, so that we have happily not yet arrived at the delineation of nature from an astigmatic point of view, and we feel bound to add that we earnestly trust we never shall. It is not, however, our province in this paper to enter into the merits of or to give our opinion on the doctrine above set forth; we desire merely to place its existence on record so far as it affects the subject of this memoir. It will doubtless be apparent to all, that the new photography, in theory at least, is something quite different from the photography identified with the name of Mr. Robinson. We have already said that we regard this battle of the giants as a healthy sign—as proving a superabundance of vitality in the photographic body which in time will undoubtedly lead to great advances in the art, but come what may we feel sure that Mr. Robinson will ever maintain that high place in the esteem of all true lovers of our art which for many years he has so deservedly occupied. If, imbued with confidence in the verdict of our craft on this point, we have criticised somewhat severely the constitution of and the methods employed by the new school, we have done so with all honesty of purpose, fully believing that when the ardour of youth shall have subsided, that which is unworthy will be discarded and a more philosophic spirit will be breathed into its propaganda. The method of dragging others down to raise one's self can certainly never meet with success, and where there is so much that is excellent on both sides, it is a device as unnecessary to employ as it is distressing to witness.

The assertion has been made by the naturalistics, that Mr. Robinson is too prone to " cutting " or " biting " sharpness in his work; but, so far as we have seen—and most of his work has, at one time or other, been under our notice—we have not discovered any objectionable sharpness nor superabundance of detail, optically speaking, in Mr. Robinson's pictures. As a matter of fact, Mr. Robinson has always deprecated over-sharpness, and was one of those who induced the late Mr. Dallmeyer to produce a lens intended to obviate the biting sharpness which so often disfigured large work. His expressed opinion is : that photography is pre-eminently the art of definition, that every art should make prominent use of its strongest points, and that it is an utter mistake to assert that with definition there can be no subordination. Subordination is, of course, a necessity of art, but subordination is by no means inconsistent with reasonable definition.

The greatest service that Mr. Robinson has rendered to photography has been, in our opinion, his bringing under our notice, in an orderly and categorical way, many of the principles which guide artists in their work. It is hopeless to argue that art has no rules;

it is true that art has no rules, but it is none the less true that, by studying the works that are accepted as most artistic, and are felt to be most elevated, artists themselves have found certain principles of composition and certain phases of sentiment so frequently recurring, and so universally underlying, as to constitute standards, or even rules. These rules are sometimes positive, giving beauty, but more frequently negative, preventing offensiveness; and many of these principles, rules, or standards have been recognized, set in order, and written for us by Mr. Robinson in his writings, and exemplified in his works. In justice to the firm which has produced the photogravures, Messrs. Annan and Swan, it should be explained that the prints are done, not from Mr. Robinson's negatives, a feat practically impossible, as will easily be understood from the description given of the method by which the purely photographic prints are produced, but from negatives taken from the combination prints produced in Mr. Robinson's own *atelier.* The original prints are, in most cases, of a size usually considered very large by photographers, for it appears that Mr. Robinson always aimed to give his work as much of importance as size could endow; doubtless, also, the manipulations necessary for combining several negatives to form one print would be more easily performed on large work than on small.

The prints in this issue cannot be put forward as representative of photography as a whole : they represent one phase of photography and the work of one egregious photographer. But it is hoped that they will represent some of the capabilities of photography in skilful hands, and certainly they do prove that photography is not the "vile mechanical" handicraft it is asserted by some, and believed by the ignorant, to be. Inseparable from every art there is a certain amount of mechanical work. The ease of photographic *technique* has been disastrous to the credit of photography as an art, leading many a fool to rush where angels have feared to tread. But the pictures here have no element of haphazard in their production ; all was carefully thought out, and with consummate skill carried out ; and we now have the pictures as monuments, if not of perfect attainment, at least of lofty aspiration.

ANDREW PRINGLE.

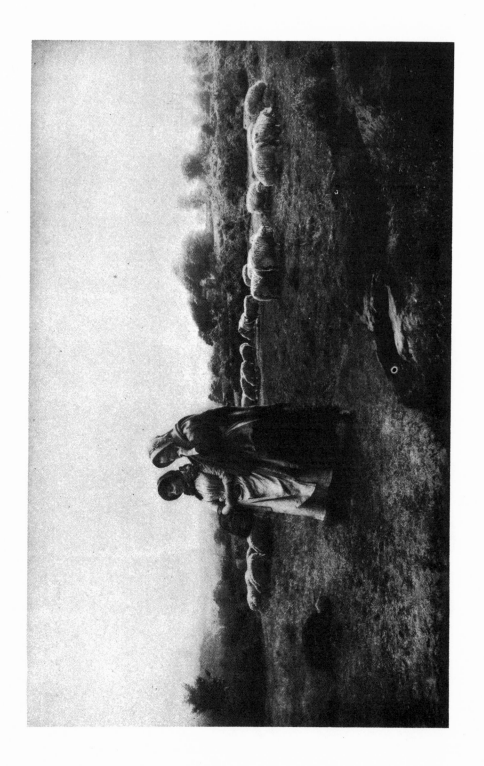

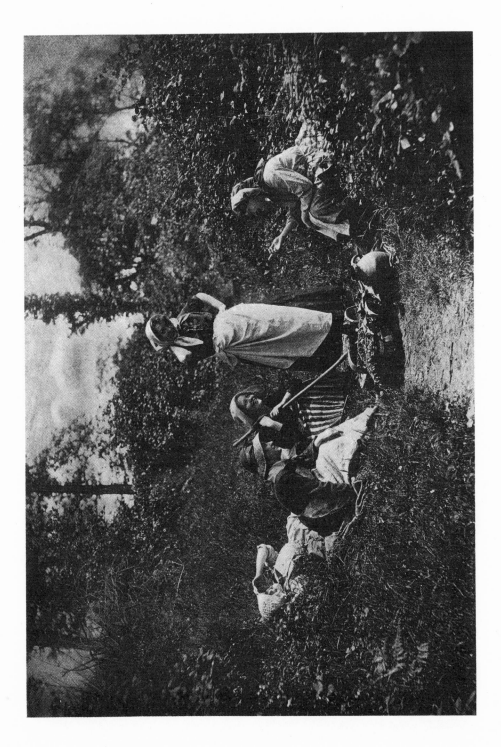

PRESS OPINIONS.

". . . The fishing smacks, the rustic scenes, and the typical foggy day on the Thames, are certainly excellent specimens of the art. . . ."—MORNING POST.

". . . Great taste and skill have been expended in connection with the 'get-up' of the magazine. We have an artistic cover, excellent paper, good printing, and, above all, four beautiful plates. . . ."—SCOTSMAN.

". . . The four plates do ample justice to the finely finished pictures. . . . The descriptive text is lively and interesting, and no pains have been spared in the preparation of 'Sun Artists.' . . ."—DAILY CHRONICLE.

". . . The four plates are beautiful productions. . . ."—ILLUSTRATED LONDON NEWS.

" An addition, and we think a valuable one, to the ranks of the illustrated magazines is 'Sun Artists.' . . . Altogether 'Sun Artists' is a handsome and attractive quarterly periodical."—THE GRAPHIC.

". . . The high water mark of modern photography. . . ."—ART JOURNAL.

". . . In composition, delicacy, softness, equable tone, avoidance of harsh effects in contrast, fore-shortening, etc., too often the bane of the photograph-picture, these examples are wonderfully fine. . . . Type, paper and general 'get-up' are all that can be desired. . . . Should certainly do much to advance artistic photography."
PALL MALL GAZETTE.

" Exceedingly interesting . . . everything possible has been done to make the work attractive."
MAGAZINE OF ART.

". . . We can but wish it all success. It is made up of eight large pages of exquisite printing upon Dutch hand-made paper. . . . Four plates of much merit are given. . . ."—THE QUEEN.

". . . It would be difficult to find anything of its kind more enchanting than the pretty scenes of field and water, horses, men and boats. . . . Indeed the whole 'get-up' of the magazine is luxuriantly artistic. . . . If 'Sun Artists' justifies the high expectations awakened by its first issue, it will indeed be a welcome addition to the art journals of the day."—MANCHESTER EXAMINER.

". . . We cannot conceive of any work of even the most skilful engraver which, if put upon the etching of 'Sleepy Hollow' could improve it in the slightest degree. The text matter is of the most racy character. . . . 'Sun Artists' is sure to take well, for never before has such an admirable five shillingsworth been offered to the public. It is of large size, and well printed on fine hand-made paper. . . ."
BRITISH JOURNAL OF PHOTOGRAPHY.

". . . This handsome publication. . . . It is almost needless to say that the work is admirably produced, and will, no doubt, find its way into every photographic library where good things are treasured."
THE CAMERA.

". . . This publication is already famous. . . . It is a step in the right direction, the first number alone is sufficient to disprove the not uncommon assertion that photography can never be a fine art. . . . The whole set should compose a very valuable collection, and we think that every member of the club ought to make a point of securing copies from the commencement. . . ."—CAMERA CLUB JOURNAL.

". . . We have to welcome another and most attractive addition to the rich world of art publications. . . . Four beautiful illustrations, together with a most interesting biographical sketch. . . ."
WESTERN DAILY MERCURY.

". . . It is a high-class production in every respect. . . ."—LEEDS MERCURY.

". . . We are glad to welcome a new serial called 'Sun Artists.' We may confidently say that we have never seen anything of the kind more perfect in point of general effect or of detail. . . . 'Sun Artists' ought to make its way."
YORK HERALD.

". . . The aim of this beautiful work is to emphasize the artistic claims of Photography. . . ."
NEWCASTLE CHRONICLE.

". . . It must be conceded that these reproductions represent photography in perhaps it highest artistic development. . . ."—NEWCASTLE WEEKLY CHRONICLE.

". . . Everything skill and taste can contribute to success has been brought to bear upon 'Sun Artists.'"
BRISTOL MERCURY.

". . . The first number of 'Sun Artists' is certainly a 'thing of beauty.' The four plates reproduce photographs good in themselves, and beautifully represented here. The letterpress is interesting, and the whole 'get-up' of the issue most luxurious. 'Sun Artists' can hardly want friends. . . ."—YORKSHIRE POST.

". . . If the succeeding numbers equal the first, 'Sun Artists' will be the most handsomely illustrated photographic periodical in this country."—PHOTOGRAPHIC NEWS.

". . . Their delicacy and beauty are very remarkable. . . . We have no hesitation in saying that these plates place photography in a higher position than it has hitherto held in public estimation. 'Sun Artists' will be not only a handsome publication, but one of genuine artistic value."—NORTH BRITISH DAILY MAIL.

"'Sun Artists,' the fine photographic art journal which has been spoken of so highly by all the European journals, has reached us. We cannot speak too highly of the publication."
THE PHOTOGRAPHIC TIMES AND AMERICAN PHOTOGRAPHER.

". . . This periodical takes new ground. . . . We heartily wish it a well-deserved success."
BIRMINGHAM DAILY POST.

" An extremely beautiful new quarterly. . . . 'Sun Artists' shows the artistic heights to which photography has attained. Nothing more beautiful has ever been presented to an art-loving public than this handsome new periodical, with its four etchings in 'Art Journal' style, on which 'all hand work has been scrupulously avoided. . . .' Pains have not been spared with the letterpress of 'Sun Artists,' the type having been cast from punches cut by Caslon in 1720."—EAST ANGLIAN DAILY TIMES.

". . . The whole work is exceedingly artistic, and will surely find large appreciation. . . . 'Sun Artists' will be not only a handsome publication, but one of genuine artistic value."—GLASGOW HERALD.

Chiswick Press

PRINTED BY CHARLES WHITTINGHAM AND CO.
TOOKS COURT, CHANCERY LANE, LONDON, E.C.

NUMBER 3. APRIL, 1890.

SUN ARTISTS

MR. J. B. B. WELLINGTON,

With a descriptive Essay.

LIST OF PLATES IN THIS NUMBER.

HON: EDITOR:

W. ARTHUR BOORD.

KEGAN PAUL, TRENCH, TRÜBNER & CO.
(LTD.), 57 & 59, LUDGATE HILL, E.C.

ABRIDGED PROSPECTUS.

OWING to various causes, too numerous to specify, no publication at present exists which adequately represents the actual artistic position of Photography.

Several amateurs have associated themselves for the purpose of placing this phase of Photography forcibly before the public, and by reproducing selected works of the foremost Photographers, in the highest style of art, hope to advance Photography in the estimation of the art-loving public, and to obtain for it the position which it now deserves. With this object in view "SUN ARTISTS" is published.

It is evident that this production marks an epoch in Photographic history, and for this reason—if for no other—it should recommend itself to the notice of every lover of Progress, whether himself a photographer or not.

NOTICES.

No. 1. MR. J. GALE (4 plates) has been reprinted.

LIST OF PLATES.

SLEEPY HOLLOW (Medal for this reproduction Photographic Society of Great Britain, 1889).
A FOGGY DAY ON THE THAMES.
BRIXHAM TRAWLERS.
HOMEWARDS FROM PLOUGH.

No. 2. MR. H. P. ROBINSON.

LIST OF PLATES.

CAROLLING.
A MERRY TALE.
DAWN AND SUNSET.
WHEN THE DAY'S WORK IS DONE.

No. 4 will be published in July next, and will contain photogravure reproductions of pictures by

MR. LYDDELL SAWYER.

A limited number of signed unlettered proof copies will be issued.

Descriptive leaflets can now be obtained of all booksellers throughout the kingdom.

Leading Press opinions appear on the third page of the cover.

All communications relative to this Serial should be addressed to

THE HON. EDITOR
"SUN ARTISTS,"
7, TEMPLE CHAMBERS,
TEMPLE AVENUE, LONDON, E.C.

MARION'S
AMATEUR PHOTOGRAPHY.

MR. J. B. B. WELLINGTON.

IT is related that not long ago a Frenchman on being introduced in society to a person bearing the name of William Shakespeare, bowed with great deference and murmured his admiration and surprise, "Si jeune!" If it were fair to judge of French acquaintance with artistic photography by its treatment at the Paris Exhibition, we should hardly feel astonished at some similar expression from one of that polite nation on being made acquainted with the subject of this number.

The present is not in general the day of young men, but if one of them comes to the front, greater interest is felt in him than in his older rivals, and he comes in for his full share of paragraph and interview, and all the attentions of the new journalism. But in photography there is an exceptionally good chance for an early start. The technique is up to a certain point so simple and so soon learned by anyone capable of ever acquiring it, the method itself so far fills up the weak points of the incomplete artist, with all the evils of incompetent judging and overmedalling, the exhibition system gives so many opportunities and so definite a recognition, that a man with natural gifts is sure to turn out good work and to make a reputation by it long before he could get beyond the preliminary drudgery in arts which depend more entirely on personal dexterity and demand a longer course of instruction. In the end this may be the worse for the photographer unless the epitaph of J. R. Green can be written over him at the last, " He died learning:", but in the meantime, within sight of thirty, he may look for more success and fame than are likely to fall to his lot in almost any other career in this country. At any rate, few men are more generally recognized among photographers, or, I may add, are less likely to be spoiled, than Mr. J. B. B. Wellington.

A well-known journalist has related the only instance of the alleged curiosity of Americans which ever came under his own notice. When he was on a lecturing tour in the States, he was reading the newspaper one morning in his hotel; suddenly there came a smart tap on the other side of the sheet. " Say, what did Thackeray die of? You didn't tell us last night." It is an old repartee to the biographer, to which several successive centuries have supplied different names, that he has added a new terror to the grave. Fortunately neither story nor epigram apply to the present case, for whatever our news is to-day, it must before all things be the newest, and the success of any man is considered small, and his lot obscure, whose life has not been written either by himself or others, long before Death has subscribed the irrevocable " Finis."

There are not many events to record in the life of this " Sun Artist," and even of these I propose only to introduce such circumstances as in any way relate to his training

or development. Moreover to write an appreciative notice is not necessarily to lose all sense of perspective, and if photography is to take a place among the arts, its criticism will gain nothing by being pitched in too high a key. Thus, should any lack of superlatives be remarked in the following pages, it must be attributed not to ungenerosity but to a prudent reticence, and certainly results from no comparisons prejudicial to Mr. Wellington.

To begin with his photographic birth. This took place a dozen years ago in the wet-plate days, and thereafter he went through the usual stages of infancy and childhood which most photographers experience. On wet plates he photographed churches and houses, streets and bicycles, friends, singly and in groups, and it was not for four or five years that he really began to "take notice" as the nurses say, or that in other words, if this history is to have dignity, " the artistic possibilities of photography first dawned upon him." The artist is born, but he must then be made, or make himself, no less than the poet. Mr. Wellington has been trained as an architectural draughtsman, but has abandoned the profession. He has been so far moved by the desire to express Nature in colour, that he has made several studies in oils. But photography has been the medium which he has consistently preferred and the method which he has thoroughly mastered. His artistic training has been derived chiefly from the study of pictures, which he always makes a point of seeing when possible, and his first impulse towards Art he attributes to the influence of a painter friend, an enthusiastic amateur. Papers on Art and lectures to photographers, it is wholesome to add, he never reads, but believes in the advantages of informal conversations and talking matters over with artists. Steady work in the country and uninterrupted study of nature are his choice, but it is just, if melancholy, to add that one or two of his best photographs have been taken on days when he has diverged from club excursions. Long ago he passed through the "smallest stop" stage, and gradually within the last five years has worked his way out to softened details and dim distances.

The accompanying plates no doubt fulfil their necessary purpose, and fairly represent the artist's best work, but their numbers are not in strict proportion to the total amount of his productions. For while two of them are devoted to pure landscape, and a third to landscape with animals, it is the remaining department of figure which, although it has but one plate assigned to it, is the favourite pursuit of Mr. Wellington. Of pure topography he has done a considerable quantity, but has rightly recognized it as something essentially different from artistic landscape, wherein his work has seldom failed of its effect, largely owing to his judicious application of good skies. But it is to figure studies that he has devoted most of his efforts and his chief affection, and if he has at times shared the common fate and has fallen short of his aim, his best hope for the future lies in the fact that nobody better realizes this than the artist himself.

He has worked indefatigably with the devotion and perseverance which command success. The hand camera he uses freely for figure studies, though rarely making direct use of the results except for lantern slides. I should like to refer to one of these, a very clever little " shot " in Birmingham, which seems to me to come nearer to achieving a picture out of the most modern elements of our generally hideous civilization than any photograph I have seen. It represents a tall hoarding covered with advertisements of

excursions which a man and woman are reading. This sounds an unlikely subject, but the disposition of masses and tones is very happy, and for my part I always greatly honour any artistic effect which is secured, not by retiring into the wilderness, but without leaving the working day world where the greater number of mankind must pass their lives, and among the objects which are always before their eyes.

Yet, after all, the only fertile field for good art, especially without colour, lies in the country, and herein Mr. Wellington's range has been chiefly confined to the South of England, which he has thoroughly explored as far as Penzance and the Land's End, although his favourite hunting grounds are Surrey and Sussex. It is true that he has done some good work at Walberswick and Southwold, in the region where so many of Dr. Emerson's finest plates were done, but instead of going on to Norfolk he has turned again by preference to the South.

Norway Mr. Wellington has visited, and he has photographed the midnight sun at the North Cape, but a voyage of this sort affords scant occasion for elaborate art, and he brought away little but a fine topographical series of fjords and mountains. This forms as yet his only foreign work, but he is casting longing eyes at some of the fishing villages on the French coast, where great opportunities are certain to be found.

But as yet he remains best known by his work in the richly varied country lying within easy reach of London, which, if it suffers to some extent from this propinquity, yet affords so great a solace to those who, " born likewise in Arcadie," are doomed to a town life, and for whom frequent visits have to compensate for long, unbroken residence. Thus there are many rivals in the field, but in consequence any achievement is sure to meet with that appreciative understanding which is the highest reward.

One favourite spot is the scene where two out of the four accompanying pictures were made, the little village of Bury, lying on a mound above the river Arun, between Pulborough and Arundel. Between it and the sea rises the long steep range of the South Downs, the river winds through meadows often flooded at its foot, the open ploughlands stretch away to the east, and all about lie the pleasant woods and sheltered driftways of Sussex. At the little inn painters stay nearly all the year long, and a visit to the district will enable anyone to identify a marvellous number of pictures hung in London exhibitions. Photographers also are no strangers, and it is here that much of Mr. Gale's best work has been accomplished. The country is so pleasantly blended that the ploughman, the shepherd, and the woodman all ply their occupations within call, while the barges bring a seafaring flavour up the river from Littlehampton.

It seems to me that the Protean nature of photography, its extraordinary versatility of style has never yet received full justice. Every writer who has anything to say in its favour as an art, is always bent on making the most of the point that every man impresses his own individuality on a plate, and forms a distinctive style of his own. There is much truth in this, but a further advantage is not incompatible with it, that a man can record various effects in styles suitable to them and yet more different than would be possible to an artist trained more slowly and painfully in another medium. In this respect Mr. Wellington stands halfway. There is not in his work the uniformity which has caused Mr. Gale's name to be the first instance rising to everyone's lips on the point referred to above, nor on the other hand has he yet displayed the marvellous diversity which,

without any loss of personality, is rendered especially conspicuous by the juxtaposition of so many plates in Dr. Emerson's "East Anglia." Of course, there are numerous well-known instances of painters in search of styles who go on to the end adopting and experimenting with the manner and types of more constant artists. But these efforts seldom prove more than a *tour de force*, whereas photographs, at any rate when photo-gravured, seem far more capable of genuine adaptability and diversity.

It is a somewhat embarrassing and delicate task to put into words the methods and ideas of an artist who is wisely enamoured of silence. Mr. Wellington has never published anything beyond formulæ and one or two purely technical papers; he is not fond of writing, and does not believe at all in writing about Art. He is perhaps justified in thinking that it is sure to raise up contentions which cannot be decided, and he loves "quietnesse" like Walton himself. Nevertheless, as he has consented to the publication of his work and of the accompanying notice, he, too, must be content to some degree to "lose the perfect touch," and to see his theories and fancies exposed in the market-place. It is not easy for the man who does the talking to secure much belief in the sincerity of his declaration, that pictures and not arguments or explanations are the only means likely to secure the recognition of photography as an art, or to set it on the right path. But, for all that, I am firmly convinced of this fact, and the only thing to be alleged in favour of the pen is that it sometimes opens up the way for Art into unfamiliar quarters. At any rate, however much this view may increase the admiration of his critic for Mr. Wellington, it certainly does not render my task easier.

But Mr. Wellington's love of retirement is shown not only by his abstinence from utterance, but also by withdrawal from general exhibitions. A friendly competition in a club, which is little more than a comparison of work, is one thing, to have one's eye for ever on the medal is another, and having taken high honours he declines to compete again, where a large number of prizes are offered as a tempting bait. If all leading photographers would follow the example of the few who have taken this stand, the medal question would soon be settled, perhaps the solution might be made still easier if, as Mr. Wellington suggests, secretaries of exhibitions would undertake to pay all expenses for the work of certain invited guests who did not desire to compete. The best men, who have already gained as many first prizes as they want, are not likely to go to much trouble or expense to exhibit their pictures, and yet it will be a serious drawback and evil to photography if its very finest results are not continually rendered familiar and easily accessible to the public.

The only proper place for labels is the Museum, and I have not the faintest desire to ticket Mr. Wellington with any particular title, to "place" him in any imaginary class list, or to include him among the followers of any one school. At the same time he has been influenced by certain ideas which are in the air to-day, and being neither blind nor deaf he has views on current topics. His chief idea is that in Art, Beauty comes first and Truth afterwards. Not that Truth can be neglected or perverted, but that reality is less important than charm. This is simply the ordinary doctrine of painters, which arises naturally out of the practice of their art. For a painter must see his landscape under many aspects before his materials allow him to have done with it, and he is tempted to blend beauties never seen together. So, unless he is a stern Naturalist, he prefers an

aggregate of beauties even at the expense of some inevitable falsities. As the distinctive feature of photography is an instantaneous and absolutely literal rendering of the thing seen, it seems to the present writer that Truth and Beauty can only go hand in hand: and that the increasing keenness of scientific observation will detract even from the artistic value of such photographs as are lovely but inaccurate. But it is by his work and not by his theories that Mr. Wellington elects to be judged, and there are few photographers more generally accepted by all schools.

However exclusively an artist may follow Art for Art's sake, a theory in which the present writer for one believes salvation is to be found, it is yet certain that there will always be discovered in his work some personal view of life, some one constant preference for certain aspects of Nature. Whatever his art may be, the man himself is also to be discovered in his productions. After all the hard things that have been said about photography, chiefly by painters, and about photographers, chiefly by one another, on taking a general survey of the results, especially those achieved in later days, it leaves a pleasant taste. It may not be great Art as yet; it is sometimes even weak and vulgar, but it is almost always kindly and generous. Landseer is reported to have called photography Justice without mercy to men, and Injustice without mercy to women. What it is to animals we must leave his shade to settle with Mr. Bolton. But while it has on the one hand, in all but a few cases, escaped the unreality which has tainted the country scenes of so many painters, it has on the other seldom imported any of the brutality or harshness which is the besetting sin of realism. And to apply the test in the present instance, the subject and the treatment of few artists will produce a more pleasant impression than those of Mr. Wellington. He has entered with quick sympathy into the life of the people, he has chosen characteristic and suitable incidents without going to out of the way events in search of exceptional picturesqueness; he is always refined and always intelligent, and he has a delicate and genuine sense of humour. Like every photographer, he finds models a great difficulty. He devoutly believes in the native article, and when he finds a good specimen he makes the most of it. It is interesting to know that he invariably poses his figures deliberately in preference to taking the chance of an instantaneous shot, but to this rule animals, which are a favourite branch of his figure work, naturally form an exception. He has worked at many places in the region of his choice, but finds that where artists most do congregate is not the best place for the photographer. The rustic models may have learned to pose, but it has become neither easy to secure their services nor economical. They have lost their natural simplicity, and their acquired artlessness is something different, something not inconsistent with a London estimate of their market value. In dealing with children, Mr. Wellington has shown what must be a remarkable inborn aptitude and sympathy, in divining the expressions and attitudes of which they are capable, and securing these without artificiality or want of naturalness. With properties he cannot be said entirely to dispense, although he keeps his stock within the most modest limits, for he often carries with him a sun bonnet which seldom comes amiss.

The photographer who makes everything for himself always commands a peculiar respect among his brethren, partly based upon the traditions of wet plate days, and partly upon a very honourable admiration for thoroughness. Such dexterity can scarcely be said

at the present time to form a necessary part of the photographer's accomplishments, and no doubt very excellent negatives may be turned out with purchased apparatus. But the man who has made his own tools will seldom or never be found a bad or careless workman, not only because he has too much respect for his work, but also he has already marked himself out as capable of taking pains. Most of the dry plate workers of a few years' standing would as soon think of making their own watch to time their exposures as of cooking emulsions or building cameras, but Mr. Wellington is not one of these. For he may be said to make everything except his own lenses, for which he is content go to Messrs. Dallmeyer, Ross or Taylor. Although he is a self-taught carpenter, he makes all his own cameras, small and large, after his own designs, his own dark backs of a very simple and excellent pattern, with clean drawing shutters of vulcanite that will not affect the plates behind them. Even his printing frames are his own make. He makes his own emulsion and coats his plates. For all this, like many other good workmen, he has no extensive or extravagant plant. He is happy in the possession of a room with a carpenter's bench, and still more in a small dark room opening off his own room. To this there is a supply of hot and cold water and of gas, but it is of the most modest dimensions, and if the traditional cat were swung in it, that distressed animal and its tormentor would do and suffer frightful damage.

Mr. Wellington's technical practice may prove of interest to any photographer who reads this. He began, as I have said, with collodion, and first used dry plates about 1882, when they became practically useful, and the artistic quality of his work at once improved. To collodion he still clings for lantern slides, and has been experimenting with collodion emulsion, but rather from love of research than from any hope of benefiting Art. He has made successful experiments in orthochromatic photography, but finds for ordinary landscapes that the unstained plates often produce a more effective result. In development he swears solemnly by pyro, bromide and ammonia in three separate bottles, the only scientific developer; but in instantaneous work he sometimes substitutes soda for ammonia. His Platinotype licence dates from the beginning of 1884, and to that style of printing he now adheres exclusively, using sepia and warm or cold black tones according to his subject. These illustrations are the first of his pictures which have been rendered by photogravure, but of course his share in the latter process is limited to the transparencies which he executed himself. I am, however, very glad to be able to mention that he is about to take up photogravure for himself, and from his cleanness of work and intelligent control of means, I venture to think that he, if anyone, is likely to find his way successfully across this new tract where it is very difficult to obtain a trustworthy guide.

For ordinary negatives his favourite size is half-plate, and for exhibition pictures he prefers to enlarge negatives from this size. He claims that it is quite easy to produce negatives of a quality certain to produce good enlargements, and that the slight loss in sharpness is all in favour of the artistic qualities of the large picture. Quarter-plate shots of which he has fired many from the hand camera, he uses chiefly for lantern slides, considering that the rapid exposure fails to allow of sufficient quality for successful enlargements. In addition, he has just finished a camera to take $9\frac{1}{2} \times 6\frac{1}{2}$, a double half-plate, for in this case the two halves are more than the whole. The glass is made originally in these dimensions by the makers, and then cut into half-plates after being coated. It is

a very convenient size, and generally all the pictures for which a 10 x 8 would be employed can be secured by it, as the failing of the latter size is in the direction of its being too square.

I was most anxious to obtain, if possible, some detailed technical notes on the plates reproduced. It seems to me that some such annotations by the craftsman himself on his work would form a far more valuable commentary than the literary eloquence of never so discerning a critic. The latter can only guess at what inspired the artist at the moment, the marvellous lights and shades, the delicate half-tones, which should go to make up the picture, and which were boldly emphasized or laboriously wrought out in development. But artists seldom care to use both pen and eye, and where a photograph is translated by another hand into photogravure there is less room for such double interpretation. At any rate, there is in this case no entry in the notebook beyond name, date, and exposure, the artist trusting entirely to his memory and judgment to obtain his result. Indeed, it is on these powers that Mr. Wellington chiefly relies in his work; and this is perhaps the more surprising as he generally waits for developing his plates until he reaches home. For this latter course he has certainly good ground in his objection to the uncertainty of strange waters, which will often seriously affect development, or injuriously stain the plate. But even for his skies, in the use of which he seems to me singularly successful, he rarely keeps any record. Thus he can only say of the accompanying plates that they represent certain effects which he saw and desired to reproduce under certain conditions, and that if he has at all succeeded, they should need no further explanation.

Of the four, certainly the best known plate is that called "Eventide." To take the public behind the scenes is always a doubtful policy, but I have already betrayed so much of the artist's views, that his account of this picture will be of greater interest as an illustration and extreme example of his method. It is an undeniable instance of the use of Imagination, that quality by which Idealists hold that photography must stand or fall as Art. It is only fair that everyone should pass his final judgment on the picture before being admitted into the secret, for no subsequent objections will have much value. The scene is Bury, the river the Arun. Two or three years ago, at Easter-time, Mr. Wellington was staying in the village to photograph, and on a dull, grey, spring day he saw the landscape here depicted. At once he imagined it with an effective sunset sky behind it, exposed his plate and waited. Subsequently he developed the landscape for contrast with the sky, from his own windows in London secured a suitable set of clouds, and here is the combined result.

The other landscape, less ambitious, but perhaps more simply true, represents Walberswick, and as criticising renderings of a country of which one has no personal knowledge is uncertain work at best, I will leave it to those who really know this coast to say whether the artist has not completely caught the spirit of the place in this picture.

"The Broken Saucer" represents another Sussex scene, a doorway in Horsted Keynes, not far from Cuckfield. It was the result of a sudden inspiration: the woman and child were obtained as models; the idea came at that terrible moment when, to most of us, it is so perversely reluctant: the child at once put up its hand in the right way, and the thing was done.

If Mr. Wellington is happy with his children, he is not less fond of animals, and

is most successful in their management. Of this we have an instance in the " Study of Sheep," which brings us back again to Bury. The device employed may not be new, but is worth recording in so happy an example. A small dog will shift the sheep and render them more lively. Here the front group had just moved, and then seeing the dog, in this case a Scotch terrier, was quiet, settled to feed again. But, adds Mr. Wellington, it is advisable to have the dog well in hand. Five seconds later the sheep were rushing across the field with the dog in hot pursuit, and a less expeditious friend missed his picture. To cows, Mr. Wellington feels that he has never yet done full justice, and indeed, considering that few animals are so often photographed in pleasant surroundings, it is wonderful that good cow-pictures should be so rare. It is true that the masterpieces of Troyon and Mauve depend chiefly on harmonies of colour, and that the form of the cow is monotonous and ungainly. And perhaps the frequent failures are due to the fact that " the kye " are most frequently a subject for literature and not for art, and it is one of Mr. Wellington's surest claims to be artist that he has never confused the boundaries of these two provinces.

GRAHAM BALFOUR.

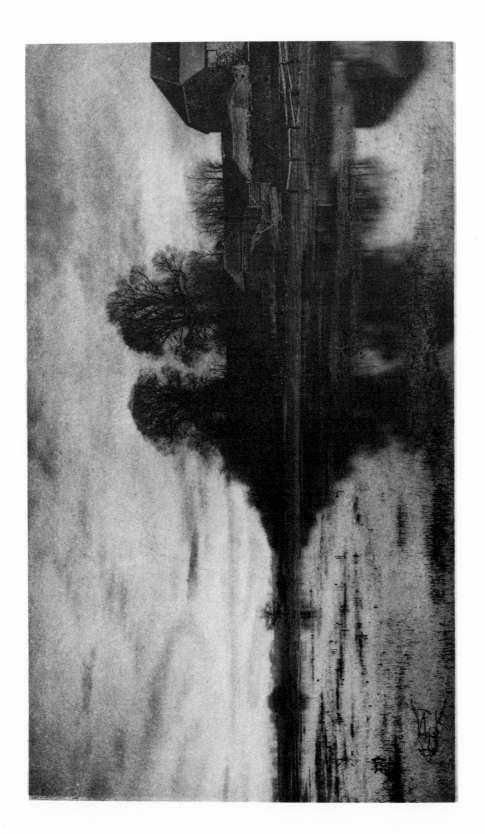

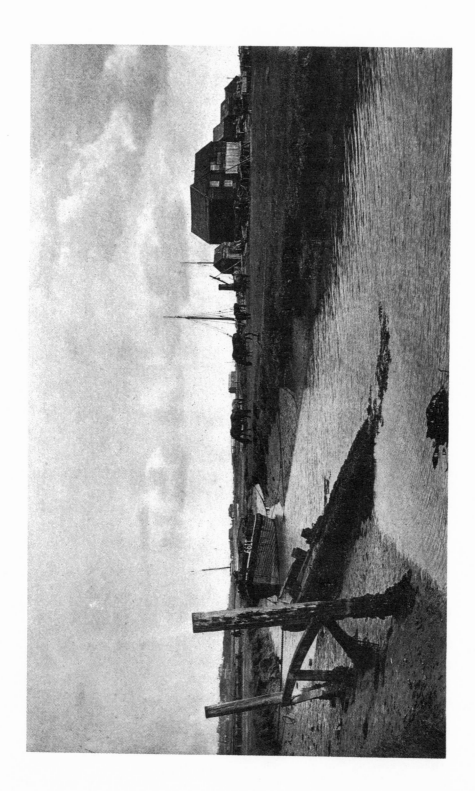

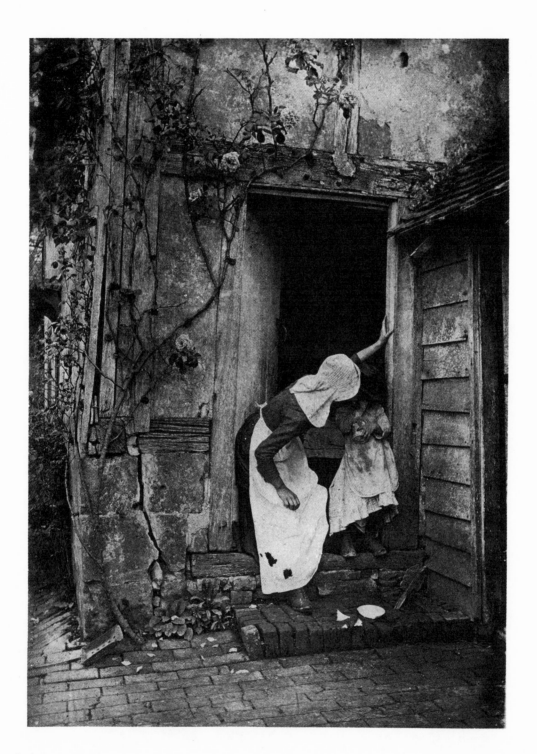

J B B Wellington

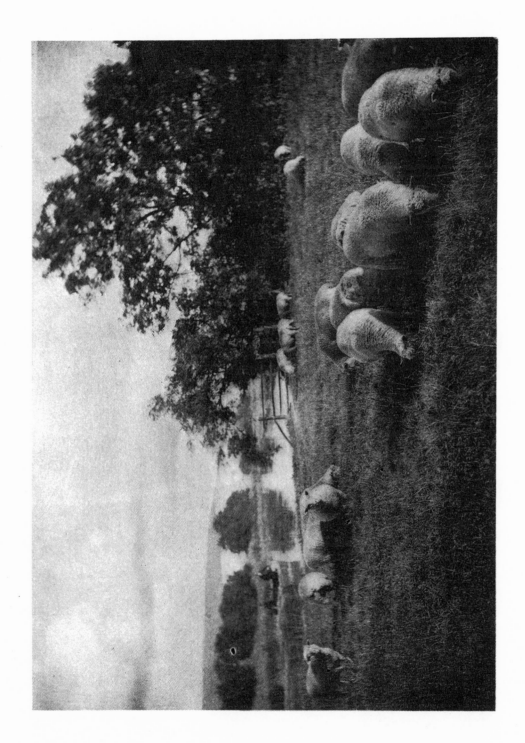

THE PHOTOGRAVURES IN THIS BOOK WERE MADE BY

ANNAN & SWAN

7, DEVONSHIRE ROAD SOUTH LAMBETH LONDON S W

W. WATSON AND SONS,

MANUFACTURERS OF

Highest Class Optical and Photographic Instruments.

WATSON'S ACME CAMERAS.

PRICE LIST.

Sizes.	6½×4¾	7½×5	8½×6½	10×8	12×10	15×12	18×16
	£ s. d.	£ s. d.	£ s. d.	£ s. d.	£ s. d.	£ s. d.	£ s. d.
Camera and Three Double Slides	9 12 0	10 0 0	12 5 0	14 0 0	16 12 6	21 0 0	31 10 0
Extra if Brass Bd. for India ..	1 10 0	1 10 0	1 15 0	2 0 0	2 10 0	3 0 0	4 0 0

OPINIONS OF THE PRESS.

British Journal of Photography, Jan. 4th, 1889:—"It folds into a smaller compass, and is lighter and more portable than any pattern we have yet seen."

Amateur Photographer, Jan. 7th, 1889:—"A wonderful, compact, and fairy-like Instrument, exhibiting several new and important features. Sure to be a favourite with Tourist Photographers."

Photography, Jan. 17th, 1889:—"One of the greatest advances in camera construction yet reached away a-head of anything we have seen."

The Camera, Feb. 1st, 1889:—"Messrs. Watson have found, by ingenious modifications, how to make the weight still lighter, and the rigid still more firm."

WATSON'S PREMIER CAMERAS.

WATSON'S DETECTIVE CAMERAS.

WATSON'S NEW THREE-FOLD TRIPOD.

½ Plate, £1 5s.; 1/1 Plate, £1 10s.

THE BEST YET INTRODUCED.

WATSON'S MATT SURFACE SENSITIZED PAPER.

GIVES MOST ARTISTIC RESULTS.

Used like ordinary albumenized paper, but finishes a plain matt surface, and gives any variety of tone, from Sepia to Velvet Black, at will of operator.

Per Quire, 13s.; ½ Quire, 6s. 6d.; ¼ Quire, 3s. 6d.
SAMPLE SHEET, 10d.

An Illustrated Catalogue of Cameras, Lenses, and every accessory Apparatus used in Photography, sent free to any address on application.

Awarded Twenty PRIZE MEDALS at International Exhibitions, including Paris, 1889 (2 Gold); Crystal Palace, 1888; Melbourne, 1888; Adelaide, 1887; Liverpool, 1886; **and five times a higher award than any other competitor.**

W. WATSON AND SONS,

Warehouses.—313, HIGH HOLBORN, LONDON, AND 251, SWANSTON STREET, MELBOURNE.
Steam Factories.—9, 10, 11, FULWOODS RENTS, W.C.; 16 AND 17, FULWOODS RENTS, W.C.

ESTABLISHED 1837.

PRESS OPINIONS.

" . . . The fishing smacks, the rustic scenes, and the typical foggy day on the Thames, are certainly excellent specimens of the art. . . ."—MORNING POST.

" . . . Great taste and skill have been expended in connection with the 'get-up' of the magazine. We have an artistic cover, excellent paper, good printing, and, above all, four beautiful plates. . . ."—SCOTSMAN.

" . . . The four plates do ample justice to the finely finished pictures. . . . The descriptive text is lively and interesting, and no pains have been spared in the preparation of ' Sun Artists.' . . ."—DAILY CHRONICLE.

" . . . The four plates are beautiful productions. . . ."—ILLUSTRATED LONDON NEWS.

" An addition, and we think a valuable one, to the ranks of the illustrated magazines is ' Sun Artists.' . . . Altogether ' Sun Artists ' is a handsome and attractive quarterly periodical."—THE GRAPHIC.

" . . . The high water mark of modern photography. . . ."—ART JOURNAL.

" . . . In composition, delicacy, softness, equable tone, avoidance of harsh effects in contrast, fore-shortening, etc., too often the bane of the photograph-picture, these examples are wonderfully fine. . . . Type, paper and general 'get-up' are all that can be desired. . . . Should certainly do much to advance artistic photography."
PALL MALL GAZETTE.

" Exceedingly interesting . . . everything possible has been done to make the work attractive."
MAGAZINE OF ART.

" . . . We can but wish it all success. It is made up of eight large pages of exquisite printing upon Dutch hand-made paper. . . . Four plates of much merit are given. . . ."—THE QUEEN.

" . . . It would be difficult to find anything of its kind more enchanting than the pretty scenes of field and water, horses, men and boats. . . . Indeed the whole 'get-up' of the magazine is luxuriantly artistic. . . . If ' Sun Artists ' justifies the high expectations awakened by its first issue, it will indeed be a welcome addition to the art journals of the day."—MANCHESTER EXAMINER.

" . . . We cannot conceive of any work of even the most skilful engraver which, if put upon the etching of ' Sleepy Hollow ' could improve it in the slightest degree. The text matter is of the most racy character. . . . ' Sun Artists ' is sure to take well, for never before has such an admirable five shillingsworth been offered to the public. It is of large size, and well printed on fine hand-made paper. . . ."
BRITISH JOURNAL OF PHOTOGRAPHY.

" . . . This handsome publication. . . . It is almost needless to say that the work is admirably produced, and will, no doubt, find its way into every photographic library where good things are treasured."
THE CAMERA.

" . . . This publication is already famous. . . . It is a step in the right direction, the first number alone is sufficient to disprove the not uncommon assertion that photography can never be a fine art. . . . The whole set should compose a very valuable collection, and we think that every member of the club ought to make a point of securing copies from the commencement. . . ."—CAMERA CLUB JOURNAL.

" . . . We are glad to welcome a new serial called ' Sun Artists.' We may confidently say that we have never seen anything of the kind more perfect in point of general effect or of detail. . . . ' Sun Artists ' ought to make its way."
YORK HERALD.

" . . . It must be conceded that these reproductions represent photography in perhaps it highest artistic development. . . ."—NEWCASTLE WEEKLY CHRONICLE.

" . . . Everything skill and taste can contribute to success has been brought to bear upon ' Sun Artists.' "
BRISTOL MERCURY.

" . . . The first number of ' Sun Artists ' is certainly a 'thing of beauty.' The four plates reproduce photographs good in themselves, and beautifully represented here. The letterpress is interesting, and the whole 'get-up' of the issue most luxurious. ' Sun Artists ' can hardly want friends. . . ."—YORKSHIRE POST.

" . . . If the succeeding numbers equal the first, ' Sun Artists ' will be the most handsomely illustrated photographic periodical in this country."—PHOTOGRAPHIC NEWS.

" . . . Their delicacy and beauty are very remarkable. . . . We have no hesitation in saying that these plates place photography in a higher position than it has hitherto held in public estimation. ' Sun Artists ' will be not only a handsome publication, but one of genuine artistic value."—NORTH BRITISH DAILY MAIL.

" ' Sun Artists,' the fine photographic art journal which has been spoken of so highly by all the European journals, has reached us. We cannot speak too highly of the publication."
THE PHOTOGRAPHIC TIMES AND AMERICAN PHOTOGRAPHER.

" . . . This periodical takes new ground. . . . We heartily wish it a well-deserved success."
BIRMINGHAM DAILY POST.

" An extremely beautiful new quarterly. . . . ' Sun Artists ' shows the artistic heights to which photography has attained. Nothing more beautiful has ever been presented to an art-loving public than this handsome new periodical, with its four etchings in ' Art Journal ' style, on which 'all hand work has been scrupulously avoided. . . .' Pains have not been spared with the letterpress of ' Sun Artists,' the type having been cast from punches cut by Caslon in 1720."—EAST ANGLIAN DAILY TIMES.

" . . . The second part of this unique and beautiful work is even finer than the first. . . . Four loose plates, all of which are most charming and artistic."—NEWCASTLE CHRONICLE.

" . . . The second number of ' Sun Artists ' is admirable. The four plates are simply matchless as specimens of photo-printing. Anything more delicate and beautiful of their kind than these pictures could not be desired. The success of this most artistic publication must now be thoroughly assured."—GLASGOW HERALD.

" . . . Four charming examples ; all of them beautiful and artistic pictures."—SUNDAY TIMES.

" . . . The plates are thoroughly artistic in workmanship, and the subjects interesting and attractive. . . . They well deserve to rank as fine art."—THE GLOBE.

Chiswick Press

PRINTED BY CHARLES WHITTINGHAM AND CO.
TOOKS COURT, CHANCERY LANE, LONDON, E.C.

NUMBER 4.

JULY, 1890.

SUN ARTISTS

MR. LYDDELL SAWYER,

With a descriptive Essay
BY THE REV. F. C. LAMBERT, M.A.

HON. EDITOR:

W. ARTHUR BOORD.

KEGAN PAUL, TRENCH, TRÜBNER & CO. (LTD.), 57 & 59, LUDGATE HILL, E.C.

ABRIDGED PROSPECTUS.

OWING to various causes, too numerous to specify, no publication at present exists which adequately represents the actual artistic position of Photography.

Several amateurs have associated themselves for the purpose of placing this phase of Photography forcibly before the public, and by reproducing selected works of the foremost Photographers, in the highest style of art, hope to advance Photography in the estimation of the art-loving public, and to obtain for it the position which it now deserves. With this object in view "SUN ARTISTS" is published.

It is evident that this production marks an epoch in Photographic history, and for this reason—if for no other—it should recommend itself to the notice of every lover of Progress, whether himself a photographer or not.

NOTICES.

No. 1. MR. J. GALE (4 plates) has been reprinted.

LIST OF PLATES.

SLEEPY HOLLOW (Medal for this reproduction Photographic Society of Great Britain, 1889).
A FOGGY DAY ON THE THAMES.
BRIXHAM TRAWLERS.
HOMEWARDS FROM PLOUGH.

No. 2. MR. H. P. ROBINSON.

LIST OF PLATES.

CAROLLING.
A MERRY TALE.
DAWN AND SUNSET.
WHEN THE DAY'S WORK IS DONE.

No. 3. MR. J. B. B. WELLINGTON.

LIST OF PLATES.

EVENTIDE.
A TIDAL RIVER, EAST COAST.
THE BROKEN SAUCER.
A STUDY OF SHEEP.

No. 5 will be published in October next, and will contain photogravure reproductions of pictures by

MRS. CAMERON.

With a descriptive essay by DR. EMERSON.

A limited number of unlettered proof copies will be issued.

A few signed proof copies of numbers 2 and 3 are still in hand, application should be made to Temple Chambers.

Descriptive leaflets can now be obtained of all booksellers throughout the kingdom.
Leading Press opinions appear on the third page of the cover.

All communications relative to this Serial should be addressed to
THE HON. EDITOR
"SUN ARTISTS,"
7, TEMPLE CHAMBERS,
TEMPLE AVENUE, LONDON, E.C.

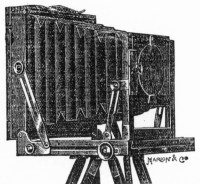

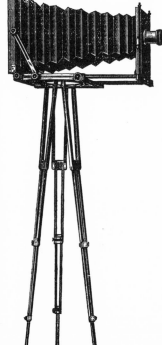

MR. LYDDELL SAWYER.

DAVID COPPERFIELD describes his profound admiration for Dora thus. " If I may so express it, I was steeped in Dora, I was not merely over head and ears in love with her, but I was saturated through and through; enough love might have been wrung out of me, metaphorically speaking, to drown anybody in; and yet there would have remained enough within me and all over me to pervade my entire existence." This quotation was brought vividly to mind by a short passage in a letter from Mr. Lyddell Sawyer to the writer. Mr. Sawyer, in speaking of his early life and introduction to that art whereby this number of " Sun Artists " is embellished, says, " I was born in photography, nursed in it, and have been continually " soaked " in it ever since. My father, uncles, brothers and cousins are most of them photographers."

How far the subtle influences of heredity have contributed to the formation of Mr. Sawyer's Art perceptions is a consideration of much interest. This much at least seems manifest, viz., that he has been able to extend the area of his sympathies more widely than is often the case with those whose time is fully occupied with the busy realities of life.

To him Art is not simply the producing and reproducing of any one particular phase of nature—but rather an appeal to any and every thing which in its turn appeals to him. In this connection it may be of interest to recall a quotation from Chesneau " On the Education of an Artist," viz.: " The end of Art is the interpretation of the soul of man, with all its emotions." Wherefrom it would seem to follow that an artist's education may embrace anything and everything which affects the emotions.

" Know thyself, presume not God to scan ;
The proper study of mankind is man."

are well-known words of Pope, and they give us at least a couple of lessons which should rank high in the list of our studies. Presuming that the artist's studies embrace *all* those influences which act and react upon the human emotions—and also the effect of these influences as well, let it not be forgotten that in each individual there are countless causes and effects, and that the sum total of these combinations and variations in humanity is infinite. So that any attempt to formulate what is or is not Art is to attempt a task which is beyond the strength of the human mind. How many have attempted and failed to define Art? Who shall number these phantom-led discoverers?

It has been quaintly said, that seeking for a definition of Art is comparable to a blind man seeking a black hat in a dark room when there is not a hat of any kind in the room.

To define Art is to attempt to place boundaries and limits to what may influence human interest—to limit the illimitable.

It is a matter of regret that certain (so-called) " schools " have sprung up in our midst. The disciples of one school would have us see nothing in nature but " grey " days—nothing in humanity but pathos. Those of another type of thought are only content with sunshine or with humour. The time has fully come for a protest to go forth from those who think and see for themselves, declaring that they will not have their sympathies, their " humanities," " cabined, cribbed, and confined," by any monopolist. There is both sunshine and shadow in the outer world, as there is also joy and sorrow in the heart of man. The usual training of students in the exact sciences often enriches certain mental powers at the expense, in part, of other powers. The continuous cultivation of the faculty of observation may partly dwarf the growth of a valuable ally, viz., the imagination. And although it is undeniable that an imagination, under orderly control, is one of the most powerful levers the scientific discoverer can use in quarrying the secrets, *i.e.*, the truths, of Nature, yet, by a curious inconsistency, these very scientific students are among the first to refuse the use of imagination to art workers.

On the one hand we are told that photography is (to parody Ben Jonson) a little optics and less chemistry ; on the other, that the only fountain from which the artists may legitimately draw is Nature. Furthermore, that the true artist, *i.e.*, the naturalist, will not even dream of, much less attempt, to employ his imagination in building up, combining, creating, anything which does not exist before his eyes. On one side an attempt is hereby made to limit Art to the actual material-existent visible matter. Nor is it difficult to see, that a gossamer thread may separate this naturalism from the common place. In another direction there is placed a boundary-mark of fact, *i.e.*, the " truth, the whole truth, and nothing but the truth."

It is altogether idle to deny, that these sporadic developments of so-called " schools," have done some good. Every honest seeker after truth for truth's sake will thankfully acknowledge that, for the most part, their motive has been laudable, and certain good results are already to be seen,—not the least welcome of them being a stimulus to independent thought. But to claim for these volcanic eruptions that their work of overthrowing many time-honoured monuments of past ages is an unmixed good is, on their part, to emphasize a deficiency of that rare virtue, viz., modesty, which, when present, commends itself the more by its rarity. " Tall trees catch much wind," says the old saw. The tragic ending of the frog and ox story is too melancholy to contemplate, but is vividly brought to mind by the frothy self-assertions which betoken a forgetfulness that " there were giants upon earth aforetime," yes, and moreover, " rampant revolution " is seldom reform.

Those to whom Mr. Lyddell Sawyer is not personally known may be interested in learning, that he is still a young man, born in '56—amid artistic surroundings. His father's skill in portrait painting, designing, and other branches of Art gave the son certain advantages of early training. At the age of sixteen Mr. Lyddell Sawyer was creditably bearing the greater part of the responsibility and work of a busy and important Studio in Newcastle. Into this work he brought considerable energy, and so life rolled on until his first real trouble came upon him, viz., the death of his mother. Of her he speaks in terms of the greatest affection. This is good to hear in times like the present, when it is too often concluded that devotion to Art is the beginning and the end of all things, and that coldness, selfishness, and cynicism, are indicative of knowledge of the world. Mr. Sawyer has

further widened his sympathies by studying Art and Nature in various places as well as under various conditions. He has contrived to find time amid a busy professional career to visit and study in Edinburgh, London, and Paris, gathering hints and experience, exchanging ideas and developing amid these various technical and artistic climates the seeds of success either inherited or sown in early life.

In addition to employing the camera as a friendly aid to expressing his sympathies in Art matters, Mr. Sawyer also contrives to find time to follow other hobbies. Music is included in the channels through which he finds himself in harmony with mankind. It is a matter of interest to note the influence of one branch of Art upon some other branch, and it would seem that the sisters which are most akin in the family group are Music and Painting. One of the most interesting lines of thought which we can take up is the inquiry and considerations of the degree of similarity and dis-similarity—likeness and difference between the various sisters of the family. Nor is it by any means an unprofitable line of thought: on the contrary, a little consideration will show how needful it is not to carry the axioms and conditions of one branch too far into another branch. It is herein that many painter-artists have failed to see that all picture-producing processes do not aim at producing the same kind of pictures, and that as the aims were not the same it fails to become such a startling defect for one man to miss what he was not aiming at, and especially when the sneer comes from another who hits but the outer rim of his own target.

Mr. Lyddell Sawyer holds strongly certain views upon Art, and has expressed his willingness that they shall be made known. In the first place, he finds himself out of harmony with certain tenets of the naturalistic school, and considers them by no means difficult of disproof—but he freely declares that the movement as a whole has been productive of much good, inasmuch as it is making photographers think for themselves—and look beyond the mere technicalities which have hitherto occupied too large a proportion of their attention. He considers the average professional photographer an absolute fraud so far as any knowledge of Art is concerned—that he is merely a technical expert. And with regard to the Amateur section, he considers that many amateurs are enjoying reputations as artists to which they have by no means an indisputable claim. The reason for this state of affairs he concludes is probably to be found in the facility with which an elementary knowledge of Photography may be acquired—and thus, more by good fortune than merit, the Amateur surprises himself by accidentally producing a picture which is somewhat better than his average productions—this picture when sent to an Exhibition secures an award much to the further surprise of the "Artist." Mr. Sawyer is also in sympathy with the general wish for a movement towards various much needed reforms in the matter of rules and regulations for Photographic Exhibitions. He thinks that it is from the standpoint of creative composition rather than selection that true artistic merit is to be estimated. With respect to the fundamental nature of Art work it is needful to give Mr. Sawyer's own words. " The foundation of Art is in the superior aspiration of the " mind or soul when, aided by genius, it seeks to tell a humanising story. The more " elevating and sympathetic the story the greater the art thought." Mr. Sawyer includes in the sisterhood of the Art family, Poetry, Drama, Sculpture, Painting, and Photography (but the latter in only a limited sense). And among the branches of Photography he regards Landscape as the most limited—in fact, he says that he cannot imagine an Artist

being content to work at that branch alone—he fails to see how there can be much room for the range of genius—where the worker is limited so much in the matter of composition, etc. Mr. Sawyer's sympathies clearly lie chiefly around that indefinable area of subject which is frequently denominated Genre. He says that it is some years ago since he first wrote in favour of this kind of work by means of communications to the British Journal of Photography.

At that time, says he, it was a much neglected branch—but that he now with much satisfaction perceives it ranking as an equal with all other branches—and in time to come he is of opinion that it will be found the first and most generous of all art pasturage for the Photographer—and that in the future Landscape will rank principally as as an auxiliary in the Art stories told by human figures. But that in Art " Humanity telling of Humanity is its highest goal."

The reproductions of Mr. Sawyer's pictures are in harmony with his views, and show clearly enough that for him there is poetry to be found in scenes of daily toil and care.

Boys in boyish occupations, real enough to them while they last—men and women in their work of life, in their passage down the stream of time—young folk culling the flowers of a love-strewn path, each and all contribute their portion to the tale which goes to make up the history of mankind—and so they appeal to Mr. Sawyer as phases of life which bear upon them the stamp of humanity. The same humanity which by an invisible bond links every mortal with every other mortal, and makes us to-day a part of and concerned in the history of all time.

Thoughtful examination of the accompanying illustrations clearly show how wide and diverse are Mr. Sawyer's thoughts and feelings. Humanity in all its states and surroundings, appeals to him, as an abundant source for varied treatment; all its phases are welcomed within the scope of his work. It would no doubt be thought out of place were I to attempt any detailed criticism, or point out in particular any feature or mark of interest, but I trust I may be permitted to recall to mind one very interesting and significant fact, viz., that two of Mr. Sawyer's pictures (" On their own Hooks," and " Waiting for the Boats,") have attracted the attention of Dr. P. H. Emerson. In a letter, during the autumn of last year, to the " American Amateur Photographer," Dr. Emerson refers to these two pictures as " masterpieces." But were they without any such commendation still they would as pictures speak for themselves with no uncertain voice ; and attract the most careful and critical attention of those into whose hands they might fall : amply repaying careful examination and furthermore conveying numerous hints and suggestions to all who employ Photography as a means whereby they fain would express their artistic conceptions. The fact that Mr. Sawyer has embraced within the scope of his work so great a variety of subject and treatment is of itself a welcome contribution of evidence supporting a point which it is desirable to emphasize, viz., that no two human heads are exactly alike (as regards the outside or the inside)—or, as Hugh Miller puts it, " Every human being is unique, has some quality in which he is singular." Or, again, as Hamerton has pointed out, that any man may learn to see beauties in Nature which no other person has seen, and thus in Nature we have an inexhaustible stream. So that any attempt to set up boundaries is to work in a direction opposite to the healthy growth of Art. Buffon is often quoted as saying, " The style is the man," and Chesterfield's words may also be cited, viz., " Style is the dress of the thoughts."

The recent craze—or crank—or cant—on formation of "schools" in Photography is in many respects comparable with what was a similar craze in literature not very long ago, the so-called "formation of a style." The good, sterling common sense, however, of both readers and writers quickly determined that the only rational plan was to let each man tell his tale, "say his say," in his own words and in his own way. That a writer would unconsciously vary and adapt his diction and style to the subject was but a natural sequence; being more concerned with *what* he had to say than the *way* he would say it—letting the *manner* wait upon the *matter*. It would seem not improbable, that, as artists of all sorts and conditions grow more generous and catholic in their sympathies and knowledge, they will learn to see that good work may be done in a way diametrically opposite to what is their own accustomed manner of working—and still further, to see that what is befitting at one time for one subject, is not equally so, for another subject; that there is a time to laugh and a time to mourn, as nature herself teaches by precept and example, so also there is a time to focus sharply, and a time to be fuzzy—thus, as the horizon of mental vision is increased, these very terms will only remain as barbaric relics of a primitive time.

That there are many who, consciously or unconsciously, work in certain grooves, is well enough known—and that they repeat themselves year by year, one need only visit the popular exhibitions to assure oneself upon that point.

It is said, that, at a recent exhibition, the various judges found themselves almost unconsciously talking about A's, B's, and C's pictures, although they were not supposed to know the names of the artists until their decisions were arrived at. Others again assert that they can pick out A's, B's, or C's pictures anywhere by some little constant feature, detail of arrangement, of pose, lighting, etc. The best story, if told often enough, loses something in the repetition, nor does the same little pleasing device gain aught by being repeated indefinitely—furthermore, the conclusion is not unwarranted that, if a man always tell the same story he knows no other.

A "school" is too often synonymous with a groove, and that again with a shallow mind. A state of things far from desirable in an individual, much less so in a community. Unity is strength—sometimes: but when one idea has to be subdivided, and do duty for individual thought in the various members of a school, it is likely to become a very much diluted idea.

A little consideration will show the undesirability, in some instances the absurdity, of applying any "cure-all" method universally. It is as futile to seek for a panacea in Art, as in medicine. And although it may be urged that artist painters are practically at one in preferring pin-hole diffusion to the sharp-all-over picture, yet in all reasonings by analogy—the degree of that analogy has to be ever kept in sight. To apply rigidly certain *dicta* of painters to the sculptor's art, or *vice-versa*, would be disastrous, but not less so than to enforce their unqualified acceptance by the camera artist. The branches of Art are as the fingers of the hand—at one and the same time different, independent yet always co-ordinated.

Even in the matter of "beauty first and truth afterwards" there are very wide limits for the terminals of this axiom—granting for the moment that it is axiomatic. Consider the case of a portrait, say of a middle-aged man and that of a very young child—or compare an architectural subject with a seascape—an appeal for some elasticity of treatment will be involuntarily made. Thus it is forced upon our notice that an art-worker in any

branch cannot afford to ignore or neglect the study of the sister arts. The quaint attempts to connect the various arts is shown in those reputed sayings of Simonides, *e.g.* : that poetry is " vocal painting " and painting is " silent poetry," and in later times that statuary is " frozen music." These and similar common sayings show that there is an elastic connecting thread upon which are strung the sparkling gems of all true art-work, although each jewel has its own " native " qualities.

It is a curious and note-worthy fact, that the majority of those untrained in exact thinking are ever ready to give, at a moment's notice, a definite opinion upon either a work of Art or a Theological problem. These very people would hesitate to give any definite opinion upon shipbuilding, astronomy, chemical analysis, or any similar science, which is capable of exact investigation or precise demonstration, subjects which in comparison with Art and Theology are conspicuously simple. Doubtless the reason, at least in part, is, they are totally oblivious to the fact that there is any science in Art. The expression " Science and Art," being used to denominate the two great classes into which they naïvely divide all knowledge, seems to lend support to their theory. It is not forgotten that an effort has been made to compromise the matter, so far as photography is concerned by assigning it the position of the missing link—dubbing it an Art-Science. But this device no more simplifies the matter than did the proposal of Hœckel's " *regnum protisticum*," to solve the problem of the boundary line between the Animal and Vegetable Kingdoms.

The artist as much as (and perhaps more than,) any other man needs knowledge— orderly, *i.e.*, scientific knowledge, in order to produce a work of Art. Nor is it less true that for the proper appreciation and estimation of Art work an equally wide and deep knowledge is required—although many grown-up children proclaim their utter ignorance of any such requirements by asserting in a manner which is (to them) conclusive " I know what I like."

So recent a writer as Goldsmith (1728-1774), in his letter " The present ridiculous passion of the nobility for Painting," says, " It is true painting should have due encouragement, as the painter can undoubtedly fit up our apartments in a much more elegant manner than the upholsterer. But I should think a man of fashion makes but an indifferent exchange who lays out all that time in furnishing his house which he should have employed in the furniture of his head. A person who shows no other symptoms of his taste than his cabinet or gallery, might as well boast to one of the furniture of his kitchen. I know no other motive but vanity that induces the great to testify such an inordinate passion for pictures. After the piece is bought and gazed at eight or ten days successively, the purchaser's pleasure must surely be over." Thus painting a hundred years ago did not hold the position that it does to-day. This is due in part to the advanced education of the painter, and in part to the wider sympathies of the art patron. And as regards photography, cannot we to-day see something resembling this contemptuous sufferance? It is in the history of other arts, music, the drama, etc., that they while in their infant stage were permitted to exist on sufferance. So with reassuring comfort may the hope be indulged that there is in store for photography a place of honour; nor is it to be wondered at that this posthumous prodigy is regarded at present as the ugly duckling of the family, but kindly nursing with generous education will remove the stigma (often only too well founded), viz., that photography is only a mechanical means of copying.

In the generous wide-spread patronage bestowed upon the elder members of the family, Music, Poetry, Drama, Sculpture, Painting, Engraving, etc., the infant suckling dares to hope for heritage. That sculptors, painters, and others, see in part her capabilities, is a matter for congratulation, but not for a complacent self-satisfaction. The camera artist has yet much to learn and unlearn. Any of the exact sciences which can help him are to be warmly welcomed. Chemistry, Physics, Physiology, Anatomy, are in a measure the tools of his trade, and if ignorant of their uses and capabilities he will most surely transfer to them the blame which lies at the door of his ignorance. But apart from this apprenticeship of his handicraft there are yet more serious, wider studies in store for him. At the outset, Earl Talbot's motto from Terence (*Humani nihil alienum*— Nothing that concerns a man is indifferent to me,) must be his pre-eminent watchword. Nor must he be content to watch only the stream of life at his own door, but to bring himself into sympathy with all sorts and conditions of men. To study the thoughts of others, the " dressing of their thoughts " in their works, not simply that he may imitate ; for if imitation be what it is often said to be, viz., a sincere form of flattery, may it not with equal truth be called insincere robbery. What other term can we apply to him who takes aught from another and calls it his own ?

And yet what can we say to the photographer who has produced a negative and printed something from it ? Truth, too often, compels us to admit that a large part of whatever merit it may possess is only his by that sincere form of flattery which by any other name would be equally unflattering to the producer of the second edition.

What then do we say is the scope and aim of the Artist? FIRSTLY, let him become a workman and learn to use the tools of his craft so that in using them he may not attempt to produce something which is outside their power. With their use let him learn their limits. But let him not limit himself to using them. To remain at this stage is to remain simply a workman, a mechanical artisan—not a workman-like Artist. It is the facility—by some termed " the fatal facility "—with which photographic representations may be made, that has caused too many to rest contented with simple reproductions of anything, or everything. It is this power of producing *a* result with a minimum of labour which has shown us but too often how true it is that few things are worth producing unless they require laborious work for their production. With how many is production not the means to an end, but the end itself?

SECONDLY, let him become a true student by studying the works of others—not simply the work of some one little sun or his admiring circle of imitative satellites, but also let him study work of all kinds. Let him go to exhibitions, not simply with the idea that there is some trick which having discovered he will be able to produce good work— but that he may see what others have done, how they have done it, and what was their object in doing it. Not that he may imitate but that he may be careful lest he attempt what others have done better than he can as yet attain to—that he may not repeat what has already been done unless he is fully sure that he can add something—that something being not only admissible but desirable or possibly essential. As nothing can come out of nothing, the productions of an empty mind must be vapid and sterile. Let him then store his mind by studying the works of others ; their objects, their methods, and their results, that he may better learn the measure of his own power and weak-

ness. For him to remain at this point is to limit himself to being at best but a workman-like imitator.

But THIRDLY and chiefly let him study to become an Artist in the common school of all creative Artists—in the school of Dame Nature. That which is essential to the maker of art work (therefore to the education of an Artist), is that first and last he shall learn to see with his eyes and with his mind; to see and think for himself. To distinguish between subtle differences, to separate cause from effect, to observe the characteristic marks which enable him to recognize and discriminate similar phases of Nature in her ever changing modes, to seek and mark the beautiful, analyzing its component parts and storing his mind with those combinations of beautiful effects which nature blends—searching for the order of things and reason why certain combinations are often found in consort—while other combinations are seldom or never seen. Observing and comparing how different workers have tried to interpret their conceptions of the various aspects of Nature—noting in what way each of them has come near to his mark, in what way any have sought to " improve on nature," and marking for himself and for his own those of Nature's smiles and frowns and tears which others have not set down. For it is herein only that he can be the true Artist—the creator, the producer of original work ; thus it behoves him to study his tools, the work of others, and Nature herself, that he may see what lessons others have for him, and lest in attempting to teach others what they have already learned he may be a blind man leading those that see.

Nay, rather let his aim be to study other men's work, that he may feel his own want of knowledge and power, that their example may stimulate him to hand on to others what he has received from them, having added an honest contribution of his own. Taking confidence in the assurance that what he has thought out with his own brain, seen with his own eyes, is undoubtedly his own ; so that, having the knowledge of its reality to himself, at any rate, he fearlessly passes it into currency, having, once for all, stamped it with his own mint-mark.

Let him cast away from his neck the mill-stone-like tenets of any and every " school," and fearlessly strike out into the stream for a treasure island of his own. To be true to himself is his first and last law, being a law to himself; not a law breaker simply for novelty's sake, or with the hope that eccentricity may be accepted in place of originality, but rather working in the consciousness that whatever he can evolve as an entity, as a reality for himself, in that, and that alone, can he be true to his work and to himself. To cultivate and use to the best of his ability, with singleness and honesty of purpose, those faculties he may possess, is to fulfil the noblest work open to him, and in doing that he may rest assured that posterity will re-echo Buffon's dictum, " The style is the man."

F. C. LAMBERT.

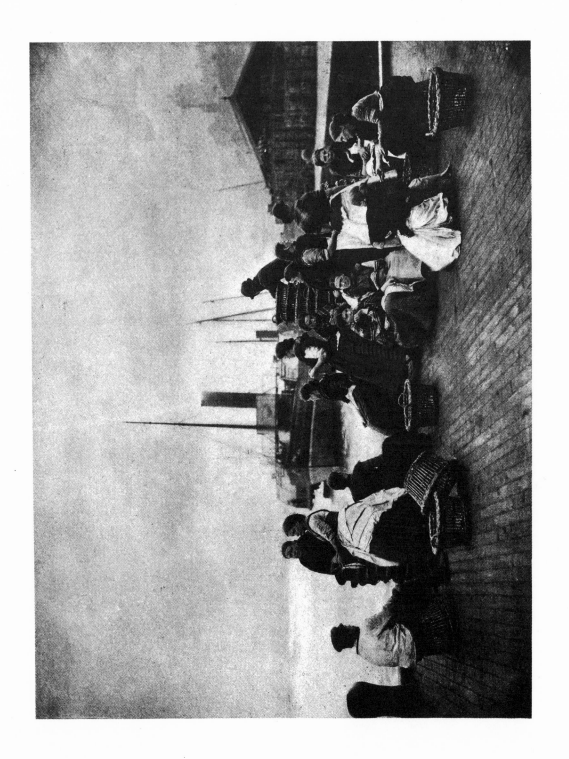

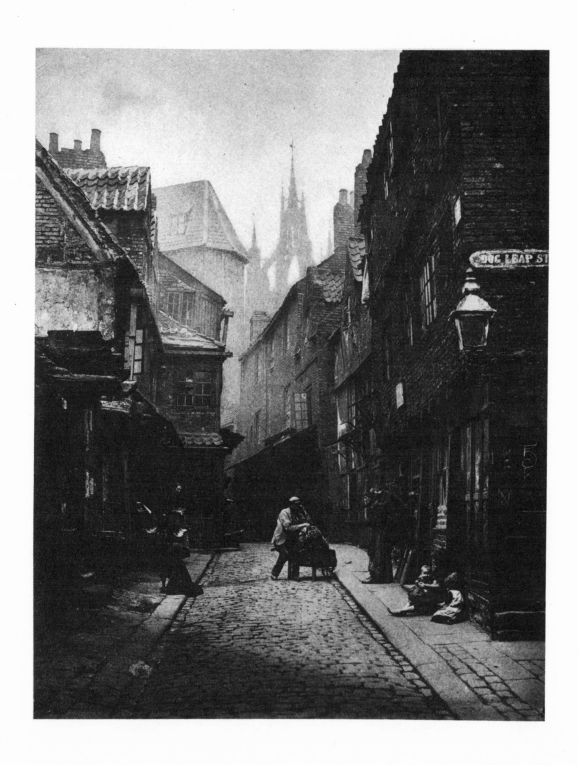

Lyddell Sawyer

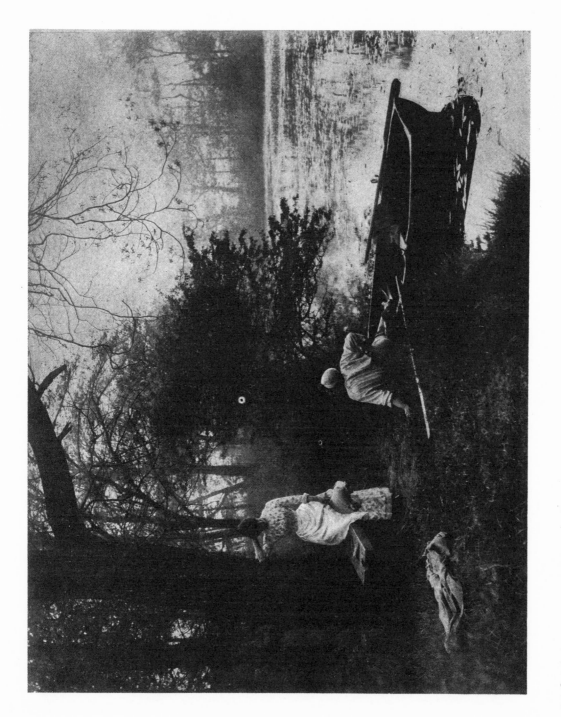

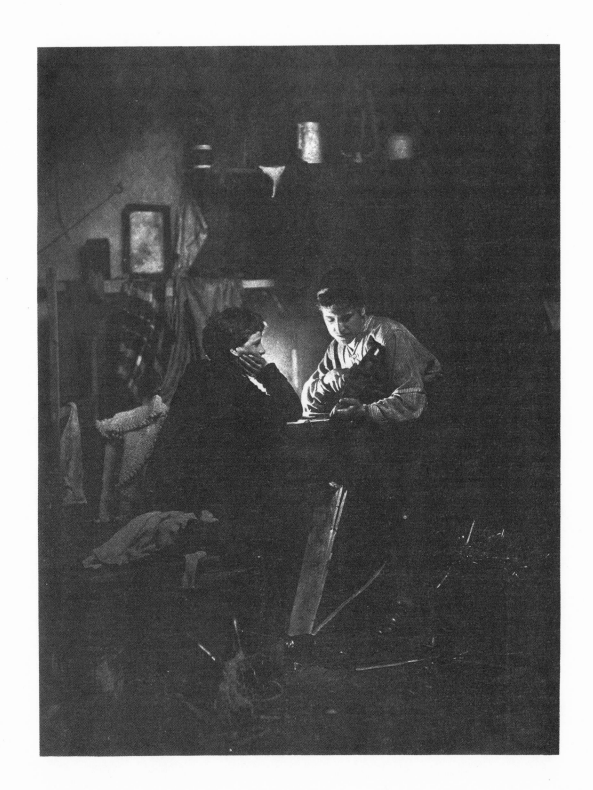

THE PHOTOGRAVURES IN THIS BOOK WERE MADE BY

ANNAN & SWAN

7, DEVONSHIRE ROAD
SOUTH LAMBETH
LONDON S W

PRESS OPINIONS.

" . . . We have received Part III. of 'Sun Artists.' The present issue deals exclusively with the life and work of Mr. J. B. B. Wellington. . . . His figure-subject 'The Broken Saucer' is exceedingly pretty, the tones very refined, and the attitude of the woman as graceful as it is original and picturesque. . . ."
SATURDAY REVIEW.

" . . . The fishing smacks, the rustic scenes, and the typical foggy day on the Thames, are certainly excellent specimens of the art. . . ."—MORNING POST.

" . . . Great taste and skill have been expended in connection with the 'get-up' of the magazine. We have an artistic cover, excellent paper, good printing, and, above all, four beautiful plates. . . ."—SCOTSMAN.

" . . . The four plates do ample justice to the finely finished pictures. . . . The descriptive text is lively and interesting, and no pains have been spared in the preparation of 'Sun Artists.' . . ."—DAILY CHRONICLE.

" . . . The four plates are beautiful productions. . . ."—ILLUSTRATED LONDON NEWS.

" An addition, and we think a valuable one, to the ranks of the illustrated magazines is 'Sun Artists.' . . . Altogether 'Sun Artists' is a handsome and attractive quarterly periodical."—THE GRAPHIC.

" . . . The high water mark of modern photography. . . ."—ART JOURNAL.

" . . . Four reproductions are given : clever studies in which the eye of the artist has had as great influence as the manipulation of the photographer. The scenes are most excellently reproduced in photogravure. . . ."
THE ARTIST.

" . . . In composition, delicacy, softness, equable tone, avoidance of harsh effects in contrast, fore-shortening, etc., too often the bane of the photograph-picture, these examples are wonderfully fine. . . . Type, paper and general 'get-up' are all that can be desired. . . . Should certainly do much to advance artistic photography."
PALL MALL GAZETTE.

" Exceedingly interesting . . . everything possible has been done to make the work attractive."
MAGAZINE OF ART.

" . . . We can but wish it all success. It is made up of eight large pages of exquisite printing upon Dutch hand-made paper. . . . Four plates of much merit are given. . . ."—THE QUEEN.

" . . . It would be difficult to find anything of its kind more enchanting than the pretty scenes of field and water, horses, men and boats. . . . Indeed the whole 'get-up' of the magazine is luxuriantly artistic. . . . If 'Sun Artists' justifies the high expectations awakened by its first issue, it will indeed be a welcome addition to the art journals of the day."—MANCHESTER EXAMINER.

" . . . We cannot conceive of any work of even the most skilful engraver which, if put upon the etching of 'Sleepy Hollow' could improve it in the slightest degree. The text matter is of the most racy character. . . . 'Sun Artists' is sure to take well, for never before has such an admirable five shillingsworth been offered to the public. It is of large size, and well printed on fine hand-made paper. . . ."
BRITISH JOURNAL OF PHOTOGRAPHY.

" . . . This handsome publication. . . . It is almost needless to say that the work is admirably produced, and will, no doubt, find its way into every photographic library where good things are treasured."
THE CAMERA.

" . . . This publication is already famous. . . . It is a step in the right direction, the first number alone is sufficient to disprove the not uncommon assertion that photography can never be a fine art. . . . The whole set should compose a very valuable collection, and we think that every member of the club ought to make a point of securing copies from the commencement. . . ."—CAMERA CLUB JOURNAL.

" . . . We are glad to welcome a new serial called 'Sun Artists.' We may confidently say that we have never seen anything of the kind more perfect in point of general effect or of detail. . . . 'Sun Artists' ought to make its way."
YORK HERALD.

" . . . Everything skill and taste can contribute to success has been brought to bear upon 'Sun Artists.'"
BRISTOL MERCURY.

" . . . The first number of 'Sun Artists' is certainly a 'thing of beauty.' The four plates reproduce photographs good in themselves, and beautifully represented here. The letterpress is interesting, and the whole 'get-up' of the issue most luxurious. 'Sun Artists' can hardly want friends. . . ."—YORKSHIRE POST.

" . . . Their delicacy and beauty are very remarkable. . . . We have no hesitation in saying that these plates place photography in a higher position than it has hitherto held in public estimation. 'Sun Artists' will be not only a handsome publication, but one of genuine artistic value."—NORTH BRITISH DAILY MAIL.

" 'Sun Artists,' the fine photographic art journal which has been spoken of so highly by all the European journals, has reached us. We cannot speak too highly of the publication."
THE PHOTOGRAPHIC TIMES AND AMERICAN PHOTOGRAPHER.

" . . . This periodical takes new ground. . . . We heartily wish it a well-deserved success."
BIRMINGHAM DAILY POST.

" An extremely beautiful new quarterly. . . . 'Sun Artists' shows the artistic heights to which photography has attained. Nothing more beautiful has ever been presented to an art-loving public than this handsome new periodical, with its four etchings in 'Art Journal' style, on which 'all hand work has been scrupulously avoided. . . .' Pains have not been spared with the letterpress of 'Sun Artists,' the type having been cast from punches cut by Caslon in 1720."—EAST ANGLIAN DAILY TIMES.

" . . . The second number of 'Sun Artists' is admirable. The four plates are simply matchless as specimens of photo-printing. Anything more delicate and beautiful of their kind than these pictures could not be desired. The success of this most artistic publication must now be thoroughly assured."—GLASGOW HERALD.

" . . . Four charming examples; all of them beautiful and artistic pictures."—SUNDAY TIMES.

" . . . The plates are thoroughly artistic in workmanship, and the subjects interesting and attractive. . . . They well deserve to rank as fine art."—THE GLOBE.

" Four pictures of considerable beauty. They might well form component parts of a new 'Liber Veritatis,' and they demonstrate clearly enough that photography is something more than a mechanical art. . . ."
BIRMINGHAM POST.

" The third number of this handsome and attractive art publication is devoted to the reproduction of photographs by Mr. J. B. B. Wellington. These show what enormous progress has been made by photography as an art. This publication should be in favour with lovers of art."—GLASGOW DAILY MAIL.

" 'Sun Artists' keeps well up to the worth and promise of the first number. We have here what is incomparably the best work in artistic photography."—LEEDS MERCURY.

Chiswick Press

PRINTED BY CHARLES WHITTINGHAM AND CO.
TOOKS COURT, CHANCERY LANE, LONDON, E.C.

NUMBER 5.

OCTOBER, 1890.

SUN ARTISTS

MRS. CAMERON,

With a descriptive Essay

BY P. H. EMERSON, B.A., M.B., (Cantab.).

HON. EDITOR:

W. ARTHUR BOORD.

KEGAN PAUL, TRENCH, TRÜBNER & CO.
(LTD.), 57 & 59, LUDGATE HILL, E.C.

ANNOUNCEMENT.

THIS, the fifth number of the serial, heralds the entry of "SUN ARTISTS" into the second year of its existence. The promoters feel that this event marks an important period in its history, and indeed in the history of Photography, conclusively proving that the public are beginning to extend their appreciation of things beautiful to an art until recently regarded as essentially belonging to the sphere of things useful.

Hope of success for the first few months was buoyed up to a large extent by curiosity on the part of the public, since then, however, the promoters have, with the keenest pleasure, observed the number of their supporters increase in ever greater circles.

Owing to the kind and enthusiastic approval of the chief organs of public opinion, attention has been directed to their efforts in many and unexpected quarters, and the trepidation inevitable to the launching of an untried vessel in unknown seas has made way for a feeling of confidence in eventual success which will urge them on to greater efforts in the future. Grateful acknowledgment is due to those artists whose pictures have been reproduced during the past year, as well as to the writers of the descriptive matter, whose disinterested and kindly help has materially contributed to the success of the serial.

The present number has (not only as a tribute of respect to the well-known lady who forms the subject of it, but chiefly in view of the loss of quality inevitable to excessive reduction in the size of the pictures) been considerably enlarged both as regards the engraved area of the plates, and the number of pages of letterpress. This would not have been possible but for the generous co-operation of Mr. Colls, who has engraved the plates with a care born of love for his work and its subject. The descriptive matter has also been most kindly undertaken by Dr. Emerson, whose recent volume on "Naturalistic Photography," and whose many beautiful portfolios of photogravure, mark him out as pre-eminent for the task.

Finally, the thanks of the promoters are due in no little degree to Mr. H. H. H. Cameron, who placed his mother's works, with commendable readiness and courtesy, at their free disposition.

TEMPLE CHAMBERS,
October, 1890.

NOTICES.

No. 1. MR. J. GALE (4 plates) has been reprinted.
LIST OF PLATES.
SLEEPY HOLLOW (Medal for this reproduction Photographic Society of Great Britain, 1889).
A FOGGY DAY ON THE THAMES.
BRIXHAM TRAWLERS.
HOMEWARDS FROM PLOUGH.

No. 2. MR. H. P. ROBINSON.
LIST OF PLATES.
CAROLLING.
A MERRY TALE.
DAWN AND SUNSET.
WHEN THE DAY'S WORK IS DONE.

No. 3. MR. J. B. B. WELLINGTON.
LIST OF PLATES.
EVENTIDE.
A TIDAL RIVER, EAST COAST.
THE BROKEN SAUCER,
A STUDY OF SHEEP.

No. 4. MR. LYDDELL SAWYER.
LIST OF PLATES.
WAITING FOR THE BOATS.
THE CASTLE GARTH.
IN THE TWILIGHT.
THE BOAT BUILDERS.

No. 6 will be published in January next, and will contain photogravure reproductions of pictures by

MR. B. GAY WILKINSON.

With a descriptive essay.

A limited number of signed unlettered proof copies, on India, will be issued.

A few signed proof copies of numbers 2, 3, and 4, suitable for framing, are still in hand, application should be made to Temple Chambers.

Descriptive leaflets can now be obtained of all booksellers throughout the kingdom.
Leading Press opinions appear on the third page of the cover.

All communications relative to this Serial should be addressed to
THE HON. EDITOR
"SUN ARTISTS,"
7, TEMPLE CHAMBERS,
TEMPLE AVENUE, LONDON, E.C.

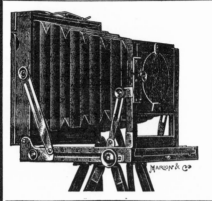

MRS. JULIA MARGARET CAMERON.

IN undertaking this task—a labour of love—I feel obliged, as a duty to myself and the subject of my memoir, to state my critical attitude. There is some necessity of doing this in the æsthetic criticism of photographers and photographs, for it could be easily shown that the appreciations of this branch of Art have sinned against proportion; that pitfall to the amateur; that mystery to the herd. I know of no *critique* on photographs that shows a just sense of relative value, an impersonal seeking after the virtue, the very marrow of the work. Nor is this surprising, for artistic photography is a new thing: the matter is but just beginning to be apprehended. Hitherto the medium has been used to imitate the conventions of painters, but for seeing the thing as it really is, for recording the very gist and marrow of life, its possibilities have only lately been demonstrated and appreciated by artists of ability imbued with the new spirit. Hitherto, in all that is elemental, conventions have been followed, and according to the innate taste and capacity of the individual, so have been the results. There have been conventionalists who, looking with brutal eyes upon Art, have degraded everything that is dainty, that is fresh, that charms, stamping photography with the blatant sentimentality of the province, the cult of the suburb, or the red tape of the warehouse. All such works are the hall-marked of vulgarity. On the other hand, there have been amongst this toiling, moiling crowd of aspirants one or two with native good taste, true artistic perception, and possessed of great sympathy, have followed good conventions and achieved success; in the case of Mrs. Cameron, brilliant glimpses of truth and beauty, instinct with æsthetic qualities recalling the great artists she took as her models. Of the crowd of dark-box bearers now with the shades, the most successful was Mrs. Cameron, whose pictures alone are worth preserving.

Before giving my appreciation of this noble-minded lady, allow me to remind the reader that in estimating her works I make the comparison with all the fairer forms of Art that were produced before her star arose. I recognize no petty world sanctified to photographers and their works, but I look upon the photograph criticised in its relative value to all great art. I am inclined to think that my predecessors have gauged the subjects of their memoirs according to the values in which they are held by photographers— an uncritical democracy at best. It is thus their sense of proportion has been at fault. Great art knows no boundaries, no distinctions, the medium used by the artist often being determined by chance or some organic idiosyncrasy. The results must be valued only in proportion as they possess the fundamental qualities found in the beautiful visions snatched from nature and hewn in marble by Pheideas and Donatello, preserved in paint by Titian, Rem-

brandt, Velasquez, Corot, Maris and Whistler, etched on metal by Rembrandt, or struck from trembling cords by Paganini. Mindful then of my aim, I shall attempt to find the ' virtue ' of Mrs. Cameron's works, and express its influence upon me ; that is all a critic is able to do. And in truth, to persons who like myself are makers, not critics, by profession, any appreciation seems ever to be dogged by the spectre of futility. All I can plead in excuse is, that pious worship has prompted the mind and a jealous regard for my own art the pen.

Julia Margaret Pattle, daughter of an Indian Civil servant, was born at Garden Reach, Calcutta, on June 11th, 1815. Her father was a Scotsman, and her mother French. The seven Misses Pattle were famous for their wit and beauty, her sisters having married Mr. Mackenzie, Mr. Prinsep of the East India Company, father of the painter, Mr. Jackson, Mr. Bayley, Lord Somers, and Earl Dalrymple. In 1837, the accomplished Julia Margaret Pattle married Mr. Charles Hay Cameron, fourth Member of Council of Calcutta—an important office in which he succeeded Lord Macaulay. Mr. Cameron was described by his friend Sir Henry Taylor,[1] the author of " Philip Van Artevelde " and other works, as a " Benthamite jurist and philosopher of great learning and ability." The old Etonian was, in addition, a good classical scholar.

Born and bred in the best Anglo-Indian society, Mrs. Cameron had the advantages of mixing with intellectual men of many shades of opinion and varied tastes, nevertheless the *milieu* was not altogether sympathetic, nor, we imagine, could it have been. Anglo-Indian society cannot have changed much in essentials since her time, and for such a noble and generous nature the superstitious, subtle, refined, and cruel vulgarity of that society could not be but uncongenial. The very genius of the race as exemplified in their Rajahs, their Juggernaut of haughty passion, fawning cunning, showy splendour and cruelty, run mad on the one hand—the comedy of red-tape gallantry, obsequious scheming, unstable family ties, and bilious querulousness on the other, could not have been as water to the parched lips of the intellectual. But even there were opportunities for the artist, altogether neglected, alas ! by Mrs. Cameron. Indeed the impulse to produce seems to have come to her very late in life, and then by chance—not auspicious to the general—but at times tardy growths bear the richest of fruits.

Mrs. Cameron has been described to us by those who knew her best at this period, as impulsive, generous to a fault, full of sympathy, brimming over with energy, and, above all, determined to conquer all difficulties that stood between her and the accomplishment of anything upon which she had set her heart : as witness at the time of the great Irish famine. Kind-hearted people all over the Empire were collecting money for the starving peasantry, and one of the chief helpers in this noble task was Mrs. Cameron, who worked with characteristic energy until £10,000 were charmed from the banking accounts of the English residents and the coffers of the Rajahs.

Sir Henry Taylor tells us that after the Governor-General's death, Mrs. Cameron was at the head of European Society in India, yet amid the bustle of such a life she was assimilating ideas that were destined later on to yield a thousand-fold. Sir John Herschel, one

[1] Autobiography, 1800-1875, 2 vols. 8vo, 1885, Longmans and Co.

of the few really great names on the roll of Photography, was corresponding with her. She has written [1] " My illustrious and revered, as well as beloved friend, Sir John Herschel. He was to me as a teacher and high priest. From my earliest girlhood I honoured him." Referring to the correspondence of this friend—in the days of Talbotype—Mrs. Cameron writes : " I was then residing in Calcutta, and scientific discoveries sent to the then benighted land were water to the parched lips of the starving, to say nothing of the blessing of friendship so faithfully evinced." After a friendship of thirty-one years, Mrs. Cameron was allowed to take his portrait. The barbaric generosity of the Rajahs seems to have taken root in her warm nature, for Sir Henry Taylor tells that upon her return from India she heaped presents upon her friends—gifts worthy of the wealth of Ormuz and of Ind.

From these notes it will have been gathered that Mrs. Cameron was sympathetic to all intellectual achievements, the wizardry of photography seeming to possess some special fascination, whether owing to the influence of Sir John Herschel's enthusiastic letters or the possibilities offered of possessing a gallery of dear friend's counterfeit presentments can only be surmised. That this passion was strong is well known in the family circle, for long before that memorable day in 1864, on which little Miss Philpot was conjured as with a magician's wand upon a glass plate covered with a chemical film, and in her new and beauteous form re-named " My first Success," Mrs. Cameron had spent hundreds of pounds in paying the degraders of the art to fix the faces of her friends. Her generous nature did not consider money, photographers were ordered with lavishness to work for her, often under her immediate supervision. The best of this vicarious photography was Rejlander's portrait of Tennyson, taken at Freshwater, but truth to tell it is a sorry product : what were the feelings of that operator when he saw his patroness produce the masterly Tennyson, it were better to leave to the imagination.

On the return of the Camerons to England from India they settled at Putney Heath, where they lived for some years. This period of their lives was full of intellectual activity, a complete and welcome change from the barbaric life of the East. Mrs. Cameron's most intimate London friends were Sir John Herschel, Lord Hardinge, Sir E. Ryan, and Sir Henry Taylor, who has written of her at this period : " She appeared to us to be a simple, ardent, and honest enthusiast. Her genial, ardent, and generous nature makes her love others and forgetful of herself. Miss Fenwick describes her as a fine generous creature, and writes, " we all love her, Alice, I, Aubrey de Vere, Lady Monteagle and even Lord Monteagle, who likes eccentricity in no other form like her's." During this happy time, she was a regular visitor at Little Holland House, where her sister, Mrs. Prinsep, used to entertain, on Sunday afternoons, the best artistic and literary society of London. There she met her old friend Mr. G. F. Watts, who had painted her portrait in 1850, Mr. Woolner, Mr. Holman Hunt, Mr. Burne-Jones, the late D. G. Rossetti, and Frederick Walker. Instinct with a natural love of the beautiful and of pictures she was, doubtless, influenced by these artists, although she was neither an amateur of painting, a collector, nor a creator—she could not draw.

[1] " Annals of my Glass House." By J. M. Cameron. A fragment published privately.

In the year 1860 the Cameron family removed to Freshwater Bay. In their delightful retreat, the rose-embowered *Dimbola*, this accomplished couple began a new life. Mr. Cameron found a congenial friend in Mr. Tennyson the poet—they were neighbours— whilst Mrs. Cameron found in photography an all-absorbing pursuit, although life at Freshwater was not one of solitude. Sir Henry Taylor, a regular visitor at the house, writes, "conventionalities had no place. The house swarmed with guests." Dimbola was Liberty Hall.

I must digress for a moment to tell a pretty little story. Whilst living at Putney Heath, Mrs. Cameron picked up a starving Irish girl, and converted her into a neathanded Phyllis, who grew to be as beautiful as she was good. As a reward she was chosen as Mrs. Cameron's printer and general photographic assistant, oft-times sitting as a model. She is the original of *Maud*. When Mrs. Cameron held her exhibition in London, "*Maud*" was sent up with a *chaperon* to explain the pictures to the public. A gentleman came in one day, and after having asked several questions, left. A year or two afterwards he passed into the Indian Civil Service, but before starting for the East, he went down to Freshwater and knocked at Mrs. Cameron's door, begging for "*Maud's*" hand. The beautiful *Maud* was willing, so they were married, and like the people of fairy story, they lived happily ever afterwards.

This brings us to the period which will most interest photographers. We have given sufficient glimpses of this noble-minded lady to enable our readers to grasp her personality. Now think of the circumstances in which she began photography. She was nearly fifty years of age, she knew absolutely nothing of practical photography, and there was no one at hand to give her instruction; she had to hammer it out for herself—and that in the days of wet collodion. Think then of the masterly work she went on producing for the next ten years, and confess the artist is born, not made.

It was by the merest chance that she began at all. Sir Charles Norman married one of her daughters, and together they presented their mother with a lens and dark-box. "It may amuse you, Mother, to try to photograph during your solitude at Freshwater." No artist ever began under kinder auspices—love smoothed all difficulties and opened all locks. "It may serve to amuse you to try to photograph." How quaint and simple those words read in these after years. The donors were innocent of the marvels that lens would transmit, and all unconscious of the genuine artistic temperament possessed by their mother. But Mrs. Cameron was no *dilettante*, she immediately set to work, and for nearly a year chased the dainty one, sometimes being favoured with a smile of encouragement, oftener being eluded. What a lesson her life should be to the blatant coxcombry of to-day, where conceited ignorance begins to preach before it has mastered the elements of its art. There are many babblers in the photographic world who play such tricks before high heaven as would make the angels weep. A short description of her tools may prove interesting to the craft. Her lens was by a French maker, Jamine by name. I am indebted to my friend Mr. T. R. Dallmeyer, who has recently examined the lens for me. He reports the following general notes. "The 'Jamine' has a focal length of 12 inches and is 3 inches in diameter. It has a fixed stop of $1\frac{7}{8}$ inch diameter—in other words, works at about F/6 —F/7. It is a 'Petzval' construction and there is no outstanding spherical aberration—but there is positive chromatic aberration." Her camera was of the simplest type, consisting of

two wooden boxes, one sliding within the other. It is still in the possession of her son, Mr. H. H. Cameron, whom I take this opportunity of thanking for courteous co-operation in gathering material for this memoir. The chemicals and apparatus were also of the simplest description, the barest necessities for the wet collodion process and silver printing. Nearly all her work was done in a studio of the simplest kind. She writes: " I turned my coal-house into my dark-room, and a glazed fowl-house I had given to my children became my glass-house. The hens were liberated, I hope and I believe not eaten, and all hands and hearts sympathized in my new labour, and the society of hens and chickens was soon changed for that of poets, prophets, painters and lovely maidens, who all in turn have immortalized the humble little farm erection." The glass-house was fitted with simple white roller-blinds; no head-rests or other abominations finding place there.

Mrs. Cameron's first sitter was Farmer Rice, who received the splendid model's fee of half-a-crown an hour. "After many half-crowns and many hours spent in experiment, I got my first picture, and effaced while holding it triumphantly to dry." Little Miss Philpot was the next sitter, the result named " My First Success," a picture 11 by 9 inches in size, was taken June 11th, 1864. It is interesting to read Mrs. Cameron's remarks upon her focussing. " I believe that what my youngest boy, Henry Herschel, who is now himself a very remarkable photographer, told me is quite true, that my first successes, viz., my out-of-focus pictures, were a ' fluke,' that is to say, that when focussing and coming to something which to my eye was very beautiful, I stopped then instead of screwing on the lens to the more definite focus, which all other photographers insist upon." I am sure, after examining her lens and looking over her prints, that she did get her results by accident, but that her explanation, given ten years afterwards, is the wrong one. The ' Jamine ' working at F/6 had no small diaphragms, abominations introduced later on by a scientist and invaluable to such an one, but utterly *useless* to the artist—nay fatal, as I have proved scientifically. In addition, though the image appeared sharp on the screen, owing to the positive chromatic aberration, the picture would be out of focus when taken. It was therefore *impossible* for Mrs. Cameron to get what is technically known as the " sharpest focus." Still, having learnt from this experience, in after years she did not work with the sharpest focus obtainable with the Rapid Rectilinear Lens. Having produced out-of-focus results at first by accident, she was artist enough, and so well advised, that she determined to imitate that effect; a determination fulfilled later on when she became possessed of an 18 by 22 Dallmeyer Rapid Rectilinear Lens—one of the triumphs of Photographic Optics. She used this lens at large aperture, so that her son, an experienced photographer, says it is almost impossible to distinguish the pictures taken with the two instruments as regards the quality of focus—but this I think an error. All her work was taken direct, indeed she claimed that as a merit, and she was right. Enlargements, as I first pointed out, are false in many elemental qualities. Mrs. Cameron gave very long exposures, ranging in duration from one to five minutes. This method was brought up against her as a matter for raillery by jealous craftsmen. Unable, with all their appliances, to produce work comparable to hers, the photographers of commerce sought every pretext to belittle her pictures, but all in vain, for many of them possessed those undying qualities of art which artists immediately recognized, and after all it is in their hands that the final judgment in such matters rests. All that can be said against her is that she used too short a focus lens for her 15 by 12 plates.

In May, 1865, Mrs. Cameron sent some of her work to an exhibition held in Edinburgh; a grand head of Sir Henry Taylor, whose only fault is an unpleasant wiriness of beard, and " La Madonna Aspettante." Concerning these works she writes : " They did not receive the prize : the picture that did receive the prize, called ' Brenda,' clearly proved to me that detail of table-cover, chair and crinoline skirt were essentials to the judges of the art which was then in its infancy." Had Mrs. Cameron been well advised, she would never have entered for these contemptible competitions, the judges were incompetent, her competitors beneath contempt, and her public uneducated. The majority of her competitors were banded together by class instincts and trade interests, and one is filled with scorn, on turning back to the photographic journalism of the period. There are to be found the ignorant criticisms of the scribe, the anonymous and abusive letters of her incompetent and jealous rivals—the crafty artsmen of the day. The editor of one of the chief Journals wrote : " the works show considerable knowledge of art scarcely well applied, in which all that constitutes the beauty of a photograph is lost, *i.e.*, detail and truth (*sic*)." " Brenda " was held up as a masterpiece. Another wrote that " bad photography was not good art." The council of one photographic society " objected to their style altogether." The editor of the oldest established Journal " protested for the credit of the art," against out-of-focus pictures. This writer was a Master of Arts of some University or the other— can it be believed ? Another comment says " a lady whose large portraits have been much praised in *Delettante* (*sic*) art circles claims it as a merit that they are taken direct, and admits that very long exposures are required." The producer of " Brenda " wrote " For the last few years some photographs by a lady, many of them failures from every point of view. It is not the mission of photography to produce smudges." Failures at painting and sculpture, many of the so-called artist-photographers naturally could not see truth and beauty in Mrs. Cameron's masterly work. What a satire upon them all, to think that at the very time these absurdities were being published, Mr. Watts was calling some of her work " Divine," and some of the greatest English artists were praising her pictures, and sympathizing with her endeavours. Mrs. Cameron took no notice whatever of these busybodies ; she treated them with silent contempt. I cannot find a single communication of hers to the photographic press. On the other hand, there were a few intelligent men who raised their voices in her behalf—all honour to them. Dr. Vogel, of Berlin, praised her work, and said, " Richter, an artist, liked them much." A writer signing himself " Artist," sent some sensible letters, showing how photographic journalists were in the main responsible for bad art in photography, at the same time pointing out that the so-called authorities in photography were wrong and inartistic. The sanest article of the period, however, was written by a Mr. H. J. Slack, F.G.S., in the " Intellectual Observer." He defends her works. Of special interest is the following—" Mrs. Cameron has especially devoted her talents to two objects, both usually neglected in photography. The first is the realisation of a method of focussing by which the delineations of the camera are made to correspond with the methods of drawing employed by the great Italian artists. The second by the introduction of an ideal pictorial element." Mr. Slack, however, proves himself one of the crowd by virtue of the works he singles out for praise—they are her failures. I am not indignant with those who opposed Mrs. Cameron because they did her any harm—that was impossible, and the whirligig of Time has already avenged her.

What arouses my wrath is the power those poor creatures had in obstructing the development of the art by misleading the young. When the true history of photography shall come to be written, their day of reckoning will dawn—then they will be pilloried, and their names disgraced.

Notwithstanding all this opposition, her pictures set some men thinking, the results being certain lenses, and the acknowledgment by the crowd of the legitimacy of a "certain amount of softness" equally diffused over all the planes of the picture. This equally diffused softness, although preferable to 'sharpness,' is a meretricious device, as I recently pointed out, and not in accordance with nature. Neither was Mrs. Cameron's positively chromatic focussing on the right track—it was not legitimately artistic; not naturalistic; because the out-of-focus planes were all treated alike and she aimed for the effect of the Italian Masters—instead of endeavouring to render the true visual impression.

As she progressed with her work her enthusiasm knew no bounds, every picture was submitted for criticism to her sympathetic husband. She writes: "this habit of running into the dining-room with my wet pictures has stained such an immense quantity of table linen with nitrate of silver, indelible stains, that I should have been banished from any less indulgent household." Sir Henry Taylor was her willing martyr. In his autobiography, he writes: "No more of Freshwater Bay for the present, except this, that I was photographed, I think, almost every day." A good story illustrating her enthusiasm in the search for the beautiful is told by her son. She was at Oxford on one occasion. Whilst walking in the "High" she passed a very beautiful girl. Going up to her she asked excitedly, "Oh, who are you?" "I'm Mrs. Donkin's cook," replied the blushing maid. Mrs. Cameron got her address, called on Mrs. Donkin, and obtained permission to take the girl to Freshwater for a time as a model. She is "Œnone."

At Freshwater all visitors were impressed into her service. Writing of Sir Henry Taylor, she says, "One chief friend lent himself greatly to my early efforts. Regardless of the possible dread that sitting to my fancy might be making a fool of himself, he with greatness which belongs to unselfish affection, consented to be in turn Friar Lawrence with Juliet, Prospero with Miranda, Ahasuerus with Queen Esther, to hold my poker as his sceptre, and to do whatever I desired him." Her spirit of work is best illustrated by her remarks upon Sir John Herschel's portrait. "When I have had these men before my camera, my whole soul has endeavoured to do its duty towards them in recording faithfully the greatness of the inner man as well as the features of the outer man. The photograph thus taken has been almost the embodiment of a prayer." Sir John Herschel watched every step in his friend's career, often writing to warn her of the deadly powers of "cyanide." His criticisms on her works too were full of innocent praise and kindly sympathy, if futile as art-appreciations. Mr. Watts' sympathy must have been very encouraging. "At this same time Mr. Watts gave me such encouragement that I felt as if I had wings to fly with," record the Annals.

The history of the next ten years of her life is but a repetition of successes and the story of the production of those works which have made her name famous. A list of her works I have appended as a catalogue. In the year 1875 the Camerons left England and went to live in Ceylon, where Mrs. Cameron died in 1878. As she did no

photographic work after leaving England her period of production is bound by ten years (1865-75).

It will be seen from a study of Mrs. Cameron's works that there are no landscapes; indeed, I am informed that she never took a single landscape. She seems to have had no eye for the poetry of inanimate Nature, or for its profound expressiveness. Sir Henry Taylor has told us that she liked "stormy seas." I do not think she ever knew the meaning of Nature, and when I come to regard the works in which proofs of such understanding would be evinced, I feel sure Nature was a closed book to her. It must be said at once that her powers were limited, for outside portraiture she was a failure—the more patent on account of the great gulf that separates such works as "The Day Dream," "Tennyson," "The Kiss of Peace," from the "Three Fishers," "Paul and Virginia," the illustrations to the "Idylls of the King," and such trivialities, as several of the fancy studies of children with angels' wings. It is debatable whether such subjects are within the province of pictorial art; and for my part I think that they are impossible to all artists. That they are beyond the powers of photography seems to me conclusive. But if anyone is to succeed with such work as a mere *tour de force*, say, he must have an intimate knowledge of Nature, and be possessed of profound power of expression. The *finesse*, the subtle discrimination and perfect touch required to truly express the sentiment of Nature is possessed by few indeed, be they poets, sculptors, painters or etchers. That essence, that "*subtilitas Naturæ*" eludes all but the most delicately organized beings. The general can comprehend this much as regards music and to some extent in poetry, but in pictorial art they fail to recognize that a picture can be as brutally out of tune as a bad barrel-organ. Mrs. Cameron, then, was not an impressionist nor naturalist, but what is known to some as an "idealist," she saw her models through the old masters' spectacles, fondly, lovingly, joyfully, as a child. She was in no way original, but the follower of good conventions. She endeavoured, it is true, to sound the stops of her model's characters, but the sentiment of the old Florentines would always obtrude itself. She was above all things a humanitarian, she loved her kind and preferred them well-favoured. A great artist she was not, though possessed of talent at times rising almost to genius. Adam Salomon is a petty modeller beside her, and Rejlander is a mere mechanic when compared with her. In photographic portraiture she remains to this day unapproached, and there are no signs of any comer to dispute her towering supremacy. Imitators there are in plenty with all things but artistic ability, better class mechanics with superficial knowledge and a brutal sort of apprehension abound, but none others, and such works as "The Day Dream," "Tennyson," "Kiss of Peace," "Mrs. Jackson," "Joachim," "Christabel," "Florence," and "Œnone," are the only "old masters" photography has to boast of: that is, according to my appreciation. I can only finish by expressing the futile regret that I did not know Mrs. Cameron, and consoling myself with her best works, which are engraved in my brain as deeply as the memory of her noble nature is enshrined in my heart.

P. H. Emerson.

LIST OF PRINCIPAL WORKS, WITH NOTES.

Mrs. Cameron's works were formerly on sale at the shop of P. and D. Colnaghi, the printsellers. They are still to be obtained of her son at 70, Mortimer Street, Regent Street, W., price 10s. 6d. each. Unfortunately, many of them suffer from retouching, and working up. We shall briefly note the principal works.

Portrait of the late Charles Darwin. Not a very successful picture, although Mr. Darwin was very pleased with it.

Portrait of the late Robert Browning. One which pleases me no better, there is a theatrical air about the work which makes it poor art. This was taken at Little Holland House.

Portrait of Mr. Alfred Tennyson. (Photo-etching by my friend W. L. Colls given herewith is reduced from $10\frac{1}{2} \times 14$ size.) A masterly work, with all the breadth of effect and vigorous simplicity that belongs to great art. Reminds me of Velasquez. Taken in 1869 at Freshwater, Isle of Wight.

Portrait of the late Sir John Herschel. A wonderful portrait of old age, and according to Sir Henry Taylor, of the man. (Photo-etching by W. L. Colls given herewith is a reduction from $10\frac{3}{4} \times 14\frac{1}{4}$ size)

Portrait of the late Henry Longfellow. A fine profile, but looks posed.

Portrait of the late Sir Henry Taylor. One of her earliest works, and one of the best. Recalls Leonardo da Vinci in its elaboration, lighting, and sentiment. A great work in many ways.

Portrait of the late Thomas Carlyle. Taken at South Kensington. A good impression of the man.

Portrait of Lord Overstone. A capital natural picture.

Portraits of Mr. Watts and Miss Thackeray I do not care for. They are noisy, and lack the simple dignity and repose of her best work.

Portrait of Mrs. Jackson. Looks exactly like a photograph from an old master, is wonderful in sentiment and decorative quality.

Portrait of Herr Joachim. A masterly work, treated with all the dignity and art of Mr. Whistler's " Sarasate." This is not too high praise.

The Kiss of Peace. (Photo-etching by Mr. W. L. Colls given herewith is reduced from $10\frac{1}{2} \times 13\frac{1}{2}$ size.) A picture instinct with delicate observation, sweetness and refinement. One of the noblest works ever produced by photography.

Maud. This is a popular picture, I believe, but personally I do not care for it. It possesses a sentimentality and lack of decorative feeling that displeases me.

Sunrise is fine in sentiment. Miss Rachel Gurney sat as model for this picture.

Portrait of Mr. Ewan Cameron. A splendid head, full of life.

Christabel. A great work, suggestive of the meaning of nature. Recalls Holbein at his best.

Florence. Another masterly work, recalling Titian in some points, in others Holbein.

Cupid's Pencil of Light. An interesting and beautiful study of the nude taken in the studio with the sunlight streaming through the glass upon the figure. The descending rays of light are produced by withholding the 'cyanide' at the proper moment, and the effect is marvellous. Altogether a most artistic picture.

Call and I follow I find a little unreal.

The Day Dream ranks with the *Tennyson,* or perhaps surpasses it. It is full of the profoundest expression, together with the simplicity, dignity, and impersonal greatness of style that belongs to the masterpieces of the world. (The photo-etching by W. L. Colls given herewith is reduced from the original which measures $9\frac{3}{4} \times 13\frac{3}{4}$ inches.)

Portrait of Mr. Norman recalls the dignity and quality of Rembrandt.

Portrait of the late Hon. Frank Charteris. Of the same quality and style as the Mr. Norman.

Œnone. A beautiful face and fine picture, a little poor in modelling.

The Rosebud Garden of Girls. An ambitious work, full of the naïve sentiment of the early Italian masters coupled with the delicate observation and masterly drawing of modern work. It is a picture that does not give me so much pleasure as others I have noted.

The illustrations to the " Idylls of the King " can be seen at the British Museum. They were published in 1875 by Henry S. King and Co. The book contained one portrait of Lord Tennyson, and ten plates, and was dedicated by permission to the Crown Princess of Germany and Prussia. Dated Freshwater, Isle of Wight, Christmas, 1874. There are in addition some eulogistic verses on Mrs. Cameron and her work by Sir Henry Taylor.

Every portrait photographer in the world will do well to hang in his studio such classical works as the " Tennyson," the " Mrs. Jackson," the " Joachim," the " Kiss of Peace," " Sunrise," " Mrs. Ewan Cameron," " Christabel," " Florence," " The Day Dream," " Mr. Norman," and " Œnone,"—a dozen pictures that would teach him almost as much as reproductions of the great masters of portraiture—Titian, Velasquez, Holbein, Rembrandt, Gainsborough, and Whistler.

P. H. E.

Chiswick, August, 1890.

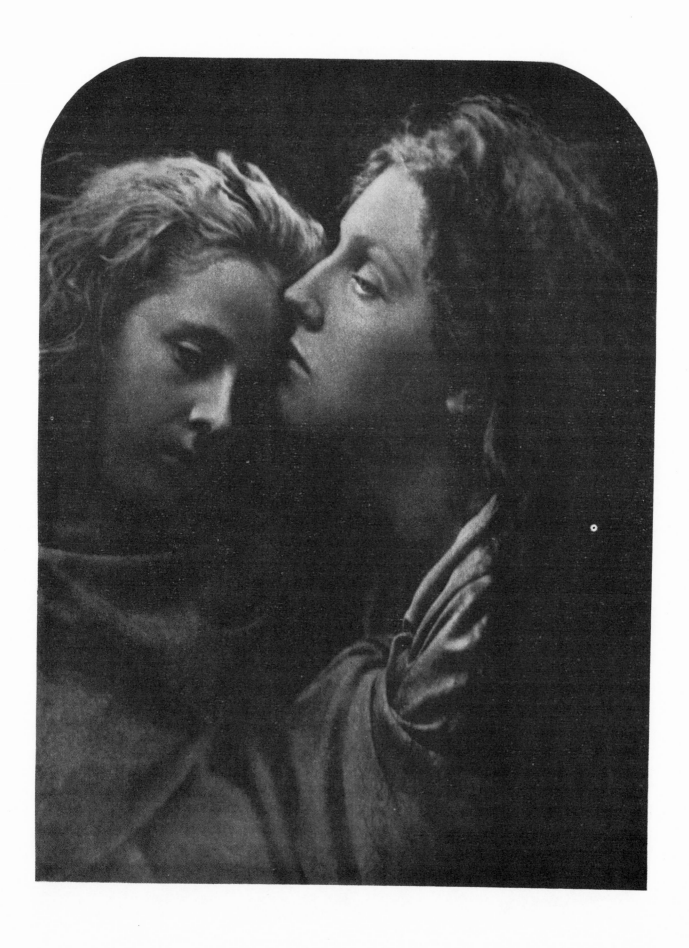

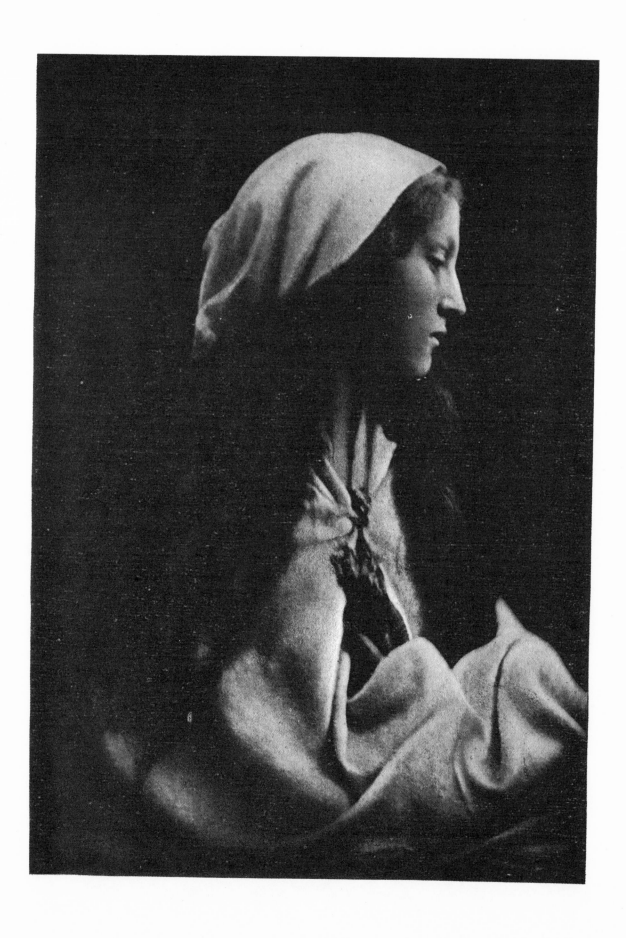

PRESS OPINIONS.

". . . We have received Part III. of 'Sun Artists.' The present issue deals exclusively with the life and work of Mr. J. B. B. Wellington. . . . His figure-subject 'The Broken Saucer' is exceedingly pretty, the tones very refined, and the attitude of the woman as graceful as it is original and picturesque. . . ."
SATURDAY REVIEW.

" We welcome two pretty photographs this No. 1 contains. 'Brixham Trawlers' has, in its vagueness, something of the charm of mystery."—ATHENÆUM.

". . . The fishing smacks, the rustic scenes, and the typical foggy day on the Thames, are certainly excellent specimens of the art. . . ."—MORNING POST.

". . . Great taste and skill have been expended in connection with the 'get-up' of the magazine. We have an artistic cover, excellent paper, good printing, and, above all, four beautiful plates. . . ."—SCOTSMAN.

". . . The four plates do ample justice to the finely finished pictures. . . . The descriptive text is lively and interesting, and no pains have been spared in the preparation of 'Sun Artists.' . . ."—DAILY CHRONICLE.

". . . The four plates are beautiful productions. . . ."—ILLUSTRATED LONDON NEWS.

" An addition, and we think a valuable one, to the ranks of the illustrated magazines is 'Sun Artists.' . . . Altogether 'Sun Artists' is a handsome and attractive quarterly periodical."—THE GRAPHIC.

". . . The high water mark of modern photography. . . ."—ART JOURNAL.

". . . Four reproductions are given : clever studies in which the eye of the artist has had as great influence as the manipulation of the photographer. The scenes are most excellently reproduced in photogravure. . . ."
THE ARTIST.

". . . In composition, delicacy, softness, equable tone, avoidance of harsh effects in contrast, fore-shortening, etc., too often the bane of the photograph-picture, these examples are wonderfully fine. . . . Type, paper and general 'get-up' are all that can be desired. . . . Should certainly do much to advance artistic photography."
PALL MALL GAZETTE.

" Exceedingly interesting . . . everything possible has been done to make the work attractive."
MAGAZINE OF ART.

". . . We can but wish it all success. It is made up of eight large pages of exquisite printing upon Dutch hand-made paper. . . . Four plates of much merit are given. . . ."—THE QUEEN.

". . . It would be difficult to find anything of its kind more enchanting than the pretty scenes of field and water, horses, men and boats. . . . Indeed the whole 'get-up' of the magazine is luxuriantly artistic. . . . If 'Sun Artists' justifies the high expectations awakened by its first issue, it will indeed be a welcome addition to the art journals of the day."—MANCHESTER EXAMINER.

". . . We cannot conceive of any work of even the most skilful engraver which, if put upon the etching of 'Sleepy Hollow' could improve it in the slightest degree. The text matter is of the most racy character. . . . 'Sun Artists' is sure to take well, for never before has such an admirable five shillingsworth been offered to the public. It is of large size, and well printed on fine hand-made paper. . . ."
BRITISH JOURNAL OF PHOTOGRAPHY.

". . . This handsome publication. . . . It is almost needless to say that the work is admirably produced, and will, no doubt, find its way into every photographic library where good things are treasured."
THE CAMERA.

". . . This publication is already famous. . . . It is a step in the right direction, the first number alone is sufficient to disprove the not uncommon assertion that photography can never be a fine art. . . . The whole set should compose a very valuable collection, and we think that every member of the club ought to make a point of securing copies from the commencement. . . ."—CAMERA CLUB JOURNAL.

". . . We are glad to welcome a new serial called 'Sun Artists.' We may confidently say that we have never seen anything of the kind more perfect in point of general effect or of detail. . . . 'Sun Artists' ought to make its way."
YORK HERALD.

". . . Everything skill and taste can contribute to success has been brought to bear upon 'Sun Artists.'"
BRISTOL MERCURY.

". . . The first number of 'Sun Artists' is certainly a 'thing of beauty.' The four plates reproduce photographs good in themselves, and beautifully represented here. The letterpress is interesting, and the whole 'get-up' of the issue most luxurious. 'Sun Artists' can hardly want friends. . . ."—YORKSHIRE POST.

". . . Their delicacy and beauty are very remarkable. . . . We have no hesitation in saying that these plates place photography in a higher position than it has hitherto held in public estimation. 'Sun Artists' will be not only a handsome publication, but one of genuine artistic value."—NORTH BRITISH DAILY MAIL.

"'Sun Artists,' the fine photographic art journal which has been spoken of so highly by all the European journals, has reached us. We cannot speak too highly of the publication."
THE PHOTOGRAPHIC TIMES AND AMERICAN PHOTOGRAPHER.

". . . This periodical takes new ground. . . . We heartily wish it a well-deserved success."
BIRMINGHAM DAILY POST.

" An extremely beautiful new quarterly. . . . 'Sun Artists' shows the artistic heights to which photography has attained. Nothing more beautiful has ever been presented to an art-loving public than this handsome new periodical, with its four etchings in 'Art Journal' style, on which 'all hand work has been scrupulously avoided. . . .' Pains have not been spared with the letterpress of 'Sun Artists,' the type having been cast from punches cut by Caslon in 1720."—EAST ANGLIAN DAILY TIMES.

". . . The second number of 'Sun Artists' is admirable. The four plates are simply matchless as specimens of photo-printing. Anything more delicate and beautiful of their kind than these pictures could not be desired. The success of this most artistic publication must now be thoroughly assured."—GLASGOW HERALD.

". . . Four charming examples ; all of them beautiful and artistic pictures."—SUNDAY TIMES.

". . . The plates are thoroughly artistic in workmanship, and the subjects interesting and attractive. . . . They well deserve to rank as fine art."—THE GLOBE.

" Four pictures of considerable beauty. They might well form component parts of a new 'Liber Veritatis,' and they demonstrate clearly enough that photography is something more than a mechanical art. . . ."
BIRMINGHAM POST.

" The third number of this handsome and attractive art publication is devoted to the reproduction of photographs by Mr. J. B. B. Wellington. These show what enormous progress has been made by photography as an art. This publication should be in favour with lovers of art."—GLASGOW DAILY MAIL.

"'Sun Artists' keeps well up to the worth and promise of the first number. We have here what is incomparably the best work in artistic photography."—LEEDS MERCURY.

Chiswick Press

PRINTED BY CHARLES WHITTINGHAM AND CO.
TOOKS COURT, CHANCERY LANE, LONDON, E.C.

NUMBER 6.

JANUARY, 1891.

SUN ARTISTS

MR. B. GAY WILKINSON.

With a descriptive Essay
BY THE REV. F. C. LAMBERT, M.A.

HON. EDITOR:

W. ARTHUR BOORD.

KEGAN PAUL, TRENCH, TRÜBNER & CO.
(LTD.), 57 & 59, LUDGATE HILL, E.C.

NOTICES.

CONTENTS OF NUMBERS ALREADY ISSUED.

No. 7 will be published in April next, and will contain photogravure reproductions of pictures by

MR. J. E. AUSTIN.

With a descriptive essay.

A limited number of signed unlettered proof copies, on India, will be issued.

A few signed proof copies of numbers 2, 3, and 4, suitable for framing, are still in hand, application should be made to Temple Chambers.

Descriptive leaflets can now be obtained of all booksellers throughout the kingdom. Leading Press opinions appear on the third page of the cover.

All communications relative to this Serial should be addressed to

THE HON. EDITOR
"SUN ARTISTS,"
7, TEMPLE CHAMBERS,
TEMPLE AVENUE, LONDON, E.C.

PORTFOLIOS.

A DEMAND for Portfolios to contain unbound copies of "SUN ARTISTS" having arisen, a supply has been placed in the hands of the publishers.

Stout boards, paper sides, linen back, with tapes, to hold eight copies (two years' issues), 3s. 6d. each.

TO HOLDERS OF SIGNED INDIA PROOF COPIES OF No. I.

The Hon. Secretaries, being desirous of accommodating a subscriber, will be prepared to give One Guinea for a Proof Copy of Part I. if delivered to Temple Chambers in good condition, during January, 1891.

ADVERTISEMENTS.

Applications for space in these wrappers should be accompanied by a draft of the proposed advertisement, the proprietors reserving the right of refusing unsuitable matter. Under no circumstances whatever will announcements be accepted for insertion in the matter pages. Full particulars as to price and circulation, etc., can be obtained from Mr. G. Reddick, 12, Furnival Street, Holborn, E.C.

MR. B. GAY WILKINSON.

IT is a well-worn maxim that "the busiest man finds the most leisure"; nor would Mr. B. Gay Wilkinson, whose pictures are now presented to us, seem to offer any exception to this aphorism. Possibly he is wise in his generation, thinking that the most grateful relaxation is not to be found in an aimless indolence, but rather in that change of occupation, which, while giving ample scope for the powers of mind and body, yet brings with it its own reward and wages in the consciousness that it is something done for its own sake, pleasant to the doer and worth the doing.

It is more than interesting to note at the outset that Mr. Wilkinson preserves in his name that also of Gay, with whom he has community of blood and lineage. John Gay, a contemporary of Pope, to whom as a friend and admirer he dedicated his first important work under the title "Rural Sports," was a poet born, *nascitur non fit*; and one who contributed by no means an unimportant part in the formation of taste and morals at the time when "men's minds ran rampant" in the South-sea-bubble blowing epoch, a bubble which, alas! swallowed the fortune which an appreciative people paid Gay for his two volumes of poems published in 1720.

How far Benjamin Gay Wilkinson, his successor in name, is also his successor in poetic fancy as a word-painter is a question upon which we cannot enter here: but that he has some measure of the poetic fantasy in nature's boundless store the accompanying pictorial expressions abundantly prove. What first induced Mr. Wilkinson to use the camera as a means for finding expression of his "loves and fancies," he himself can scarcely say; but he generously expresses an unbounded appreciation of, and grateful acknowledgment to, Mr. J. Gale, under whose ripened experience and cultured taste Mr. Wilkinson had the good fortune to shelter his own earlier efforts. The observant will probably see in the accompanying picture, entitled a "Windy Corner," an indescribable something which, for want of a better name, we may call "Gale influence," and in a perhaps somewhat less marked degree in the picture which is entitled a "Pastoral." Like so many modern photographers Mr. Wilkinson is but a David in years, born in London in 1857— and since the age of discretion chiefly occupied in a professional calling which admits of but scanty leisure, with an occasional holiday snatched at a moment's notice when the sterner duties of life permit his absence for a while. His first plunge into the photographic sea was made some twelve or fourteen years ago, and took the form of what is known to most of us as "wet plate work." This process was of course soon abandoned for the "dry plate" of commerce: although for the production of lantern transparencies (for which Mr. Wilkinson is so well and widely known) he at times returns to his first

love. In the matter of apparatus he seems to have no very special predilection—as a matter of general custom using a rapid symmetrical lens of about nine inches focus for his 7 x 5 plates and a single Grub lens of twelve inches focus for the 10 x 8 work.

For some years past he has been an active and productive member of the Amateur Photographic Field Club, of which enthusiastic and well-known Society he was unanimously elected Secretary and Treasurer some two years ago—offices which he still holds. He has travelled far and wide in search of the picturesque—but for the most part finding the more congenial subjects, either " 'long shore," or on the breezy downs of Sussex, etc., and picturesque bye-paths of unrestored English homesteads in out-of-the-way villages of Kent, Surrey, Sussex, Essex, Bedfordshire, Cornwall, Devon, and Yorkshire.

To turn for a moment to our four typical examples of Mr. Wilkinson's productions. It is no part of the present writer's duty to attempt anything approaching laudation or criticism; nor would either function be other than superfluous, seeing that in the former connection we have the pictures to bear witness to themselves; while in the latter it is a matter of almost universal acceptation that criticism is synonymous with fault finding, which last named operation is often easy enough, and as often the more gladly undertaken in that spirit which builds itself upon the shattered ruins of a demolished castle, be it real or imaginary: whereas criticism, which really should only exist by reason of its absolute verity and perception, is of service only when it is at the same time suggestive and interpretive of, as well as stimulative to, good works. Nevertheless, the following notes may at least serve to give further interest to the pictures now presented for our especial notice.

Taking the pictures in the chronological order of their production, we first have " A Windy Corner," produced some three or four years ago—in the month of April, when, in place of the showers especially appropriated by poets to that month, Mr. Wilkinson had a "tearing" wind, the evidence of which may be seen in the tree tops. It was a general consciousness of the picturesque which was in this case the chief source of attraction.

Next in point of time comes " Prawning." This was produced in February, now nearly three years ago. A strong sea breeze, carrying light clouds across the sky, was now and again permitting gleams of sunlight to play upon the weed-clothed rock and glancing round the oil-skin garments of the Prawner as he gathered up with deft fingers the nimble captives in his net; the whole forming a common enough scene to those who are familiar with that part of the Sussex coast here represented, and is as welcome and grateful as the face of an old and loved friend.

And now we come to " Sand Dunes," a sea of sand with wind-born ripple-marks— the study of which have taught geologists so much. Note, too, that here we have the constructive power of herbage seen as though in action, gathering sand and forming a new continent. This stretch of South Devonshire coast was found in the course of a very hot afternoon's walk in August last, and the " find " entailed a walk back of a couple of miles to fetch the camera. The idea, which in the first attracted notice, was the utter desolation, dreariness and solitude of an expanse of sand, as it lay, wave after wave, receding into the far distance.

The last of the series brings us close up to the present times, seeing that it dates no further back than October of this year. Some time ago Mr. Wilkinson's poetic fancy had

been caught by Milton's musical words, " Where the nibbling flocks do stray," (L'Allegro, l. 72), but Fortune presented no propitious opportunity until a few months ago, when "Zephyr with Aurora playing," in the morning following a dew-laden night, brought shepherd, sheep and sheep-dog together under favourable circumstances. It would seem as though the dog entered into the spirit of its duties of assigning some limit to the straying flock—and while his ears were " pricked," a half second's up-lifting of the Lens cap secured " A Pastoral," such as, alas! is growing rarer day by day, as our hills are being, one by one, quarried and tunneled out of all knowing.

A few points in Mr. Wilkinson's customary practice call for some precise notice. The first of these may be surmised and to some extent verified by examination of the illustrations accompanying this number, viz., that as a general rule he concentrates his attention of mind on the principal object or group of objects in his picture, and uses such a diaphragm in the lens as will give him the sharpest focus possible under the particular circumstances of the case, taking into his calculations the probability of movement in the important part of the composition. In those cases, however, where the interest is not especially concentrated upon any one part or group, but is more or less spread and diffused throughout the whole, then he, with what appears to be a sound and rationalistic basis, equalizes more or less the sharpness of definition throughout the whole scene. Thus the sharpness, clearness, distinctness, with which the parts of the picture appeal to the eye, are well calculated to call up corresponding mental images, which shall have their parts placed in relative importance in such manner, as to have a proportionate bearing to the corresponding impression received from without, *i.e.*, the optical and mental impressions if not coincident shall at least be commensurate and correlative. Herein I for my own part venture to express opinion that this is a procedure which has in its favour not only a presumably sound logical basis, but has also the additional attraction of a satisfactory issue when brought within the arena of daily practice. Another matter gleaned from Mr. Wilkinson's account of his usual procedure is suggestive, viz., his practice of " prospecting" for pictures. He will often take a ramble unaccompanied by any apparatus, simply with a view to seeing some previously noticed district, and patiently examine it from various standpoints, and under various atmospheric conditions, returning, if need be, again and again, until the best, and to him the only favourable conditions, have been arrived at.

One other common sense custom of his observes careful attention, and in this respect actual imitation is not only pardonable, but highly commendable, viz., the very proper step of winning the confidence of the human element of the picture. If there is one characteristic which above all others may be said to characterize the great majority of so-called figure pictures, it is the painfully self-evident consciousness and " gawkiness" of the figures. Nor is this to be wondered at in any measure, seeing that in almost every case the figure and the operator are brought together in this relation without any previous knowledge of each other. Not only are they unknown to each other, but what is still more disastrous, they are, in the majority of cases, out of all harmony with each other, with practically no aim in common, and not infrequently is the figure entirely out of harmony with his surroundings. What wonder, then, that the figures are betraying by every angular contortion of limb that for the moment they assume an attitude which is as strange and new to them as the operation in which their efforts are to form an

essential element. They are instructed to pretend to do something which has no precedent, outside the fertile brain of the inventive artist; what is more natural than that they should betray themselves to be as sham as the actuating sentiment. Well may one pardon such a victim were he to quote

> " Like a dull actor now
> I have forgotten my part and I am out
> Even to a full disgrace."

Much, if not all, of this can be easily avoided, or, at the worst, materially modified for the better, by following the common sense method of first making the acquaintance of the proposed figures, and learning by means of patient ear what are their likes and dislikes, the way they follow the daily round of toil, the use of each tool of their craft, and the precise manner of using it : all this and much more in a similar direction can be quickly learned by one who has patience to listen, and be content to let a man do his work in a workman-like manner, instead of attempting to teach him a trade of which both teacher and learner are equally ignorant. By following the natural order of his proceeding when actually at work, a sympathetic and observant eye will quickly learn to select just those moments of transient rest where all the lines of the body by long usage have acquired a grace together with a suggestion of potential action. This being not so much the critical moment of the action as it is the characteristic moment, and probably the chief moment of transition wherein the spent forces of the past are being restored in a relaxation of muscular effort, together with a renewal for a more important part yet to follow. In a sense this may be called the self-interpretive or historic moment, and manifestly is the chief one for pictorial purposes, so that its discovery can only be made by those who throw to the winds any preconceived notion of how this or that *ought* to be done, being content—nay, rather—preferring to observe how nature, custom, and convenience has decreed that it must be and *is* done.

To secure this obviously important knowledge requires no great logical power for deducing the conditions of favourable acquirement. Clearly, any irregularities—strange clothes, tools, surroundings, etc.—are certainly well calculated to divert the thoughts of the worker (*i.e.*, the model in action) from his work. Still more the consciousness that he is being watched for some strange, uncanny purpose and process. This sets his torpid imagination wondering, so that we often enough see photographs representing men performing with their hands some operation in a half-mechanical manner, while their eyes are fixed with a wondering and glassy stare on the operator or his camera. Again, any feeling of " strangeness " between model and picture-maker is sure to find its way to the surface in some unfavourable manner. So that we may, without much risk of controversy, say that one important round of the ladder which leads to success is that of gaining at the outset the confidence of the model, in order that he may carry on his work in front of you with as much easy and natural movement as though you were non-existent as far as he is concerned. So far I find Mr. Wilkinson's recent practice in accord with what seems desirable *per se*.

It may be remembered by some of my readers, that I have made some effort to attract the attention of thinking men in the direction of developing that spark of originality which seems to be rarer in its cultivation than in its bestowal. Some of the suggestions

therein thrown out with a somewhat reticent tentativeness may here conveniently be followed up in other side channels. Assuming then for our immediate purpose that the honest worker will ever carry on his shield the motto, "To thine own self be true," we at once find ourselves expressing the obverse of this motto, in the one word sympathy. At this point it may be advisable to extend the ground which this term shall be held to cover, to something more than gaining an easy confidence of the human contributors to the pictorial efforts, and for present purposes let the term expand in such manner as to include all those subtle influences which appeal to our sense of beauty, by arresting and partaking of the stream of affection, which runs as a golden thread through the darkest of human lives, though oftentimes its river banks are shaded to a gloomy depth with the sable leaves of sorrow, pain, and disappointment. Let the mind's eye wander for a moment among the sculpture of Greece in her best times, and consider the question— How did these rude people in such uncivilized times produce works of art which have since then never been equalled? The answer surely lies in the one word sympathy. Their mythology, the realistic attributes of their gods, gave them powers of mind which we can but very dimly understand. Zeus, Athene, Here, Ares, and the rest, were not to them, as we too often suppose, merely anthropomorphic envelopes for a deity. Their various divine attributes were incapable of being confined by wood or stone, but intense sympathy with the nobility of these divine attributes seized the mind of the sculptor so completely that his life, hope, and work were but an echo of those things which most strongly grappled his soul in bonds of sympathy. Look again at the early ecclesiastic art of Italy; it is also a reflex of those impulses of mind which were paramount at the time. The subjects which they treated—which for all practical purposes represented the only art efforts of the time—were but a necessary echo of those things which gained their heart, and so guided their hand.

Wherein lies the "*fons et origo*" of that universal adulation which every intelligent mind pays to the works of Shakespeare? To prince and peasant alike his words appeal because there is in them that intimate reflexion of those subtle influences which guide the hearts and lives of all men. His words appeal to all because they "speed the soft intercourse from soul to soul," and with invisible fingers sweep the strings of the heart, making sweet music with that "one touch of nature," which "makes the whole world kin." At first sight perhaps one might be disposed to say that sympathy is by its nature confined to the human element of life. But the writings of many poets, and the pictures of many artists, all tell another tale. Although it is admitted that the proper, the especial and most engaging study for most men is mankind, yet it in no wise follows that the *non*-human part of Nature is *contra*-human. On the contrary the lives and writings of such true disciples of Nature as Wordsworth and Kingsley show those studies to be the most refining and perfectly calculated to engender a delicacy of sympathetic feeling almost *super*-human. When Parry said, "The effect of beauty is to engage affection, and its power is irresistible. We love what is beautiful, and we cannot love what is hideous," he was but enunciating a law which we all as children obeyed, yet "knew no law." Until the false money-standard of value crept in, we hitherto valued our flowers, our pets and our homes for just what was to us beautiful in itself. Although Byron's words were not written with reference to a child's natural impulses, yet they are in great part true thereof:—

" I live not in myself, but I become
Portion of that around me ; and to me
High mountains are a feeling . . ."

Once again let us turn to the early life of almost any of the great artists of the past. In how many instances do we not find the same story—of their being started in various uncongenial callings, although showing, as youths, great graphic talent, and sooner or later the governing impulse of their first love making a way for them to follow that path which alone engaged all their powers, because it had already absorbed their chief and leading sympathies. To turn the pages of the past and take them at random, we have Claude Lorraine, the pastry-cook ; Tintoretto, the dyer ; the two Caravaggios, the one a colour grinder, the other a mortar carrier ; Salvator Rosa, the associate of bandits ; Giotto, the peasant boy ; Zingaro, the gipsy ; Canova, the stone-cutter ; Benvenuto Cellini, the goldsmith ; Barry, an Irish sailor-boy ; Maclise, a banker's apprentice ; Opie, Romney, Inigo Jones, carpenters ; Northcote, a watchmaker ; Jackson, a tailor ; Etty, a printer ; Laurence, son of a publican ; Turner, son of a barber ; and so on runs the same story. How then came it about that with such an unpromising start in life did one and all ultimately reach a common goal of success ? Surely there is an open secret in the lives of all these men, viz., concentration of their thoughts and wishes upon that which they felt to be the one engaging impulse of their appreciative powers. Their sympathy was in each case with what is beautiful. To them the beautiful became the good and the desirable ; and therefore the only thing on which energy could be properly spent. If then this element played such a part in forming the characters of those who should be to us not only guides but helpers, we cannot be far from the mark in asking the question—To what extent does sympathy enter into the governing impulses of our own courses ? Further-more, before a proper answer to this pertinent inquiry be found, there must be taken into account all the probable disturbing elements, such as a false standard of excellence, and the very general impulse towards imitation of what gains public attention without due regard as to how far our own natural and unbiassed honest likings and judgments can concur in the popular verdict. "He that seeks popularity in art," says Mrs. Jameson, " closes the door on his own genius ; as he must needs paint for other minds, and not for his own." Whether it be an absence of what we call genius, or a blind follow-ing of those who for the moment by chance strike a spark with the steel edge of some eccentricity upon a flinty-headed unthinking public, it matters not for our present purpose to inquire, we are content to observe the result, viz., that each photographic exhibition of the year contains distant and feeble imitations of some effort which for the moment has been left high and dry by the tide of novelty's fancy. It is a very old but none the less true saying, that a work of art is at once a thrice blest effort, inasmuch as it is conjointly a work of beauty, of labour, and of love. Take away any of the legs of the tripod, and its precious burden will fall.

Of what beauty consists, it has baffled all men to say, it is a strange mystery, an invisible, intangible binding-thread which connects impressions of forms and colours, received from without, gathers them together as pearls upon a thread and weaves ideal associations, having a forceful existence, but only from within. Like as in music and sculpture, the poetry of sound and sight, there is rhythmic form and structure

which is the very imponderable substance of which the thread of beauty is woven. Like that strange substance "such stuff as dreams are made on," which exists and yet is not, though beauty is that which we cannot express, it is yet the end and aim of fine art to express it in all its various forms and conceptions—an embodiment of that which is created with and from impulses received from without, realistically conceived and ideally wrought.

Next, of labour. As that which we call genius is better termed "an infinite capacity for taking pains," so then work which is great in merit, whose greatness is in itself because of itself, is also a work which is great by reason of the labour, skill and knowledge expended on it. As John Sebastian Bach said of himself, "I was industrious; whoever is equally sedulous will be equally successful." So also when Beethoven, receiving the pianoforte score of "Fidelio" from Moscheles, turned to the last page, and finding subscribed, "Finis with God's help," immediately added, "O man! help thyself!"

Thus may we almost always find those who have produced great work to be also indefatigable, indomitable in perseverance, and not seldom prolific in production. Call to witness the almost numberless sketches and studies of Turner's which have been preserved, the countless pages of Sir Walter Scott, of Shakespeare. "Whatever is worth doing," says Lord Chesterfield, "is worth doing well," and that it may be well done needs our best, our very best efforts.

Now of the third and last element, though in no wise inferior to the others, Love. It is not enough to say that the worker must love his own works, but rather that it is by very reason of his loving that which he would have them be, that they exist at all. To go back a moment in order that one may gather up some dropped threads, it may be said that the first effort is to be true to oneself—to follow that bent, and cultivate that which each feels is his own from within. Next, to see with eyes and not through the borrowed spectacles of any master or school. Then to cultivate those influences, which to each seem the essential element, whether it be of storm clouds, pastoral scenes, story-telling pictures, portraits, or what not; for some are sure to find a stronger echo in the eye and heart of the beholder than others. By much seeing and often thinking some fuller knowledge and power will come : but there is seeing and seeing; and moreover, learning to see is like all other learning, a matter of time and patience, with keen application. With many, perhaps the majority, there are but two kinds of skies, a blue sky or a cloudy sky; as to clouds, there are rain clouds and wind clouds : as to flowers, there are wild flowers, and flowers that cost money. These are they who seeing see not, of such an one Wordsworth said :

"The soft blue sky did never melt
Into his heart; he never felt
The witchery of the soft blue sky.

* * * * *

"A primrose by a river's brim
A yellow primrose was to him
And it was nothing more."

For such as these the artist does not work. It is not for the deaf man that the musician pours forth his poetry of sound. For one to understand, to feel, to love the works of others, one must at least know the symbols of their language. But the deeper the

knowledge of all that nature can teach, the firmer grows the demand for what is worth knowing. " Drawings ought always to be valuable," says Kingsley, " whether of plants, animals, or scenery, provided only that they are accurate ; and the more spirited and full of genius they are, the more accurate they are certain to be, for Nature being alive, a lifeless copy of her is necessarily an untrue copy." Or as Ruskin has again and again pointed out, the more knowledge of a thing a man has the better artistic work will he make. " Painting," says he, " with all its technicalities, difficulties, and peculiar ends, is nothing but a noble and expressive language, invaluable as the vehicle of thought." He also in another passage points out how Athena was not only the clear air, the spirit of beauty and art, but also " the great helpful spirit of wisdom which leads the children of men to all knowledge, all courage, and all art." True is it that in many cases knowledge gives power, but equally true is it that real knowledge brings a humble adoration. " It is the love of that which your work represents," says Ruskin, " if, being a landscape painter it is the love of hills and trees that moves you—if, being a figure painter, it is the love of human beauty and the human soul that moves you—if, being a flower or animal painter, it is love, and wonder, and delight in petal and in limb that moves you, then the spirit is upon you, and the earth is yours and the fullness thereof." Surely then, not least is this element of love for your work, for all that it can teach you, for all the thoughts that it can give you, for all the flights of fancy for which it can give you speed of wing, for all the new world that it can enable you to see with new eyes and feel with larger heart, for all this and more, it is not to be forgotten or despised. The Beauty is there for you to see; the work is for you to learn if you but say, I will; and the love is there, too, for you to draw from and give you a newer, fuller, and higher life; it is that sympathy of all that is worthy of your mind and your adoration which for you

> " Finds tongues in trees, books in the running brooks,
> Sermons in stones, and good in everything."

F. C. LAMBERT.

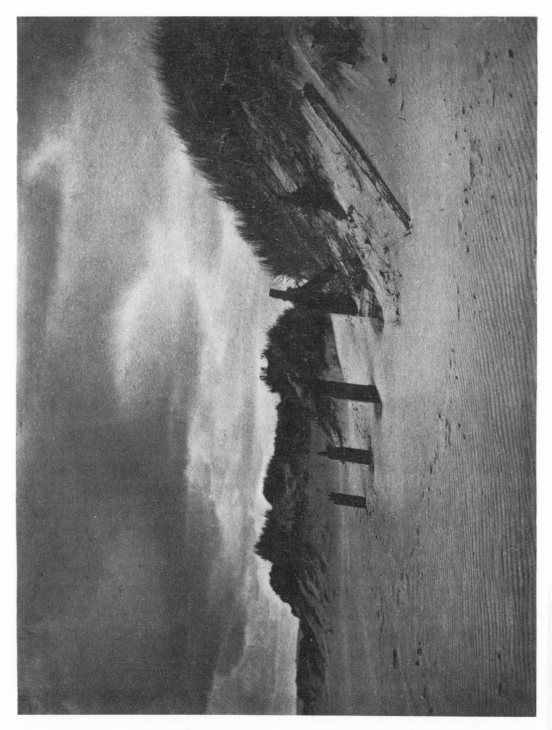

Bay Wichiwan. —

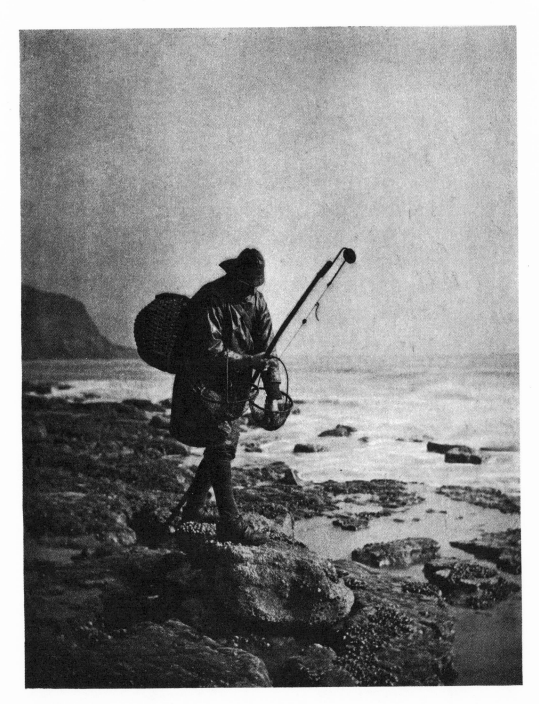

B Gay Wilkinson. —

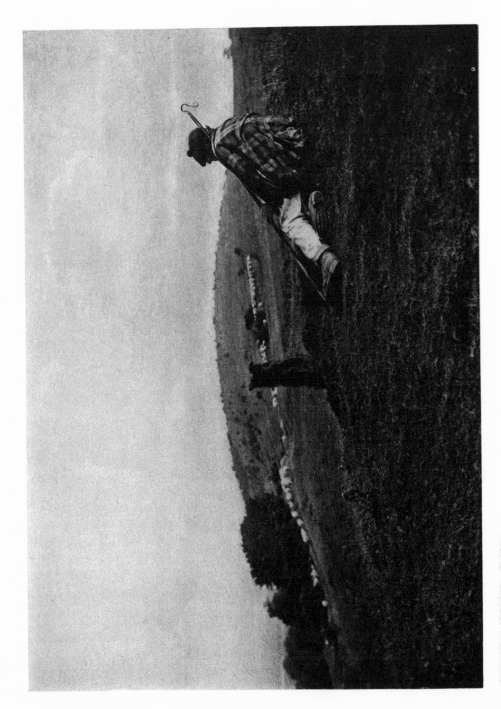

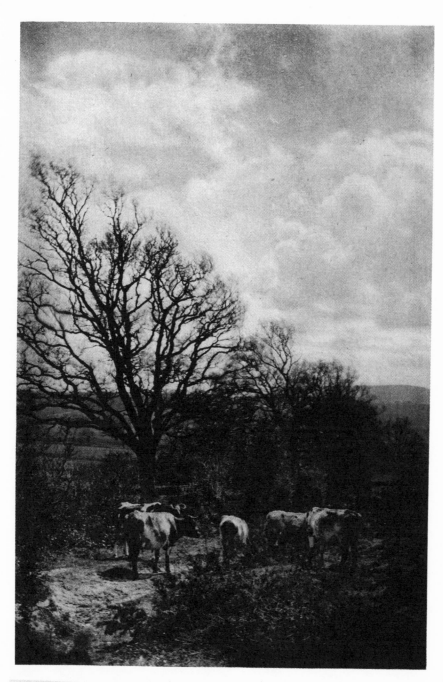

B.Gay Wilkinson. —

PRESS OPINIONS.

"... We have received Part III. of 'Sun Artists.' The present issue deals exclusively with the life and work of Mr. J. B. B. Wellington. ... His figure-subject 'The Broken Saucer' is exceedingly pretty, the tones very refined, and the attitude of the woman as graceful as it is original and picturesque. ..."—SATURDAY REVIEW.

"We welcome two pretty photographs this No. 1 contains. 'Brixham Trawlers' has, in its vagueness, something of the charm of mystery."—ATHENÆUM.

"... The fishing smacks, the rustic scenes, and the typical foggy day on the Thames, are certainly excellent specimens of the art. ..."—MORNING POST.

"*Chefs d'œuvre* of photographic art. ... Incomparably superior to anything of the kind which has yet been produced."—UNITED SERVICE GAZETTE.

"The current number is one of the best which has yet been issued."—SCOTSMAN.

"... The four plates do ample justice to the finely finished pictures. ... The descriptive text is lively and interesting, and no pains have been spared in the preparation of 'Sun Artists.' ..."—DAILY CHRONICLE.

"... The four plates are beautiful productions. ..."—ILLUSTRATED LONDON NEWS.

"An addition, and we think a valuable one, to the ranks of the illustrated magazines is 'Sun Artists.' ... Altogether 'Sun Artists' is a handsome and attractive quarterly periodical."—THE GRAPHIC.

"... The high water mark of modern photography. ..."—ART JOURNAL.

"... Four reproductions are given : clever studies in which the eye of the artist has had as great influence as the manipulation of the photographer. The scenes are most excellently reproduced in photogravure. ..."—THE ARTIST.

"The number before us contains four splendid plates."—FREEMAN'S JOURNAL.

"... In composition, delicacy, softness, equable tone, avoidance of harsh effects in contrast, fore-shortening, etc., too often the bane of the photograph-picture, these examples are wonderfully fine. ... Type, paper and general 'get-up' are all that can be desired. ... Should certainly do much to advance artistic photography."—PALL MALL GAZETTE.

"Exceedingly interesting ... everything possible has been done to make the work attractive."—MAGAZINE OF ART.

"... We can but wish it all success. It is made up of eight large pages of exquisite printing upon Dutch hand-made paper. ... Four plates of much merit are given. ..."—THE QUEEN.

"That delightful *journal de luxe*. ... It is a remarkable example of the progress made in the art of photography."—GENTLEWOMAN.

"... It would be difficult to find anything of its kind more enchanting than the pretty scenes of field and water, horses, men and boats. ... Indeed the whole 'get-up' of the magazine is luxuriantly artistic ... If 'Sun Artists' justifies the high expectations awakened by its first issue, it will indeed be a welcome addition to the art journals of the day."—MANCHESTER EXAMINER.

"... We cannot conceive of any work of even the most skilful engraver which, if put upon the etching of 'Sleepy Hollow' could improve it in the slightest degree. The text matter is of the most racy character. ... 'Sun Artists' is sure to take well, for never before has such an admirable five shillingsworth been offered to the public. It is of large size, and well printed on fine hand-made paper. ..."—BRITISH JOURNAL OF PHOTOGRAPHY.

"It is very gratifying to notice that the high character with which 'Sun Artists' commenced its career is admirably sustained, and reflects great credit on all concerned in its production."—CAMERA.

"... This publication is already famous. ... It is a step in the right direction, the first number alone is sufficient to disprove the not uncommon assertion that photography can never be a fine art. ... The whole set should compose a very valuable collection, and we think that every member of the club ought to make a point of securing copies from the commencement. ..."—CAMERA CLUB JOURNAL.

"The high quality with which this publication started out is still maintained."—PHOTOGRAPHY.

"... The first number of 'Sun Artists' is certainly a 'thing of beauty.' The four plates reproduce photographs good in themselves, and beautifully represented here. The letterpress is interesting, and the whole 'get-up' of the issue most luxurious. 'Sun Artists' can hardly want friends. ..."—YORKSHIRE POST.

"... Their delicacy and beauty are very remarkable. ... We have no hesitation in saying that these plates place photography in a higher position than it has hitherto held in public estimation. 'Sun Artists' will be not only a handsome publication, but one of genuine artistic value."—NORTH BRITISH DAILY MAIL.

"'Sun Artists,' the fine photographic art journal which has been spoken of so highly by all the European journals, has reached us. We cannot speak too highly of the publication."—THE PHOTOGRAPHIC TIMES AND AMERICAN PHOTOGRAPHER.

"They are not only remarkably good photographs—they are genuine pictures, well selected in subject, capitally grouped, and exquisite in gradations and tones."—BIRMINGHAM POST.

"... The second number of 'Sun Artists' is admirable. The four plates are simply matchless as specimens of photo-printing. Anything more delicate and beautiful of their kind than these pictures could not be desired. The success of this most artistic publication must now be thoroughly assured."—GLASGOW HERALD.

"... Four charming examples; all of them beautiful and artistic pictures."—SUNDAY TIMES.

"... The plates are thoroughly artistic in workmanship, and the subjects interesting and attractive. ... They well deserve to rank as fine art."—THE GLOBE.

"It is not enough to say that they do him credit, for it must be allowed that they do honour to the photographic art itself."—NEWCASTLE CHRONICLE.

"The third number of this handsome and attractive art publication is devoted to the reproduction of photographs by Mr. J. B. B. Wellington. These show what enormous progress has been made by photography as an art. This publication should be in favour with lovers of art."—GLASGOW DAILY MAIL.

"'Sun Artists' keeps well up to the worth and promise of the first number. We have here what is incomparably the best work in artistic photography."—LEEDS MERCURY.

𝕮𝖍𝖎𝖘𝖜𝖎𝖈𝖐 𝕻𝖗𝖊𝖘𝖘

PRINTED BY CHARLES WHITTINGHAM AND CO.
TOOKS COURT, CHANCERY LANE, LONDON, E.C.

NUMBER 7.

APRIL, 1891.

SUN ARTISTS

MRS. F. W. H. MYERS.

With a descriptive Essay
BY JOHN ADDINGTON SYMONDS, M.A.

HON. EDITOR:

W. ARTHUR BOORD.

KEGAN PAUL, TRENCH, TRÜBNER & CO.
(LTD.), 57 & 59, LUDGATE HILL, E.C.

NOTICES.

CONTENTS OF NUMBERS ALREADY ISSUED.

No. 8 will be published in July next, and will contain photogravure reproductions of pictures by

MR. SEYMOUR CONWAY.

With a descriptive essay.

A limited number of signed unlettered proof copies, on India, will be issued.

A few signed proof copies of back numbers suitable for framing, are still in hand, application should be made to the Hon. Secretary.

The work incidental to the conduct of this Serial has rendered a change into more commodious chambers imperative.

All Editorial communications therefore should now be addressed to

THE HON. EDITOR

"SUN ARTISTS,"

33, CHANCERY LANE,

LONDON.

Correspondence other than Editorial should be sent to the Hon. Secretary, A. R. DEANE, ESQ., at the same address.

PORTFOLIOS.

A DEMAND for Portfolios to contain unbound copies of "SUN ARTISTS" having arisen, a supply has been placed in the hands of the publishers.

Stout boards, paper sides, linen back, with tapes, to hold eight copies (two years' issues), 3s. 6d. each.

TO HOLDERS OF SIGNED INDIA PROOF COPIES OF No. I.

The Hon. Secretaries, being desirous of accommodating a subscriber, will be prepared to give Twenty-five Shillings for a Proof Copy of Part I. if delivered to 33, Chancery Lane in good condition, during April, 1891.

Descriptive leaflets can now be obtained of all booksellers throughout the kingdom. Leading Press opinions appear on the third page of the cover.

ACKNOWLEDGMENT.

The Hon. Editor, in the name of the promoters of the Serial, begs to return thanks to all those correspondents whose kindly letters of congratulation and appreciation, arriving by nearly every post, are too numerous to acknowledge singly.

It is very grateful to the promoters of the Serial to see the critical opinions of the press endorsed in this flattering manner.

MRS. F. W. H. MYERS.

I HAVE no practical acquaintance with photography. In writing about it, I am therefore forced to take up the ground of æsthetical criticism, and to consider photography both as a handmaid to the fine arts and also as their rival. Practical photographers may perhaps be interested to see the subject treated from this point of view.

It is obvious that photography enters the sphere of the æsthetic as distinguished from the mechanical arts, under the same conditions as monochromatic painting. I say "painting" rather than drawing, because photography, in reproducing the solid objects of the world, can never work by outline. The surface-picture produced is modelled in all its details: with far more literal accuracy, indeed, and far less power of selection, than the art of painting possesses. I say "monochromatic," because up to the present date at least, photography has not been able to reproduce colour. As is notorious, it even falsifies the hues; nor are any of the orthochromatic methods in use for correcting this defect, so far as I have yet observed, quite satisfactory. Under these circumstances photography loses the colour-values of the world, and relies for imitation of reality upon values of light and dark, which it is able to render with almost unerring subtlety, variety, and gradation.

I remarked that photography may be regarded by the æsthetical critic from two points of view: either as ancillary to the fine arts, or as their rival. In its former capacity, the qualities I have described above render it uniquely valuable for reproducing outline drawings, etchings, engravings, inscriptions, inlaid work in wood or marble, niello, chiaroscuro sketches in fresco, tempera, sepia, etc. When we pass to painting proper, the chromatic defects of photography place it at a disadvantage. Photographs of a picture by Titian or del Sarto can never pretend to be more than useful reminders of the composition, outline, dark and light effects, intended by the master. Failing to render his scheme of colour, and to some extent falsifying its relation to chiaroscuro by confusing the specific values of blue and yellow and so forth, the photograph of a great symphonic picture, like Giorgione's altar-piece at Castel Franco, gives less pleasure than dissatisfaction. Good line-engravings are, in some ways, preferable. They do not annoy us by suggestions of the main point missing; and they present the picture translated into the language of another art. Photographs cannot be compared to translations. They are the mechanical *Schatten-Bilder* of objects, over which the photographer loses control, when he has finally arranged them, settled the lighting, and focussed his lens. No independent mental process, analogous to that which gives its value to a translation or an engraving, affects the result produced.

If photography is at a disadvantage in the case of painting, it regains lost ground with sculpture. No one will pretend that drawings from statues are equal to photographs in truth, sincerity, exact and satisfying information. They may be more interesting from the impressionist point of view, as showing how such and such a work of plastic art affected

such and such a draughtsman. But as documents for the study of sculpture, they are obviously inferior to photographs; and a good photograph will often supply essential qualities which are missed in the most perfect casts: I allude especially to qualities of surface-treatment involving sheen and light-reflection.

With regard to architecture, the case is slightly different. A bold and genial drawing of a building has always seemed, to me at least, more full of the real architectural spirit, the life and genius of the work, than photographs can be. Inexorably true to scale, photography dwarfs edifices, as it often appears to dwarf mountain masses. Its incapacity for any kind of selection, except perhaps by some process which involves a blurring of outline, forces upon the photograph a multiplicity of details, many of which escape attention by the natural eye. Still, photographs of architecture, viewed as documents, rank above hand-studies by a draughtsman.

Passing from photography as a handmaid of the fine arts, to photography regarded as their rival, we have to consider how this youngest of the arts of presentation deals with nature. I propose therefore to treat of photographic landscapes, studies from the nude, groups arranged to vie with pictures, and portraits. The last two kinds I have reserved for a final discussion, because this will enable me to review the work of Mrs. F. W. H. Myers in the sphere where it is artistically admirable and historically of permanent value.

In all of these branches photography exhibits the same qualities of strength and weakness as belong to the art in its ancillary function. That is to say, for pure veracity, within the limits of its action, photography is superior to any other representative process. But on the other hand, it suffers from that inability to deal with colour on which so much stress has previously been laid. Moreover, for the highest imaginative or ideal treatment of nature, the photographic artist labours under difficulties through his powerlessness to select, when once the subject has been chosen. The defect of human art work, that of the brain and hand, is that personal qualities specific to the artist are always imported into his transcripts from nature. Consequently pure realism and pure naturalism cannot be expected from painter or sculptor. The defect of machine-work, even when guided by a sensitive artistic instinct, is that it renders fact with unsympathetic fidelity. After the machine has been set in action, it works independently of the human agent. Furthermore, photography can only cope with certain aspects of the world, owing partly to its incapacity to transcend monochrome, and partly to obstacles in the region of perspective, notably aerial perspective. As an æsthetic agent, photography does not appeal to the intelligence in the way that the human brain and hand do. But as furnishing an infinite series of absolutely though partially complete documents, it takes higher rank than the arts of design.

It is not needful to dilate upon the interest and the topographical importance of photographic landscape. We are so dependent on this function of the art now that we can hardly think ourselves back into the condition of our grandfathers. The remotest quarters of the globe are ransacked and brought close to everyone by the photographer. Again, there are certain aspects of the stormy sea and spacious cloud masses which photographic monochrome suggests more forcibly to the imagination than the palette of the painter. But these are not within the purely æsthetic province of landscape. In making a picture, the quality demanded from the photographer is pre-eminently taste—faculty of selection and the feeling for tone. It requires very delicate perceptions in the artist to choose exactly

the right subject, and to foresee what will make a harmonious whole. He has to detach from the broad scheme of the world a portion of its loveliness; and when he has succeeded in doing this, the photographer is often able to demonstrate how far more perfect is nature's composition, in her apparent want of symmetry, than the studied work of landscape-painters upon principle. Amateur photographers not unfrequently exhibit a fine tact for detaching precisely the proper motive for a picture. It seems to me that the professional anxiety to obtain perfectly clear negatives diminishes the purely æsthetic value of the product. Some of the best examples of photographic landscape, combining groups of figures, which I have met with, lie before me on the table as I write. They were made in the Abruzzi by a Bernese painter, Julius Luz, with a detective camera, and have, I suppose, no technical merit. But they are exquisite vignettes, containing more of detail in more perfect balance than a tail-piece by some prince of French or German etchers.

In another place I have spoken at some length about the relation of photographs from the nude to drawings made by painters, maintaining that the photograph of a model is second, the drawing of the same model third in degree removed from the truth and subtlety of nature.* In this province, as it seems to me, photography is best able to compete with the plastic arts, just as it reproduces their creations best in the sphere of sculpture. The most skilful draughtsman cannot vie with the photographer in rendering the muscular structure of a well developed nude, the play of light and shade upon the skin-surface, and the texture of the flesh. The ablest painter is unable to place a figure against some simple background, say of discoloured or time-worn plaster, and to detach it as completely as the photographer may do, without hardness of outline, without sacrifice or forcing of values. It is impossible to model the nude with equal roundness and with equal economy of tones. Since I published the essay referred to above, my views upon this subject have been confirmed by two series of photographs issued by Plüschow of Naples and Von Gloeden of Taormina. Both of these gentlemen work in the open air, posing their models upon the sea-shore of Sicily or Capri, among pines and olive groves, in the court-yards of Pompeii, or beneath the columns of Paestum and Girgenti. Thus they add landscape and architecture to their studies, and in many instances produce pictures of incomparable grace, which display the finer qualities of creative art.

Closely allied to these transcripts from the nude are the subject-photographs which Mrs. Cameron first made popular in England. Here photography competes directly with painting, essays to tell a story, or suggests a poem. On the whole, they do not seem to me as successful as the nude studies which I have been describing, principally because the superiority of photography in the purely plastic region is not here so manifest. It is extremely difficult to treat drapery by any mechanical process of reproduction; and the composition of groups with a dramatic or narrative intention almost invariably recalls a *tableau-vivant.* Mrs. Myers shows her true æsthetic feeling in this branch of the photographic art. She does not attempt too much; and what she aims at, is carried through. I might point to "The Summer Garden" as a good example of a photographic idyl. The figures of the two children are beautifully combined, and brought into harmony with a leafy background. Of even higher æsthetic value to my mind are "Rebekah," and the "Beggar Maid." In both of these studies the drapery is handled with masterly

* Essays Speculative and Suggestive. Vol. I. "The Model."

skill, reminding one of the folds of a Greek chitôn in some marble of the Attic age. The figures are posed with simple dignity. While perfectly natural, they are plastically picturesque. The illumination too leaves nothing to be desired, and the dark masses of the model's hair are kept in proper tone-relation to the lights and shades upon the drapery. Moreover, the structure of the living person is felt beneath the dress, which clothes but does not conceal the limbs. If I were to make any adverse criticism on these fine specimens, I should say that the rough paper on which they are printed (an accident perhaps in the proofs sent to me) has injured the proper development of tone-values. But this is a matter for practical photographers to decide.

It is my privilege to have before me now another of Mrs. Myers' pictures: her two boys in the attitude of Raphael's cherubs in the Sistine Madonna. No photographs which I have seen are penetrated with poetry so deeply felt. The subject is composed with exquisite artistic tact, and the colour-suggestion of this really admirable work transports us into the region of Correggio's subdued luminosity.

A good photographic portrait has greater documentary value, deeper psychological veracity, than the best of paintings. That is because the painter or the sculptor does not depict the man he has to represent, but what he thinks and feels about the man. Perforce he brings his own personality into the portrait. Therefore the historian would prefer a platinotype of Leo X. to Raphael's celebrated picture of that Pope, magnificent as the work of art may be. How gladly would we exchange Droeshout's engraving and the bust at Stratford for a photograph of Shakespeare! Indeed it might be said that no National Portrait Gallery ought to exist without photographs of eminent men and women. Since permanent processes have been introduced, there is no excuse for defrauding posterity of these *verissimæ effigies*. Mrs. Cameron was successful in this branch of art, her portrait of Sir John Herschel being one of the finest pictures in existence. Mrs. Myers follows close upon her steps. The photograph of Robert Browning, reproduced in this number, will be for ever precious to those who knew the poet in his vigorous old age. The rugged force of that massive head combining the majesty of Buonarroti's Moses with a delicacy of curve in the forehead and a watchful intensity in the keen clear eyes, remains stereotyped in her plate. Set it beside Watts' picture; and the comparison of these two interpretations, the painter's and the photographer's, will enable those who come after us to form an accurate conception of Browning as he really was.

If space permitted, I would dwell upon Mrs. Myers' portraits of Mr. Gladstone, Mr. Arthur Balfour, Sir Alfred Lyall, and many other distinguished contemporaries, whose memory the world will not willingly let die. Such is the excellence of her work in the two departments I have mentioned (imaginative composition and portraiture) that invaluable contributions to art and historical records are to be expected from the mastery she has attained within the space of a few years. It does not seem that Mrs. Myers has turned her attention to landscape; but her powers are so marked in the direction of humanity that the world will probably not suffer by her neglect of this province.

It may be added that Mrs. Myers (*née* Eveleen Tennant) began to study photography at the end of 1888, with the view of taking portraits of her children. Since that date she has applied herself assiduously, not only to the æsthetic side of the pursuit, but also to its less attractive mechanical processes. JOHN ADDINGTON SYMONDS.

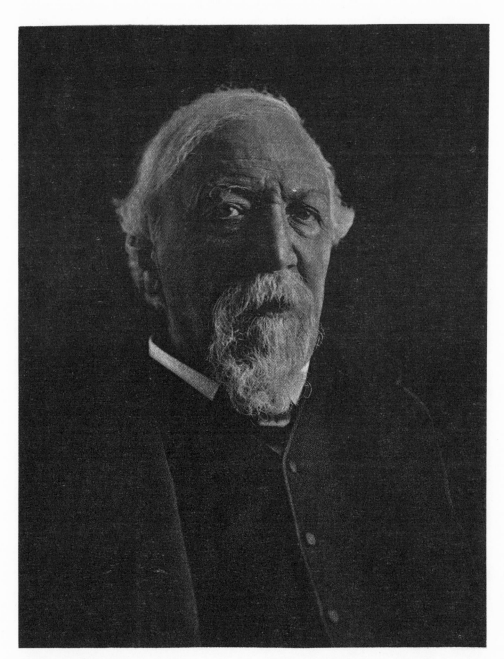

Eveleen Myers.

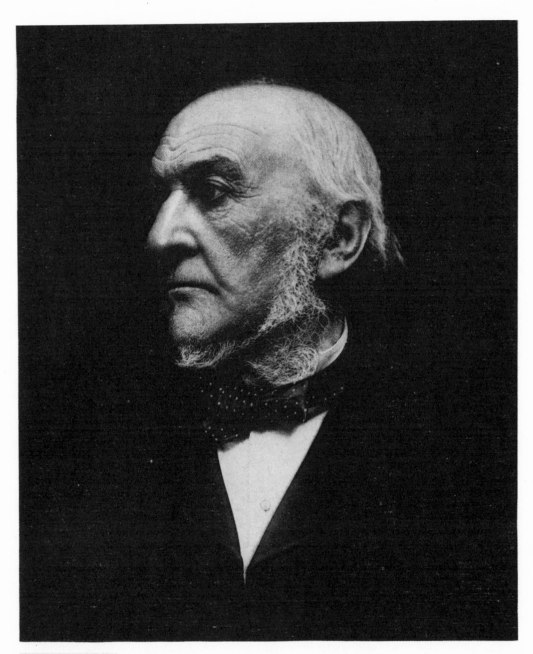

Eveleen Myers.

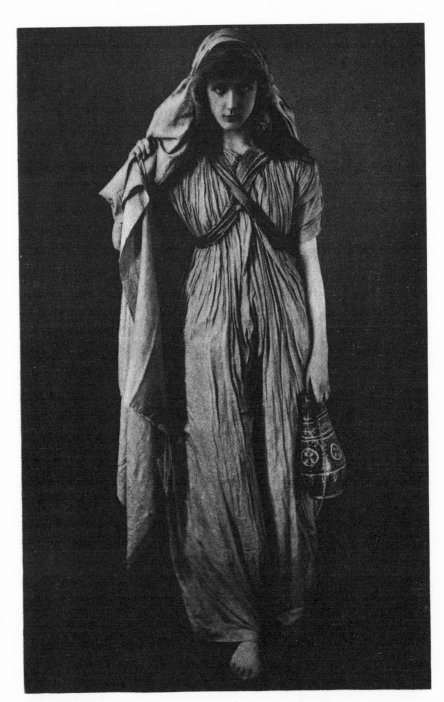

Eveleen Myers.

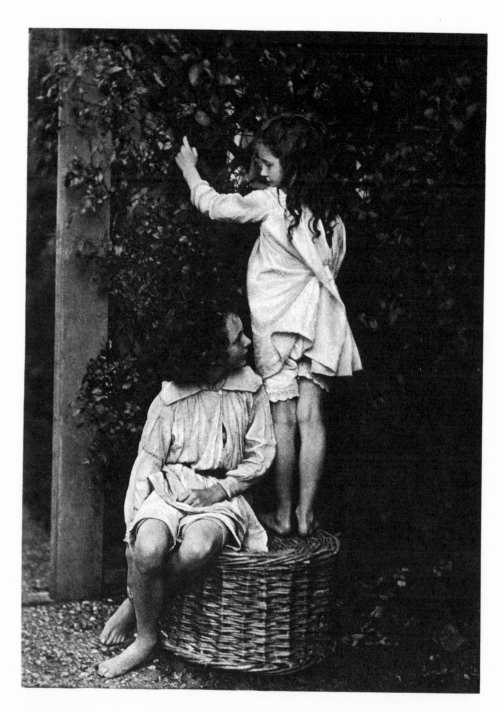

Eveleen Myers.

ANSWERS TO CORRESPONDENTS.

(When space permits, we propose giving insertion to replies to Correspondents).

JOB.—We publish *during* the month, not on any specific day. The photogravure process differs widely from the rapid mechanical ones you mention. If you will think the matter out, you will arrive at the conclusion that four engraved plates cannot be prepared in a day. We have destroyed seven or eight plates and over four hundred proofs. When we are late " out," it is to ensure satisfactory work.

H. J. (Liverpool).—No, we are not contemplating the production of plates in colour; the process is merely chromo-lithographic, and (so far as we have observed) is incapable of producing results sufficiently good for our purpose.

H.—We thank you for the names, and will investigate their merits.

" X. T."—We will let Mr. Wilkinson know. He should be gratified.

Kῦδος.—Your question as to lady photographers is partly answered by this number. We will make the enquiry.

E. S.—You see we have adopted your suggestion, but we shall only publish when we have space to spare. We fear it will not materially check the volume of our correspondence.

F. L.—Come and see us at our new address: we have much to talk about. We note your further remarks.

O. B. O. (Hereford).—Your remarks on our ability, etc., are appreciated. Our publishers will give you any further information you require.

ERIC.—So much has been written about " the development of the latent image," that any list of the *best* formulæ would be necessarily cumbersome, and perhaps useless. Try any *one* of those you mention, and by practice you will gradually learn how to vary its activity to suit your exposure. It has been well said that a " rolling stone gathers no moss;" and, in the same way, a photographer, always in search of a new developer, rarely accomplishes satisfactory work in the dark room. Negatives required for photogravure, collotype, etc., would often give better plates if the negative-maker had had a more adequate knowledge of the art you refer to, viz., " the development of the latent image."

R. W****.—Yes, we agree with you; photogravure is the best method. If amateurs were to photo-etch their own work, it would take a long time before they attained a success. Amongst the few who have succeeded, Dr. Emerson is, perhaps, the only one with courage enough to publish his " pulls."

LANCELOT R.—Your remedy lies in getting one of our portfolios.

J. B.—We wish you would not put these leading questions to us. You know our opinion. Your anecdote is certainly characteristic.

W. A. M.—Our plate paper is 100 lbs. It is quite absurd to mention wood pulp in the same breath.

J. N. O.—" The Kiss of Peace."

T. U. M.—Photographic formulæ are neither receipts nor prescriptions. Ask the " British Journal."

QUERY.—(1). Pt Cl 2. (2). In transferring considerable care must be taken. It is always well to re-wax the sheets.

BROMIDE.—The points you sent are still under consideration. When you are writing again, if you happen to have a platinotype of the " seascape" at hand, you might send it for comparison.

W. JONES (CARDIFF).—To give you any concise instructions would only lead to error. The various stages of etching, and the strengths of the different perchloride solutions, are only tentatively discussed in the work you mention. Much depends on skill displayed in " dusting on." You will find all you require in M. G. Bonnet's book, entitled *Le Manuel d'Héliogravure.* At the same time, we must warn you against the distinction M. Bonnet draws between " photogravure " and " héliogravure." He uses the latter term to represent what is known to us in England by the former, which he restricts to process block-work.

TIME PRINTING.—Certainly; for a beginner it is always better to work with an actinometer. Ready sensitized tissue will not keep for so long a period. But its price is so very moderate, and the possibility of procuring small quantities such an advantage, that we do not think this part of your work likely to prove wasteful. You are far more certain to mourn over your spoilt copper-plates.

Investigator.—We give you this name, as we cannot decipher your signature or address. Should this meet your eye, kindly write it plainer; as, from what we can read of your letter, we should like to hear further from you: of course in strictest confidence.

R. W. C.—We have had no previous opportunity of replying to your letter. Will you kindly communicate with the Hon. Treasurer, 45, Avenue Road. We certainly know of no photographic paper unworthy of support. The paper you mention simply does not answer your particular purpose. There is no need to abuse it on that account. We cannot deviate from our course, and take up a branch we have no sympathy with, for such reasons.

J. E. W.—We are not working for any particular phase of photographic endeavour in the sense you attach to the words. Why seek some hidden motive for our work? All concerned in this undertaking are working for amusement, and a genuine desire to further the interests of artistic photography. Yours is the only letter of this kind we have yet received. You should blow out your candles when the sun rises.

SOILED ENGRAVINGS.—There are many ways of cleaning these; perhaps the old-fashioned careful rubbing with stale bread is the safest. Be wary of solutions! Some engravings have been utterly ruined by doubtful bleaching agents.

PRESS OPINIONS.

" 'Sun Artists' (Kegan Paul, Trench, Trübner and Co.), the new periodical devoted to exemplifying modern artistic photography, comprises well-written essays on eminent photographers, and some extremely beautiful reproductions of their work. The October part, for instance, contains admirable plates illustrative of the wonderful skill of the late Mrs. Cameron, of whose gifts and work Mr. P. H. Emerson writes with due appreciation."—SATURDAY REVIEW.

" We welcome two pretty photographs this No. 1 contains. ' Brixham Trawlers' has, in its vagueness, something of the charm of mystery."—ATHENÆUM.

" . . . The fishing smacks, the rustic scenes, and the typical foggy day on the Thames, are certainly excellent specimens of the art. . . ."—MORNING POST.

" *Chefs d'œuvre* of photographic art. . . . Incomparably superior to anything of the kind which has yet been produced."—UNITED SERVICE GAZETTE.

" The current number is one of the best which has yet been issued."—SCOTSMAN.

" . . . The four plates do ample justice to the finely finished pictures. . . . The descriptive text is lively and interesting, and no pains have been spared in the preparation of ' Sun Artists.' . . ."—DAILY CHRONICLE.

" . . . The four plates are beautiful productions. . . ."—ILLUSTRATED LONDON NEWS.

" An addition, and we think a valuable one, to the ranks of the illustrated magazines is ' Sun Artists.' . . . Altogether ' Sun Artists' is a handsome and attractive quarterly periodical."—THE GRAPHIC.

" . . . The high water mark of modern photography. . . ."—ART JOURNAL.

" . . . Four reproductions are given : clever studies in which the eye of the artist has had as great influence as the manipulation of the photographer. The scenes are most excellently reproduced in photogravure. . . ."—THE ARTIST.

" The number before us contains four splendid plates."—FREEMAN'S JOURNAL.

" . . . In composition, delicacy, softness, equable tone, avoidance of harsh effects in contrast, fore-shortening, etc., too often the bane of the photograph-picture, these examples are wonderfully fine. . . . Type, paper and general ' get-up' are all that can be desired. . . . Should certainly do much to advance artistic photography."—PALL MALL GAZETTE.

" Exceedingly interesting . . . everything possible has been done to make the work attractive."—MAGAZINE OF ART.

" . . . We can but wish it all success. It is made up of eight large pages of exquisite printing upon Dutch hand-made paper. . . . Four plates of much merit are given. . . ."—THE QUEEN.

" That delightful *journal de luxe*. . . . It is a remarkable example of the progress made in the art of photography."—GENTLEWOMAN.

" . . . It would be difficult to find anything of its kind more enchanting than the pretty scenes of field and water, horses, men and boats. . . . Indeed the whole ' get-up' of the magazine is luxuriantly artistic . . . If ' Sun Artists' justifies the high expectations awakened by its first issue, it will indeed be a welcome addition to the art journals of the day."—MANCHESTER EXAMINER.

" . . . We cannot conceive of any work of even the most skilful engraver which, if put upon the etching of ' Sleepy Hollow' could improve it in the slightest degree. The text matter is of the most racy character. . . . ' Sun Artists' is sure to take well, for never before has such an admirable five shillingsworth been offered to the public. It is of large size, and well printed on fine hand-made paper. . . ."—BRITISH JOURNAL OF PHOTOGRAPHY.

" It is very gratifying to notice that the high character with which ' Sun Artists' commenced its career is admirably sustained, and reflects great credit on all concerned in its production."—CAMERA.

" . . . This publication is already famous. . . . It is a step in the right direction, the first number alone is sufficient to disprove the not uncommon assertion that photography can never be a fine art. . . . The whole set should compose a very valuable collection, and we think that every member of the club ought to make a point of securing copies from the commencement. . . ."—CAMERA CLUB JOURNAL.

" The high quality with which this publication started out is still maintained."—PHOTOGRAPHY.

" . . . The first number of ' Sun Artists' is certainly a ' thing of beauty.' The four plates reproduce photographs good in themselves, and beautifully represented here. The letterpress is interesting, and the whole ' get-up' of the issue most luxurious. ' Sun Artists' can hardly want friends. . . ."—YORKSHIRE POST.

" . . . Their delicacy and beauty are very remarkable. . . . We have no hesitation in saying that these plates place photography in a higher position than it has hitherto held in public estimation. ' Sun Artists' will be not only a handsome publication, but one of genuine artistic value."—NORTH BRITISH DAILY MAIL.

" ' Sun Artists,' the fine photographic art journal which has been spoken of so highly by all the European journals, has reached us. We cannot speak too highly of the publication."—THE PHOTOGRAPHIC TIMES AND AMERICAN PHOTOGRAPHER.

" They are not only remarkably good photographs—they are genuine pictures, well selected in subject, capitally grouped, and exquisite in gradations and tones."—BIRMINGHAM POST.

" . . . The second number of ' Sun Artists' is admirable. The four plates are simply matchless as specimens of photo-printing. Anything more delicate and beautiful of their kind than these pictures could not be desired. The success of this most artistic publication must now be thoroughly assured."—GLASGOW HERALD.

" . . . Four charming examples ; all of them beautiful and artistic pictures."—SUNDAY TIMES.

" . . . The plates are thoroughly artistic in workmanship, and the subjects interesting and attractive. . . . They well deserve to rank as fine art."—THE GLOBE.

" It is not enough to say that they do him credit, for it must be allowed that they do honour to the photographic art itself."—NEWCASTLE CHRONICLE.

" The third number of this handsome and attractive art publication is devoted to the reproduction of photographs by Mr. J. B. B. Wellington. These show what enormous progress has been made by photography as an art. This publication should be in favour with lovers of art."—GLASGOW DAILY MAIL.

" ' Sun Artists' keeps well up to the worth and promise of the first number. We have here what is incomparably the best work in artistic photography."—LEEDS MERCURY.

Chiswick Press

PRINTED BY CHARLES WHITTINGHAM AND CO.
TOOKS COURT, CHANCERY LANE, LONDON, E.C.

Number 8.

July, 1891.

SUN ARTISTS

Mr. FRANK SUTCLIFFE.

With a descriptive Essay

BY CHARLES NOEL ARMFIELD.

List of Plates in this Number.

Water Rats.

Dinner Time.

Excitement.

Sunshine and Shower.

HON. EDITOR:

W. ARTHUR BOORD.

KEGAN PAUL, TRENCH, TRÜBNER & CO. (LTD.), CHARING CROSS ROAD, W.C.

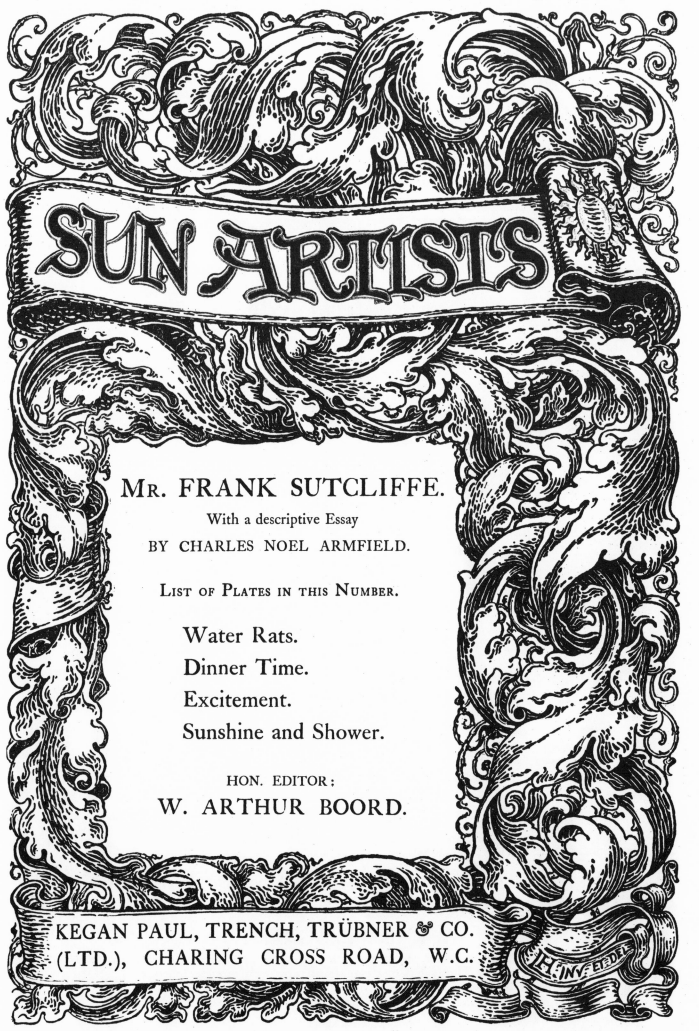

NOTICES.

Special attention is called to the notice regarding the close of this Series, given on the inner advertisement wrapper of this Number.

CONTENTS OF NUMBERS ALREADY ISSUED.

A few signed proof copies of back numbers suitable for framing, are still in hand, application should be made to the Hon. Secretary.

The work incidental to the conduct of this Serial has rendered a change into more commodious chambers imperative.

All Editorial communications therefore should now be addressed to

The Hon. Editor
"SUN ARTISTS,"
33, Chancery Lane,
London.

Correspondence other than Editorial should be sent to the Hon. Secretary, A. R. Deane, Esq., at the same address.

PORTFOLIOS.

A demand for Portfolios to contain unbound copies of "SUN ARTISTS" having arisen, a supply has been placed in the hands of the publishers.

Stout boards, paper sides, linen back, with tapes, to hold eight copies (two years' issues), 3s. 6d. each.

TO HOLDERS OF SIGNED INDIA PROOF COPIES OF No. I.

The Hon. Secretaries, being desirous of accommodating a subscriber, will be prepared to give Two Guineas for a Proof Copy of Part I. if delivered to 33, Chancery Lane in good condition, during September, 1891.

Descriptive leaflets can now be obtained of all booksellers throughout the kingdom. Leading Press opinions appear on the third page of the cover.

ACKNOWLEDGMENT.

The Hon. Editor, in the name of the promoters of the Serial, begs to return thanks to all those correspondents whose kindly letters of congratulation and appreciation, arriving by nearly every post, are too numerous to acknowledge singly.

It is very grateful to the promoters of the Serial to see the critical opinions of the press endorsed in this flattering manner.

IMPORTANT NOTICE.

CLOSE OF THE ORIGINAL SERIES.

ON and after the 1st of October, 1891, the price per copy of the Eight numbers forming the original series of "SUN ARTISTS" will be raised from 5s. to 6s. 6d. No further numbers of this series will be issued. Signed proof copies on india of most of the numbers can be obtained of the Hon. Secretary, "Sun Artists," 33, Chancery Lane, E.C., till March, 1892, if the supply is not sooner exhausted; after that date application should be made to the publishers.

TO BE SOLD

A COLLECTION OF

HOGARTH PRINTS

AND OTHERS (upwards of 60 in all),

INCLUDING

8 prints "Rake's Progress."

4 „ "Morning, Noon, Evening & Night."

4 „ "Stages of Cruelty."

APPLY, TO VIEW, AT

"SUN ARTISTS," 33, CHANCERY LANE.

(APPOINTMENTS ONLY).

P. MEAGHER,

Photographic Apparatus Manufacturer.

COMPLETE SETS.

Camera, Reversing Frame, Single Swing, and 3 Double Dark Slides, 6½×4¾	£7 16 0	} £15 11 6
Ross' Rapid Symmetrical Lens, 6×5	5 5 0	
Leather Case for Camera, &c.	1 12 6	
Tripod Stand (Folding)	0 18 0	
Camera, 7½×5	£8 0 0	} £16 8 0
Ross' Rapid Symmetrical Lens, 8×5	5 15 0	
Leather Case	1 15 0	
Tripod Stand	0 18 0	
Camera, 8¼×6½	£9 5 0	} £19 9 0
Dallmeyer's Rapid Rectilinear Lens, 8¼×6½	7 0 0	
Leather Case	2 0 0	
Tripod Stand	1 4 0	

10 per cent. Discount for Cash with Order. Illustrated Catalogue Post Free.

MANUFACTORY:

21, Southampton Row, High Holborn, LONDON, W.C.

ROSS' Symmetrical Lenses & Dry-Plate Cameras.

Gold Medals & Highest Awards at all Great Exhibitions.

Many Recent Improvements Resulting from the **Introduction of the New JENA GLASS.**

All Lenses are now supplied mounted in Brass or Aluminium, and fitted with either Waterhouse Stops or New Patent Iris Diaphragm.

Ross' Universal Symmetrical Lenses.

Extra Rapid. A new series for Landscapes, Portraits, Groups, and Instantaneous. F—5,657.

Ross' Rapid Symmetrical Lenses.

New Formula. For Groups, Views, Interiors, Copying, and all Out-door Photography. F—8.

Ross' New Wide-Angle Symmetricals.

A new series, adjusted to an angle of 90 deg.

Ross' Portable Symmetrical Lenses.

The most popular Lenses for Landscapes, Architecture, and Copying. F—16.

Ross' New Wide-Angle Single Lenses.

Introduced for purely Landscape purposes. Flat Field and Brilliant Image. F—16.

Ross' Improved Portrait Lenses.

Cabinets and C.-de-V.'s. Invaluable for either Standing or Sitting Figures.

Special Lenses for Detective & Hand Cameras.

A NEW ILLUSTRATED CATALOGUE NOW READY.
Sent Post Free on application.

SPECIAL SHOW-ROOMS

and a

Fully-equipped Dark-Room,

Where the Apparatus may be practically tested, and Useful Instructions given to Beginners.

Pattern No. 1.

EXTRA LIGHT AND PORTABLE
Double-Extension Cameras,

FOR LENSES OF LONG FOCUS,
With Swing Back, Reversible Holder, Turn-table, and Legs.

Pattern No. 1 closes to the smallest substance consistent with stability, and is the most Portable Camera affording every desirable motion.

Pattern No. 2 closes like Pattern No. 1, and being made for the new form of double backs is considerably LESS in its other dimensions. It is consequently the SMALLEST and LIGHTEST Camera yet introduced.

	Pattern No. 1.		Pattern No. 2.	
Size	With one Double Back	With three Double Backs	With one Double Back	With three Double Backs
6½×4¾	£6 11 0	£8 15 0	£5 8 0	£7 4 0
7½×5	7 9 0	9 13 0	5 16 0	7 12 0
8¼×6½	8 1 0	10 11 0	7 3 6	9 5 6
10×8	9 1 0	12 5 0	8 14 0	11 6 0

TURN-TABLE AND LEGS, 37/6 EXTRA.

Improved Stereoscopic Cameras.
Universal Studio Cameras.
New Portable Divided Hand Camera.
The Great Success of the Season.

SEND FOR LIST.

10 per cent. Discount for Cash.

ROSS & CO., Opticians, 112, New Bond Street, LONDON, W.

MR. F. M. SUTCLIFFE.

ON the 12th day of December, 1871, "The Institute[1] of Painters in Water Colours" lost, by the death of Mr. Tom Sutcliffe, one of its most thorough, thoughtful, and humorous members, I one of my dearest and most charming friends, but, greatest loss of all, Mr. Frank M. Sutcliffe (whose photographs form the subject of my remarks), while hardly yet a young man, lost one of the most affectionate fathers that ever man was blest with. The late Mr. T. Sutcliffe was a man of very extraordinary attainments, indeed, he was one of those men of whom it might truly be said " Nihil tetigit quod non ornavit,"—his art-working was not confined to painting in oil and water colour, in both of which mediums he was an expert, but he was equally at home in lithography, in etching, when etching was not the fashion that it now is, in practical printing of both lithographs and etchings, for each of which he had complete apparatus in his studio, in photography, the great future of which he foresaw, and to the artistic development of which he gave much time and thought; but perhaps his greatest power was as an artistic analyst, and those who had the privilege of hearing his lectures on the faults common to all uneducated and semi-educated Schools of Art, illustrated by examples from the earliest attempts at Art by barbaric nations down to the school-boy's drawing on his slate of the present day, left the lecture room after an evening spent in laughter, with their store of Art knowledge incredibly increased—they hardly knew how—it had been so humorously but incisively poured into them. Again, many of us who thirty years ago listened to him descanting in another lecture on how to decorate and enliven the streets of our great towns, have lived to see most of the details which he advocated carried out to the vast improvement of the appearance of our streets, for what he advocated was never Utopian, but was always well within practical possibilities. Then again, he was possessed of literary powers of a high order, and though I believe he never published anything through the public press—he did publish from his own private press—his children being his compositors and printers—some most charming, humorous, dreamy stories, always with a benevolent maxim running through them, the character of which may be gathered from the fact that shortly after " Alice in Wonderland" came out, on meeting Sutcliffe out sketching, I felt so sure of my ground that I shouted out before I got to him " Bravo! Lewis Carrol, you have made a hit." Of course everyone knows now who " Lewis Carrol " is, so I need say no more about my mistake or of Sutcliffe's repudiation of the *nom de plume*. Much more I could say, but I think I have said enough to show that the father of Mr. Frank Sutcliffe was a remarkable man. What wonder then is it that with such a father we have in the son one who has raised photography to a high place in the Arts, and has by inborn gifts inherited, and by the careful Art training he received from his father, shown that in the hands of an

[1] Now the *Royal* Institute of Painters in Water Colours.

artist photography can and has become something better than a mere more or less successful mechanical and chemical experiment. I spoke a line or two back of the "inborn gifts inherited" by Mr. Frank Sutcliffe, and in using those words I was speaking of my own knowledge, for I have known him from his boyhood, and have watched in him the development of artistic powers of various kinds; he is, as I know, an excellent draughtsman, no mean hand with the brush and palette, and possessed of a fund of kindly genial humour, which, like his father's, never becomes vulgar or offensive; he has an artist's eye for selection, and a trained power of composition which enables him to catch a picture from the happiest point at the happiest moment.

All these gifts and acquirements he has brought to bear on the branch of Art to which he has more especially devoted himself, and the result is before the world in a large series of photographs which to my eye contain a wealth of artistic teaching very difficult to equal. Of this great collection I am, by the limits of this publication, confined to dealing with four only so far as directing the reader's eye to pictorial illustrations, but I trust it will not be deemed impertinent to the review I have to make if I refer somewhat in detail to some others in the large collection of Mr. Sutcliffe's photographs, provided I give such clues to them that those interested in his work may easily procure copies for themselves. In treating of any Art it must never be forgotten that every art has its limits, and that to attempt to go outside those limits is to insure certain artistic failure; of this truth we have no more constant example before our eyes than that of many of our stained glass workers who, in trying to vie in pictorial effects with the painter on canvas, wall or panel, fight against the laws of Nature, and so fail to produce the splendid effects which are within the limits of their art, and struggle hopelessly to achieve artistic results in a direction that the material they are working in does not and cannot admit of. Let us then before going further briefly examine what are the legitimate limits in an artistic sense of photography. It is manifest at once, and it is of no use to burke the matter, that there are certain qualities which go to make what the artistic world regards, and will continue to regard, as necessary to "Fine Art" which are and must be for ever forbidden to photography—such as invention, the use of emphasis, ideality, and several other subtle poetic qualities which I need not categorize, but which are entirely beyond the reach of photographic Art; still, if these high qualities are forbidden to photography by the natural condition of things, it yet has left to it many very valuable qualities which, in the hands of artistic photographers like Mr. Sutcliffe, and artistic printers like Mr. Colls, produce results which within the limits of the Art are pictorial in a very high degree, and are decidedly artistic successes. The first valuable quality we have is absolute accuracy of drawing—a quality which some time ago artists regarded as hopeless for photography to achieve, but now, by the combined efforts of the chemist, the optician, and the mechanician, the spray of the storm-driven wave, the bending of the wind-torn pine—yes! even the momentary startling flash of the lightning are recorded for us with unerring accuracy never before achieved by artist's pencil. An art that can do this, though it may not take its place as a "Fine Art" in the fullest sense understood by that term, yet may claim to hold a first place amongst the teachers of artists as a truthful recorder of effects too transient for the human eye to analyze with accuracy. With this great power of accurate drawing the artistic photographer can by the use of selection, composition, and even

humour, produce works which in the qualities within the means of photography may fairly be termed pictures. The qualities of selection of light and shade on the one hand, and of composition on the other, are most admirably shown in "Sunshine and Shower" —the distribution of the light into one major light with its two minor lights joined by numerous broken half lights could not be excelled by the most subtle craft of the painter; nor do I think that, as a matter of composition, any artifice would add to its beauty, for we have here the three chief dark objects which go to make the picture most artistically disposed, the topsail schooner with the row of cobles and the collier without top-masts forming the principal dark object, and dominating, as it should do, every other object in the picture; secondly, the crane, with the mooring post just breaking the base of the crane, by the force of their light and shade, rightly occupying the position of first minor dark object, and partly veiling the schooner behind it, which, though nearly equal in pictorial size to the crane, yet by diminished force of tone falls most artistically into the place of the second minor dark, while the subsidiary objects of the distance, the mud banks, mooring posts and harboured fishing boats break and veil the horizon just in the way a painter would wish. I have a particular interest in this photograph, for I happened to be passing at the time Mr. Sutcliffe was taking it, and one of the most charming effects of it is one which, so far as my knowledge goes, no painter has ever attempted to paint, nor do I think that until Mr. Sutcliffe took this photograph any painter would have dared to attempt to paint it, and yet it is a very beautiful effect, I refer to the fact that owing to the shower the direct rays of the sun behind the topsail of the schooner were refracted by the particles of moisture right through the sail, and so we have a point of semi-transparence on an opaque object against the light. To have a scientific indisputable record of such a beautiful effect as this is of inestimable value to the Art World, for, as photography has established the existence of the effect beyond cavil, no artist would hesitate to use it if it would add to the beauty of his picture. Before quite leaving this subject of "Sunshine and Shower" I should like to speak of the extreme beauty and delicacy of Mr. Colls' prints. It so happens that of this particular picture I have three prints: 1st, a silver print; 2nd, a platina print; 3rd, the one by Mr. Colls. The first two are by Mr. Sutcliffe, the first given to me by him some six years ago, and the second sent to me by him early this year—the second is in many points superior to the first, but I am sure Mr. Sutcliffe will forgive me if I say that neither of them can compare with Mr. Colls', indeed, unless I had seen and examined them I could not have believed that the printing from the same negative could have produced such different results. In the two prints by Mr. Sutcliffe many of the details which I knew I ought to see I never could find, whereas in Mr. Colls' print these details, such as the cordage against the dark sails, the overlapping of the sails, the seams in the sails, the details of the hull and deck of the schooner, the lines of the cobles, with their thwarts, oars, and other details, are most beautifully and delicately defined, and make this print a most valuable record for the artist. That Mr. Sutcliffe's artistic gifts and training enable him, as I said some time back, "to catch a picture from the happiest point at the happiest moment," we can have no better illustration than his group of bathing boys, which he entitles "Water Rats." The scene is no set picture, but is one of a kind of daily occurrence during the summer in Whitby Harbour; yet at what a happy moment has Mr. Sutcliffe seized upon it, and what a happy

point has he taken it from—the whole thing is full of " go " and vitality—see the strained shoulder muscles of the boy who is evidently going to splash with his right foot while balancing himself on his hands under water, then see the pained face of the poor little chap in the boat who has just hurt himself, or note the grip of the hands of the boy in the left hand group who is trying to reach a higher standing place on his slippery perch, or mark the vibrating reflections in the water; indeed, look where you will, the whole thing is full of life, and is a splendid specimen of what photography can achieve in the hands of an artist. It is only due to Mr. Colls that I should again call attention to the valuable qualities of his printing, whereby he has developed the beauties of the photograph in a far higher degree than were shown in the original print, which I believe took the gold medal at New York some four or five years since. Especially would I call attention to the evanescence of the old town in sunlit misty atmosphere—it is no mere blur, but is full of the most delicate detail, and must recall to those who know Whitby well the fairy-like effect of almost floating in the sea that the old place so often has.

That the photographer has within certain limits the expression of humour at his command, I think no one who looks at the group of boys intently staring over the pier wall, all with their backs to the spectator, will for one moment deny—Can anything really be funnier in its way? We have presented to our view sundry bare legs, some hob-nailed boots, and a considerable variety of curious needlework in the " seats of the breeks," but what " makes the picture" is the evident intentness of each individual boy to secure for himself a good place to see what is to be seen. What there is to be seen we don't know —it may be a fishing boat crossing the bar in a heavy swell, it may be a wonderful dog that has made a 40-foot plunge off the pier-end, or it may be that some accident has taken place; but whatever it is, the interest is so strongly marked in the eager attitudes of the boys, that, as we look at the photograph, we instinctively take our place in the scene and want to know " What is it?" No one but a born humorist would have dreamed of taking such a subject for a picture.

Before dealing with the remaining illustration I will refer somewhat to a few of Mr. Sutcliffe's photographs not here illustrated; unfortunately, I have no titles by which to define them, but the numbers and initials that each bears will be quite sufficient to identify them. The first, " F.M.S., 9," is wonderfully valuable as showing the power of strong sunlight to almost entirely destroy local colour even in dark objects, and the degree in which it does so according to the angle at which the light falls, as seen on the starboard side of the schooner half heeled over in low tide; this is very beautifully shown in the platinum print that I have, but, from what I have seen of Mr. Colls' success with Photogravure, I feel sure that in his hands many beauties and details would be disclosed that are not now clear to my eye, and I trust it is not too much to hope that at no distant day the photograph may receive the benefit of his exquisite craft. The second photograph that I would notice is " 106, F.M.S." and, though in many other respects a beautiful work, is particularly to be noted as a study of rippling water, which I have never seen surpassed, for the subtleties of the sky reflections so keep their places amidst all the rippled dark reflections from the crowd of boats and houses on either side of the harbour, that as we look at the photograph the water verily seems to be moving, while the large lug fishing boat toiling up the harbour, with too light a wind to take her to the quay side,

makes, with her huge "sweeps," eddying circles in the water that most happily add to the sense of motion. The third photograph, marked " F.M.S. 174," is most delightful in selection and disposition of light and shade—it is a view from Whitby dock end, close by the railway station, and shows the view down the inner harbour with the old town in the distance crowned by its glorious abbey; while in the immediate front to the right hand is a top-mast schooner moored to the dock end, in most picturesque disorder, just as she has run into harbour, with her double topsails loose and half down, yards all awry, jib and fore staysail half run down and mainsail partly " scandalized," altogether a charming chief object, balanced in composition on the left of the picture by a long curved line of schooners, brigs and nondescript colliers broken in upon here and there by a few fishing cobles, backed up by the old houses on the staithe side; indeed, so admirable is it as a composition, that it might almost be taken for a photograph from a picture, rather than the result of artistic selection of an accidental combination, and it is completed by a most delicate presentment of the old town, nearly every building of which I recognize, veiled in the fine sunlit film of smoke that is so characteristic of the place, and which, by rarifying as it rises, brings into stronger relief the crowning glory of the place—the ruins of the once magnificent Abbey of St. Hilda. The last photograph, external to this number of " Sun Artists," that I shall refer to is the best example that I know of, of how very humorous a photographer can be with his Art. The subject is a queer old character of Whitby carrying a sandwich-board advertisement of the forthcoming appearance at the local theatre of Miss Bateman. I will not say wherein the humour consists, for everyone who sees the photograph, if they have the slightest spark of humour in them, will see at once wherein the funniness lies, and will recognize that it is entirely due to the disposition of the figure under Mr. Sutcliffe's direction.

Now that photography has done so much, may I suggest that perhaps it can do still more—there are many things that artists would be only too glad to have accurate photographs of, but I don't know that they have hitherto been done. The moors of North Yorkshire every winter give us splendid effects of drifting snow swirling itself up into deadly dangerous piles, swallowing up all living things in their way, but many of these, as I know by experience, can be regarded from safe cover: what a grand picture might be had from this if photography can only compass it! Then again, there is the tearing snowstorm with high wind, or again can photography illustrate for us Alexander Smith's beautiful poem—

> " 'Twas Winter, and the driving rain
> Came slanting down in lines,
> And Wind, that mighty harper, struck
> His thunder harp of pines."

In North Yorkshire all the materials for such a picture exist in abundance, and what a triumph it would be to photograph the very wind itself as shown in the bending and straining pine-tree and the torrent of the storm rain coming " slanting down in lines!"

I must now return to the " Sun Artists" illustrations, the last of which—the ploughing scene—has so many beautiful points in it that I hardly know how to begin reviewing it.

The perfection of the detail of the figures, of the plough and its tackle, of the horses and their harness, and the play of light and shade upon them are, even at first sight, so self-evident that I shall not dwell upon them, but what strikes me as so fine in the pictorial arrangement is the utter absence of all parallelism, and the fine broken wedge of dark, running from the lower left hand corner of the picture nearly up to the line of horizon, formed by the bushes, the figures and the furrows, which first of all takes the eye well into the picture and then so happily insists on " a way out "; then there is to be specially noted that most subtle effect to the right of the picture of the moist atmosphere in the ravine cutting off the one upland from the other—this is an effect very common in the moorland districts, excepting during an east wind, but it is one that is rarely satisfactorily painted, for the painter as a rule either under-estimates the degree of evanescence caused by the moist air in the ravine, and adopts variety of tone to cut off one upland from another, or he exaggerates it and makes too much of a feature of it. In this photograph the tone all through is perfect, and contains many lessons which artists may study with advantage; indeed, it is to the artist that photography must eventually have its highest value, for while such photographs as Mr. Sutcliffe's, and such prints from them as Mr. Colls has made, are in themselves works of great beauty and pleasure, it is in the *accurate* knowledge of passing effects which they convey, that eventually their greatest Art value will be felt, and with the combined efforts of two such Art workers, we may hope for and hail with joy a vast series of pictures, undeniable in their beauty, and unchallengeable in their truthfulness, painted by that great painter of our universe—the Sun—who will, with *unerring* pencil of light, record for us, for all time, the glories he day by day reveals to us.

<div align="right">CHAS. NOEL ARMFIELD.</div>

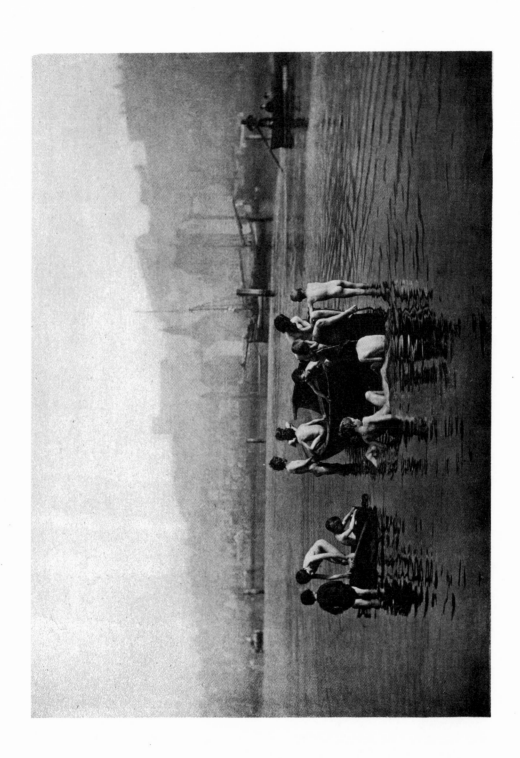

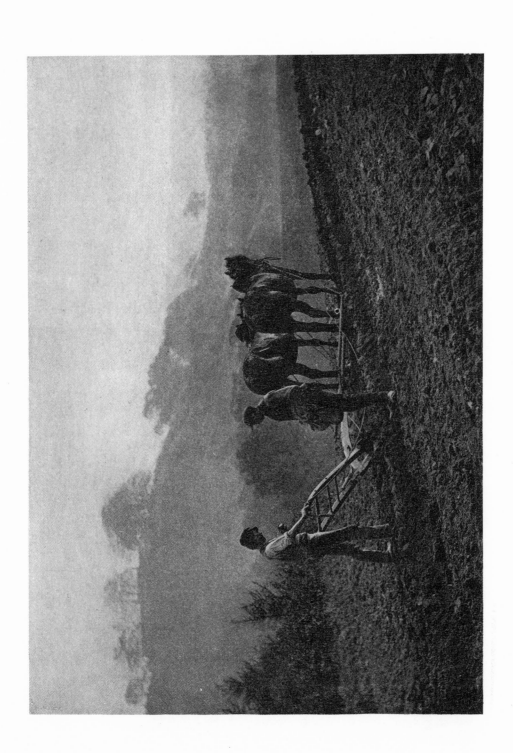

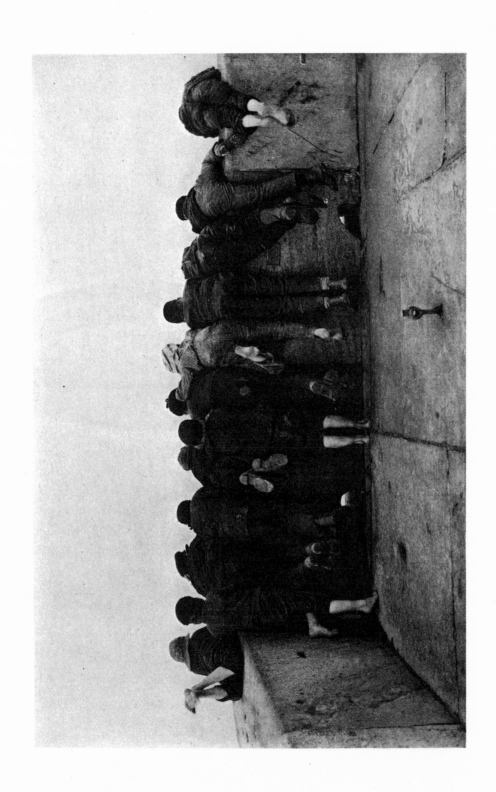

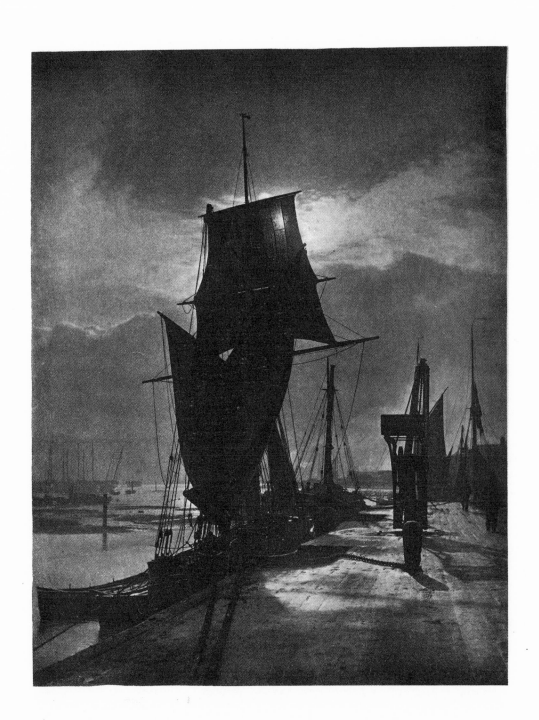

CONCLUSION.

OUR labour, extending now over a period of two years, has at length reached a term, and in a few words we would close this series, allowing our work to speak for itself without apology or defence. Photography may be described as a young Art with a great future. The immaturity of its years finds due reflection in the low average merit of its production, the possibilities of its future are to be found in its marvellous adaptability and obedience to control in master hands. In truth it has scarcely emerged from the experimental stage, and to this circumstance must be set down the explanation of the existence of bold or rash adventurers, who, gaining the public ear, always open to the bizarre and the novel, are proclaimed artists without other justification. We have resisted the temptation of giving way to such popular clamour, and our original series enshrines only that which is worthiest and most enduring in the Art we honour.

It may be observed that some few workers, chiefly of the younger generation, are not here represented. We forestall criticism on this point by admitting that their efforts are of great promise. We believe the future will amply compensate them for want of premature recognition on our part.

Attacks have recently been made on the Art qualifications of photography. Some of these have been answered by our Editor in another place; there is one charge, however, of which this series is the readiest weapon of successful refutation. Photography has been held up as incapable of possessing any capacity for individual expression. We invite sceptics to consult our pages.

We trust in the not far distant future to open a fresh series of this publication on broader lines. The original series will stand as a monument to those great English photographers who have brought honour on the Art, and will serve to inspire future conductors of future series with hope and high intention.

A few words of acknowledgment will most fittingly close our remarks. To our artists we owe thanks for unfailing courtesy and readiness to oblige, combined with evidence of a high sense of their own responsibility. To our essayists we are under equal obligations. We would especially select for public thanks, Mr. John Addington Symonds, Dr. P. H. Emerson, and Mr. Graham Balfour, as the peculiar circumstances under which they con-

tributed, double the burden of our indebtedness. Our engravers through-
out have been the faithful translators of the intentions of our artists; we
gratefully acknowledge their cordial and necessary assistance. A record
of their names is appended.

Finally, we beg to thank an appreciative public, the volume of whose
support has increased commensurately with the rolling months. And so
we take our leave.

July, 1891.

No.	Plates.	Engraved by
I.—Mr. J. GALE. Descriptive essay by GEORGE DAVISON.	SLEEPY HOLLOW. BRIXHAM TRAWLERS. A FOGGY DAY ON THE THAMES. HOMEWARD FROM PLOUGH.	*Mr. Dawson of the Typographic Etching Company.*
II.—Mr. H. P. ROBINSON. Descriptive essay by ANDREW PRINGLE.	CAROLLING. DAWN AND SUNSET. A MERRY TALE. WHEN THE DAY'S WORK IS DONE.	*Mr. Cameron Swan of Messrs. Annan and Swan.*
III.—Mr. WELLINGTON. Descriptive essay by GRAHAM BALFOUR.	EVENTIDE. THE BROKEN SAUCER. A TIDAL RIVER. A STUDY OF SHEEP.	*Mr. Cameron Swan of Messrs. Annan and Swan.*
IV.—Mr. L. SAWYER. Descriptive essay by the REV. F. C. LAMBERT, M.A.	WAITING FOR THE BOATS. THE CASTLE GARTH. IN THE TWILIGHT. THE BOAT BUILDERS.	*Mr. Cameron Swan of Messrs. Annan and Swan.*
V.—Mrs. CAMERON. Descriptive essay by DR. P. H. EMERSON, B.A., M.B.	THE KISS OF PEACE. SIR JOHN HERSCHELL. LORD TENNYSON. THE DAY DREAM.	*Mr. W. L. Colls.*
VI.—Mr. WILKINSON. Descriptive essay by the REV. F. C. LAMBERT, M.A.	SAND-DUNES. PRAWNING. A PASTORAL. A WINDY CORNER.	*Mr. W. L. Colls.*
VII.—Mrs. MYERS. Descriptive essay by JOHN ADDINGTON SYMONDS.	ROBERT BROWNING. RT. HON. W. E. GLADSTONE, M.P. REBEKAH AT THE WELL. THE SUMMER GARDEN.	*Mr. W. L. Colls.*
VIII.—Mr. SUTCLIFFE. Descriptive essay by CHARLES N. ARMFIELD.	WATER RATS. DINNER TIME. EXCITEMENT. SUNSHINE AND SHOWER.	*Mr. W. L. Colls.*

PRESS OPINIONS.

"'Sun Artists' (Kegan Paul, Trench, Trübner and Co.), the new periodical devoted to exemplifying modern artistic photography, comprises well-written essays on eminent photographers, and some extremely beautiful reproductions of their work. The October part, for instance, contains admirable plates illustrative of the wonderful skill of the late Mrs. Cameron, of whose gifts and work Mr. P. H. Emerson writes with due appreciation."
SATURDAY REVIEW.

"We welcome two pretty photographs this No. 1 contains. 'Brixham Trawlers' has, in its vagueness, something of the charm of mystery."—**ATHENÆUM.**

". . . The fishing smacks, the rustic scenes, and the typical foggy day on the Thames, are certainly excellent specimens of the art. . . ."—**MORNING POST.**

"*Chefs d'œuvre* of photographic art. . . . Incomparably superior to anything of the kind which has yet been produced."—**UNITED SERVICE GAZETTE.**

"The current number is one of the best which has yet been issued."—**SCOTSMAN.**

". . . The four plates do ample justice to the finely finished pictures. . . . The descriptive text is lively and interesting, and no pains have been spared in the preparation of 'Sun Artists.' . . ."—**DAILY CHRONICLE.**

". . . The four plates are beautiful productions. . . ."—**ILLUSTRATED LONDON NEWS.**

"An addition, and we think a valuable one, to the ranks of the illustrated magazines is 'Sun Artists.' . . . Altogether 'Sun Artists' is a handsome and attractive quarterly periodical."—**THE GRAPHIC.**

". . . The high water mark of modern photography. . . ."—**ART JOURNAL.**

". . . Four reproductions are given : clever studies in which the eye of the artist has had as great influence as the manipulation of the photographer. The scenes are most excellently reproduced in photogravure. . . ."
THE ARTIST.

"The number before us contains four splendid plates."—**FREEMAN'S JOURNAL.**

". . . In composition, delicacy, softness, equable tone, avoidance of harsh effects in contrast, fore-shortening, etc., too often the bane of the photograph-picture, these examples are wonderfully fine. . . . Type, paper and general 'get-up' are all that can be desired. . . . Should certainly do much to advance artistic photography."
PALL MALL GAZETTE.

"Exceedingly interesting . . . everything possible has been done to make the work attractive."
MAGAZINE OF ART.

". . . We can but wish it all success. It is made up of eight large pages of exquisite printing upon Dutch hand-made paper. . . . Four plates of much merit are given. . . ."—**THE QUEEN.**

"That delightful *journal de luxe*. . . . It is a remarkable example of the progress made in the art of photography."—**GENTLEWOMAN.**

". . . It would be difficult to find anything of its kind more enchanting than the pretty scenes of field and water, horses, men and boats. . . . Indeed the whole 'get-up' of the magazine is luxuriantly artistic . . . If 'Sun Artists' justifies the high expectations awakened by its first issue, it will indeed be a welcome addition to the art journals of the day."—**MANCHESTER EXAMINER.**

". . . We cannot conceive of any work of even the most skilful engraver which, if put upon the etching of 'Sleepy Hollow' could improve it in the slightest degree. The text matter is of the most racy character. . . . 'Sun Artists' is sure to take well, for never before has such an admirable five shillingsworth been offered to the public. It is of large size, and well printed on fine hand-made paper. . . ."
BRITISH JOURNAL OF PHOTOGRAPHY.

"It is very gratifying to notice that the high character with which 'Sun Artists' commenced its career is admirably sustained, and reflects great credit on all concerned in its production."—**CAMERA.**

". . . This publication is already famous. . . . It is a step in the right direction, the first number alone is sufficient to disprove the not uncommon assertion that photography can never be a fine art. . . . The whole set should compose a very valuable collection, and we think that every member of the club ought to make a point of securing copies from the commencement. . . ."—**CAMERA CLUB JOURNAL.**

"The high quality with which this publication started out is still maintained."—**PHOTOGRAPHY.**

". . . The first number of 'Sun Artists' is certainly a 'thing of beauty.' The four plates reproduce photographs good in themselves, and beautifully represented here. The letterpress is interesting, and the whole 'get-up' of the issue most luxurious. 'Sun Artists' can hardly want friends. . . ."—**YORKSHIRE POST.**

". . . Their delicacy and beauty are very remarkable. . . . We have no hesitation in saying that these plates place photography in a higher position than it has hitherto held in public estimation. 'Sun Artists' will be not only a handsome publication, but one of genuine artistic value."—**NORTH BRITISH DAILY MAIL.**

"'Sun Artists,' the fine photographic art journal which has been spoken of so highly by all the European journals, has reached us. We cannot speak too highly of the publication."
THE PHOTOGRAPHIC TIMES AND AMERICAN PHOTOGRAPHER.

"They are not only remarkably good photographs—they are genuine pictures, well selected in subject, capitally grouped, and exquisite in gradations and tones."—**BIRMINGHAM POST.**

". . . The second number of 'Sun Artists' is admirable. The four plates are simply matchless as specimens of photo-printing. Anything more delicate and beautiful of their kind than these pictures could not be desired. The success of this most artistic publication must now be thoroughly assured."—**GLASGOW HERALD.**

". . . Four charming examples ; all of them beautiful and artistic pictures."—**SUNDAY TIMES.**

". . . The plates are thoroughly artistic in workmanship, and the subjects interesting and attractive. . . . They well deserve to rank as fine art."—**THE GLOBE.**

"It is not enough to say that they do him credit, for it must be allowed that they do honour to the photographic art itself."—**NEWCASTLE CHRONICLE.**

"The third number of this handsome and attractive art publication is devoted to the reproduction of photographs by Mr. J. B. B. Wellington. These show what enormous progress has been made by photography as an art. This publication should be in favour with lovers of art."—**GLASGOW DAILY MAIL.**

"'Sun Artists' keeps well up to the worth and promise of the first number. We have here what is incomparably the best work in artistic photography."—**LEEDS MERCURY.**

Chiswick Press

PRINTED BY CHARLES WHITTINGHAM AND CO.
TOOKS COURT, CHANCERY LANE, LONDON, E.C.

THE LITERATURE OF PHOTOGRAPHY
AN ARNO PRESS COLLECTION

Anderson, A. J. **The Artistic Side of Photography in Theory and Practice.** London, 1910

Anderson, Paul L. **The Fine Art of Photography.** Philadelphia and London, 1919

Beck, Otto Walter. **Art Principles in Portrait Photography.** New York, 1907

Bingham, Robert J. **Photogenic Manipulation.** Part I, 9th edition; Part II, 5th edition. London, 1852

Bisbee, A. **The History and Practice of Daguerreotype.** Dayton, Ohio, 1853

Boord, W. Arthur, editor. **Sun Artists** (Original Series). Nos. I-VIII. London, 1891

Burbank, W. H. **Photographic Printing Methods.** 3rd edition. New York, 1891

Burgess, N. G. **The Photograph Manual.** 8th edition. New York, 1863

Coates, James. **Photographing the Invisible.** Chicago and London, 1911

The Collodion Process and the Ferrotype: Three Accounts, 1854-1872. New York, 1973

Croucher, J. H. and Gustave Le Gray. **Plain Directions for Obtaining Photographic Pictures.** Parts I, II, & III. Philadelphia, 1853

The Daguerreotype Process: Three Treatises, 1840-1849. New York, 1973

Delamotte, Philip H. **The Practice of Photography.** 2nd edition. London, 1855

Draper, John William. **Scientific Memoirs.** London, 1878

Emerson, Peter Henry. **Naturalistic Photography for Students of the Art.** 1st edition. London, 1889

*Emerson, Peter Henry. **Naturalistic Photography for Students of the Art.** 3rd edition. *Including* The Death of Naturalistic Photography, London, 1891. New York, 1899

Fenton, Roger. **Roger Fenton, Photographer of the Crimean War.** With an Essay on his Life and Work by Helmut and Alison Gernsheim. London, 1954

Fouque, Victor. **The Truth Concerning the Invention of Photography:** Nicéphore Niépce—His Life, Letters and Works Translated by Edward Epstean from the original French edition, Paris, 1867. New York, 1935

Fraprie, Frank R. and Walter E. Woodbury. **Photographic Amusements Including Tricks and Unusual or Novel Effects Obtainable with the Camera.** 10th edition. Boston, 1931

Gillies, John Wallace. **Principles of Pictorial Photography.** New York, 1923

Gower, H. D., L. Stanley Jast, & W. W. Topley. **The Camera As Historian.** London, 1916

Guest, Antony. **Art and the Camera.** London, 1907

Harrison, W. Jerome. **A History of Photography Written As a Practical Guide and an Introduction to Its Latest Developments.** New York, 1887

Hartmann, Sadakichi (Sidney Allan). **Composition in Portraiture.** New York, 1909

Hartmann, Sadakichi (Sidney Allan). **Landscape and Figure Composition.** New York, 1910

Hepworth, T. C. **Evening Work for Amateur Photographers.** London, 1890

*Hicks, Wilson. **Words and Pictures.** New York, 1952

Hill, Levi L. and W. McCartey, Jr. **A Treatise on Daguerreotype.** Parts I, II, III, & IV. Lexington, N.Y., 1850

Humphrey, S. D. **American Hand Book of the Daguerreotype.** 5th edition. New York, 1858

Hunt, Robert. **A Manual of Photography.** 3rd edition. London, 1853

Hunt, Robert. **Researches on Light.** London, 1844

Jones, Bernard E., editor. **Cassell's Cyclopaedia of Photography.** London, 1911

Lerebours, N. P. **A Treatise on Photography.** London, 1843

Litchfield, R. B. **Tom Wedgwood, The First Photographer.** London, 1903

Maclean, Hector. **Photography for Artists.** London, 1896

Martin, Paul. **Victorian Snapshots.** London, 1939

Mortensen, William. **Monsters and Madonnas.** San Francisco, 1936

*Nonsilver Printing Processes: Four Selections, 1886-1927. New York, 1973

Ourdan, J. P. **The Art of Retouching by Burrows & Colton.** Revised by the author. 1st American edition. New York, 1880

Potonniée, Georges. **The History of the Discovery of Photography.** New York, 1936

Price, [William] Lake. **A Manual of Photographic Manipulation.** 2nd edition. London, 1868

Pritchard, H. Baden. **About Photography and Photographers.** New York, 1883

Pritchard, H. Baden. **The Photographic Studios of Europe.** London, 1882

Robinson, H[enry] P[each] and Capt. [W. de W.] Abney. **The Art and Practice of Silver Printing.** The American edition. New York, 1881

Robinson, H[enry] P[each]. **The Elements of a Pictorial Photograph.** Bradford, 1898

Robinson, H[enry] P[each]. **Letters on Landscape Photography.** New York, 1888

Robinson, H[enry] P[each]. **Picture-Making by Photography.** 5th edition. London, 1897

Robinson, H[enry] P[each]. **The Studio, and What to Do in It.** London, 1891

Rodgers, H. J. **Twenty-three Years under a Sky-light,** or Life and Experiences of a Photographer. Hartford, Conn., 1872

Roh, Franz and Jan Tschichold, editors. **Foto-auge, Oeil et Photo, Photo-eye.** 76 Photos of the Period. Stuttgart, Ger., 1929

Ryder, James F. **Voigtländer and I:** In Pursuit of Shadow Catching. Cleveland, 1902

Society for Promoting Christian Knowledge. **The Wonders of Light and Shadow.** London, 1851

Sparling, W. **Theory and Practice of the Photographic Art.** London, 1856

Tissandier, Gaston. **A History and Handbook of Photography.** Edited by J. Thomson. 2nd edition. London, 1878

University of Pennsylvania. **Animal Locomotion. The Muybridge Work at the University of Pennsylvania.** Philadelphia, 1888

Vitray, Laura, John Mills, Jr., and Roscoe Ellard. **Pictorial Journalism.** New York and London, 1939

Vogel, Hermann. **The Chemistry of Light and Photography.** New York, 1875

Wall, A. H. **Artistic Landscape Photography.** London, [1896]

Wall, Alfred H. **A Manual of Artistic Colouring, As Applied to Photographs.** London, 1861

Werge, John. **The Evolution of Photography.** London, 1890

Wilson, Edward L. **The American Carbon Manual.** New York, 1868

Wilson, Edward L. **Wilson's Photographics.** New York, 1881

All of the books in the collection are clothbound. An asterisk indicates that the book is also available paperbound.